X

DIGITAL
GRAPHIC DESIGN

To Julia

Digital
Graphic Design

Ken Pender

Focal Press
An imprint of Butterworth-Heinemann
A division of Reed Educational and Professional Publishing Ltd

⊖ A member of the Reed Elsevier plc group

OXFORD BOSTON JOHANNESBURG
MELBOURNE NEW DELHI SINGAPORE

First published 1996
Reprinted 1997

TRADEMARKS/REGISTERED TRADEMARKS
Computer hardware and software brand names mentioned in this book are
protected by their respective trademarks and are acknowledged.

British Library Cataloguing in Publication Data
A catalogue record for this book is available
from the British Library

ISBN 0 2405 1477 7

Printed and bound in Great Britain by
Hartnolls Limited, Bodmin Cornwall

Contents

Introduction

Fine art is that in which the hand, the head, and the heart of man go together.
John Ruskin 1859

'Beauty', as the saying goes, 'is in the eye of the beholder.' If it were not so, the warthog may well have become an extinct species long before now!

As with beauty, so it is with art. Just as the male warthog is captivated by those stumpy little legs and that long tapering snout, so there are those who find artistic satisfaction in what seems to others to be a shapeless lump of metal or a few random dabs of paint on an otherwise virgin canvas.

Over the centuries, art has taken many twists, turns and branches; from the earliest cave paintings and the decorated tombs of the Pharaohs to classical frescoes, stylised portraits and serene landscapes; from the intuitive renderings of the Impressionists to a can of Campbell's soup and a shark preserved in formaldehyde, to name but a few.

While classical values endure, the boundaries of art continue to change to reflect our changing society and environment, both in content and in means of rendering. The early stylus progressed to the goose quill to the horse-hair brush, palette knife and aerosol—indeed to application of paint from the tyres of a bicycle or even parts of the human body. The cave wall and stone tablet progressed through parchment and canvas not only to the artboard, but also to the face of a mountain, the wall of a building and even the side of a subway train.

A study of the history of art also shows that expression of art, in its various forms, has always been a extension of people's need to communicate on a more practical level. Even the original cave painting may well have been less a work of art and more an attempt to establish an inventory of local meat stocks! The skills, tools and materials of the scribe, the signwriter, the stonemason, the printer and the architect were all adapted by those with the vision necessary to see their artistic possibilities.

If such a link between art and commercial communication does exist, then we are indeed in for a roller-coaster ride. The pace of change in commercial communication technology has never been greater, as companies seek to gain competitive advantage through 'globalising' their operations by means of high-speed modems, fibre optic laser links and orbiting satellites.

At the heart of this new communications revolution lies the digital computer. Although first conceived as a means of relief from the tedium of manually tabulating numbers in business and scientific environments, the technology has been rapidly and successfully exploited in a myriad of areas which touch all of our lives in both seen and unseen ways.

An earlier book by the author—*Creative PC Graphics*—traces the history of printing and publishing and the rapid changes which computing has imposed on these traditionally conservative business sectors. The objective of *Digital Graphic Design* is not to cover this ground again, but rather to explore the ever-growing possibilities opening up, as the enormous capital invest ment in commercial computing provides 'spinoff' in the form of high-powered, low-cost computer systems and graphic applications with feature sets so extensive that poor designers are almost embarrassed by the riches bestowed upon them!

Digital Graphic Design is also *not* about art. The author has no pretensions in this direction. What it *is* about is inviting the reader to step through the looking glass into this amazing new world and to scratch the surface of the infinite possibilities offered to those with the necessary vision and the talent to seize the opportunities presented to create stunning designs at the least and, at best, work deserving of true artistic merit.

Part 1

Materials and Tools

Raw Materials

Drawing Tools

Painting Tools

Scanning and Photoediting

Three-Dimensional Tools

1

Raw Materials

In any endeavour, the results which will be achieved will depend upon the skills and resources which are available. Over the centuries, the choice of tools and materials available to record design concepts has broadened considerably, particularly in the last century, as design has become a multiskilled discipline, combining traditional tools and crafts with sophisticated photographic techniques and materials from the space age.

By comparison, digital design is still in the cradle. However, in spite of this, the digital designer already has at his or her disposal an impressive array of building blocks from which to compose designs. The objective of this chapter is to review the growing pool of such resources, starting with the hardware required to assemble the design workstation.

Hardware

Figure 1.1 shows a typical configuration, at the heart of which lies the central processing unit. The design and manipulation of complex graphic objects places heavy demands on the central processor, therefore if frustrating delays are to be prevented, investment in a fast processor is well advised.

Choice of Macintosh or PC platform is as much an emotional decision as a logical one, as both schools have their aficionados who would defend the attributes of their choice to the last! The fact is that either platform offers processors suited to the task. It should be recognised, however, that Parkinson's law applies here in the sense that as each new generation of processor is unveiled with more MIPS (Millions of Instructions Per Second) than its predecessor, so each new application update seems to offer exciting new features which make even more demands on processing power, so that the ideal machines seems always to be just around the corner—good marketing, I suppose. The only advice here is to aim as near the top of the range as the budget permits, in the knowledge that, a few weeks hence, the top will have moved on again. At the low end of the range, at least a 68040 or 486DX chip should be considered as the entry level.

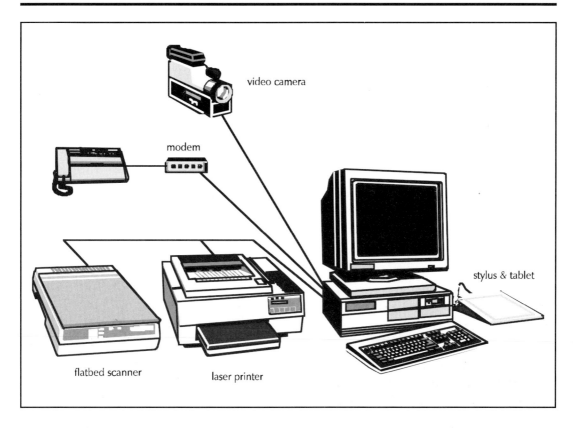

Figure 1.1 *Typical design workstation configuration*

While the central processor is an important determinant of system performance, it is by no means the only one. Graphics card, hard disk and available RAM will all influence performance. Graphics cards are now available with powerful on-board processors designed specifically for fast screen refresh and capable of displaying 16.7 million colours at high resolutions even on 21"screens.

Hard drives with access times below 8 ms now offer sparkling performance when twinned with a hard drive controller card using an on-board RAM cache, or one of the newer protocols such as Enhanced IDE or Fast SCSI, which claims a data transfer rate of around 10 Mb per second. However, no matter how fast the hard drive/controller combination is when loading applications or saving files, it is no substitute for system RAM. Manipulating large colour files in applications like Photoshop makes heavy demands on RAM, even if no other applications are running in the background. When the capacity of available RAM is exceeded, swopping out to disk will slow the system to a crawl. Once again, more is better and 16 Mb should be considered as a minimum figure.

A CD-ROM drive is rapidly becoming a standard feature on all but low-end systems and CDs are replacing floppy disks as the vendor-preferred medium for supplying both new applications and clipart libraries. A fast drive is not critical when only occasional use is anticipated, but for heavier usage, and especially if multimedia work is planned, then the higher cost of a four-speed or even six-speed drive may be justified.

The visual point of contact with the system is, of course, the monitor screen and, for the designer spending many hours a day at the screen, picture size, clarity and stability are all important. Although not cheap, the cost of 17″ or 21″ screens with fine spot sizes and high refresh rates is falling in real terms, so, if possible, at least a 17″ screen should be used. Having said that, the author spent many years working on a 12″ screen—a working environment probably akin to that of keyhole surgery—but, in the end, the jobs got done, so it only goes to prove that there are no absolutes here!

At least as important as the visual point of contact with the system is the tactile point of contact. While a mouse or trackball can be used successfully for manipulating objects on screen, a stylus and, preferably pressure-sensitive tablet combination is far superior for detailed drawing or painting work.

A flatbed scanner is preferable to the hand-held variety for input of line art or photographic images and a Polaroid camera provides a quick way of capturing a subject for digitisation by the scanner. Better quality, although less instant, results can of course be obtained using images captured with a conventional 35 mm camera and scanned by means of a transparency adapter fitted to the scanner. Additional means of inputting digital images are provided via one of the small hand-held digital cameras which are now becoming available, or by capturing still video frames from a video camera. Unless professional quality cameras (read *expensive!*) are used, however, high quality results should not be expected.

Prices have fallen so fast that the laser printer has become the *de facto* standard for monochrome proofing. For text or line art, 600 dpi laser output is of sufficiently good quality that it is often used to produce camera ready copy for plate-making. For proofing of work, including graduated tones or halftone photographs, laser printers offering 1200 and 1800 dpi are now available, although at a premium cost. For colour proofing, inkjet printers provide the best low-cost solution, while dye sublimation printers offer photorealistic quality in a higher price bracket. In between lies the colour laser printer which is presently expensive but, like its monochrome predecessor, seems likely to become the colour proofing workhorse of the future.

A desirable, although not necessary, addition to the configuration is a modem to allow connection of the workstation to the telephone network. Such a connection allows dispatch and receipt of conventional electronic mail, sending and receiving faxes (with the addition of a fax card) and more important, access to networks like CompuServe and the Internet. While much of the electronic traffic on these networks is irrelevant to the designer, there are user forums and electronic bulletin boards which can provide valuable sources of information.

Additional output devices, such as image recorders for creating colour slides for projection, or large format pen or inkjet plotters may be added to meet specialist requirements, but the configuration in Figure 1.1 represents the more typical setup.

Software

Next to the hardware which constitutes the workstation, the designer's most important resource is the software which breathes life into the hardware, transforming it from an inert mass of silicon, metal and plastic into a vibrant, responsive palette. Software relevant to the graphic designer can be divided into the following categories:

Operating systems

For Mac users, the proprietary system supplied by Apple is System 7 (Figure 1.2), with the possibility of Windows as an option, via either emulation software or an add-on card. The PC *de facto* standard has become Microsoft Windows (Figure 1.3), but IBM's multi-tasking OS/2 (Figure 1.4) is steadily gaining acceptance with corporate customers and could still become a serious competitor for Windows if the right applications are upgraded to use the features it has to offer.

Graphic applications

These are the 'mission-critical' software components in the designer's arsenal and will be addressed separately in Chapter 2.

Figure 1.2 *Apple System 7 user interface*

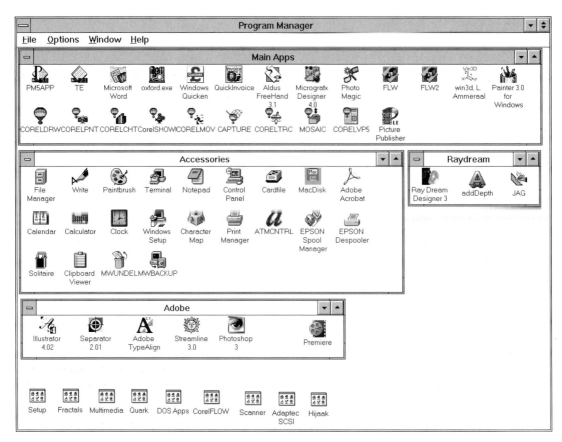

Figure 1.3 Microsoft Windows user interface

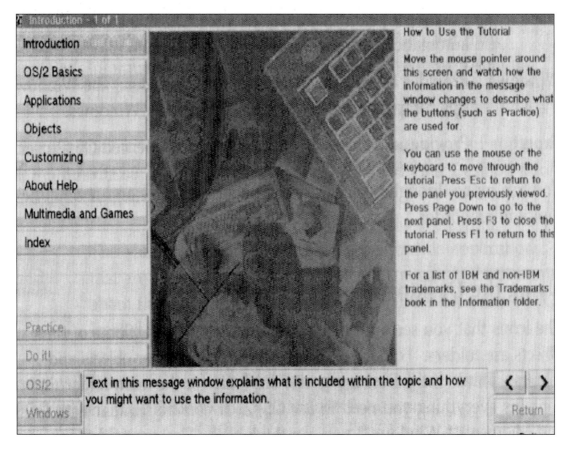

Figure 1.4 IBM OS/2 user interface

Extensions

Also sometimes called 'plug-ins' or 'additions', these are mini-applications designed to add features to existing major applications. After first appearing for use on page-layout programs like Quark XPress, they are now becoming increasingly common as a means of adding filters and other features to graphic applications

Utilities

From on-screen clocks to complex font management systems, utilities come in many shapes and sizes. For the designer, Adobe's Type Manager and Inset System's Hijaak file conversion program are examples of utilities which provide important supporting features.

Clipart

Until a few years ago, clipart was supplied in the form of low resolution, often low quality, stereotyped bitmap images, often bundled as incidental add-ons to painting programs. Today, clipart comes in many formats, both vector and bitmap and the range of subjects offered in the form of both general and highly specialised clipart libraries has grown enormously.

The now omnipresent CD-ROM (Figure 1.5) offers the many emerging clipart vendors an ideal medium for distributing their products. Although quality of the output is variable, some vendors now employ designers skilled in exploiting the capabilities of the leading drawing and painting programs to produce work of high quality. For the user, the CD-ROM provides an ideal medium for clipart, with its enormous storage capacity and acceptable file retrieval time for what is normally occasional use.

Figure 1.5 *Chestnut Software's Clipart Goliath CD-ROM*

The pros and cons of vector versus bitmap clipart are essentially the same as those for vector and bitmap art in general (see Chapter 2). However, vector clipart does have the two important advantages in that (a) it can be ungrouped into its elements and freely edited by the user, and, (b) because of its editability, it can provide a valuable source of learning for the new user.

Suppliers of clipart—either directly, or through bundling with a design or DTP program—are generally happy for their art to be used 'as is' or in an edited form, in a host document for commercial purposes. Some bundled clipart, however, is included to demonstrate the kind of product available for purchase from a vendor and its use is restricted, therefore the user is well advised to consult the vendor before using such material for any commercial purpose.

Scanned images

The scanner is one of the most versatile tools available to the designer. It can be used to create bitmapped images of line art, rendered drawings, paintings, photographs and even, in the case of a flatbed scanner, three-dimensional objects (Figure 1.6). Textures of common artefacts like fabric, wood, leather or leaves can also be captured (Figure 1.7) and saved for application to objects created later in a drawing or painting application.

35 mm transparencies can also be scanned using an adapter which is available as an option for most flatbed scanners, but, for 'instant' results, a colour Polaroid camera is a useful accessory.

In recent years, the quality of flatbed scanners has improved as rapidly as their prices have fallen, to the point where the top-end machines are beginning to rival the output from much more expensive drum scanners. To obtain optimum results, however, care must be taken in following certain guidelines which are covered in Chapter 4.

Figure 1.6 Scanned coach clock

Figure 1.7 Scanned cork coaster

PhotoCDs

Until recently, access to good quality, high resolution digitised photographs involved an expensive visit to one of many photo libraries which have evolved as a service principally to the media. Kodak's PhotoCD process has changed all that, providing vendors with a relatively low cost and high quality means of mastering CDs containing typically 100 colour photographs. Usually the photographs are stored on the CD at a number of different resolutions, with the highest rivalling the drum-scanned quality available from photo libraries.

While the use of a single photo library image can cost in the order of £40 ($60) for a one-time use, the PhotoCD images can cost as little as 8p (12¢) each, if the CDs are bought as a library set, and royalty rights are included in the cost of purchase. In addition, a growing number of high-street shops offering conventional photographic film processing are now also offering a PhotoCD service which digitises the customer's own 35 mm film images at a cost of around 50p (75¢) an image.

Hard copy thumbnails are normally provided with each CD, but images can be previewed on screen using a utility like the PhotoCD lab (Figure 1.8) and the selected image is then saved to the system hard disk and imported to a photoediting application, where it can be manipulated and edited like any other bitmapped image.

Figure 1.8 PhotoCD lab

Screen-grabbed images

Screen-grabbing—taking a digital snapshot of part or all of what appears on the designer's screen—is a fast and convenient way of placing the grabbed image into a document. Screen-grabbers are provided as accessories with a number of graphics programs and operating systems. Figure 1.8 was grabbed using Corel CAPTURE, which is bundled with CorelDRAW. Some screen-grabbers—such as the one provided with Windows—simply copy the grabbed image to the clipboard, from where it can be pasted on to the page in process. Corel CAPTURE (Figure 1.9) has much more functionality than the Windows grabber, providing the user with a range of options regarding how to

(a)

(b)

(c)

(d) (e)

Figure 1.9 The Corel CAPTURE screens

activate capture (Figure 1.9a), exactly what area of the screen is to be captured (Figure 1.9b), whether the grabbed image is to be sent to the clipboard, saved as a file or printed and at what size, resolution and bit depth (Figure 1.9c), what filename and type should be used for a saved image (Figure 1.9d) and what colour and weight of border should be placed around the image (Figure 1.9e).

Mathematical images

From their schooldays, some readers at least will remember how simple mathematical equations could be visually represented on paper, e.g. $y = x + 3$ turned out to be a straight line with a gradient of 1, intersecting the y axis at $y = 3$ (Figure 1.10a); a simple quadratic equation like $y = x^2$ produced a symmetrical parabolic curve passing through the origin (Figure 1.10b); when a third variable z was introduced, an equation such as $y = x^2 + z^2$ transformed into a more interesting surface of revolution, symmetrical about the y axis (Figure 1.10c).

Another maths lesson taught us the concepts of arithmetic/geometric series and number patterns—series or arrays of numbers which were not random, each member exhibiting some special relationship to other members.

In the days before computers, the plotting and displaying of any but the simplest of equations and series led to severe headaches at best and abrupt mathematician career changes at worst. It turned out, however, fortunately for the mathematics profession, that one of the things computers do best is carry out repetitive simple calculations very quickly. When allied with a graphics card able to use colour to distinguish the different parameters of an equation or a series, the computer's processor can almost literally bring mathematical expressions to life on the computer screen, where they can be captured for use in graphic compositions.

Perhaps the best known visual manifestation of the above phenomenon is the generation of hauntingly beautiful fractal patterns—patterns created when the results of each step of a relatively simple mathematical equation is fed back into the equation and repeated and repeated (Figure 1.11).

A number of applications, such as Mathematica, Maple or MathCAD, oriented mainly towards academic mathematical and scientific modelling work, have emerged and evolved to exploit this new opportunity, but such applications can also produce results of value to the graphic designer. On a more aesthetic level, work like William Latham's 'Garden of Unearthly Delights'—available on CD-ROM—provides a superb demonstration of the strangely beautiful graphic forms which can be created at the leading edge of this exciting new direction in computer graphics.

Some graphics applications are already beginning to employ fractal 'engines' to make interesting new and infinitely variable textures available to the user, while other developers such as Kai Krause of MetaTools have released new

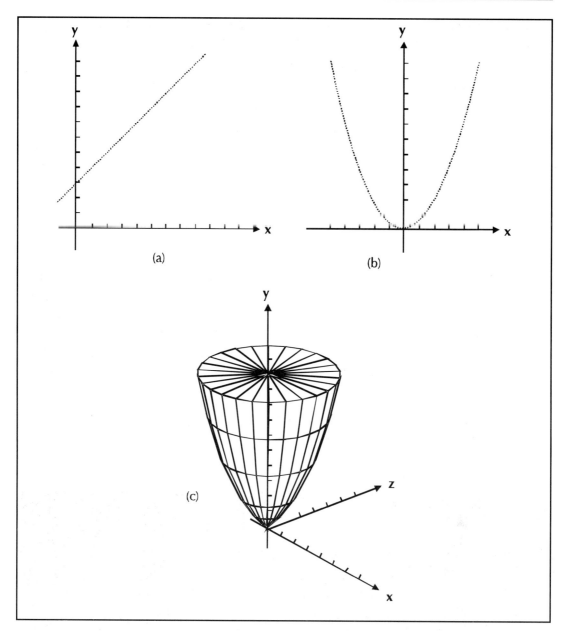

Figure 1.10 *Visual representation of simple mathematical expressions*

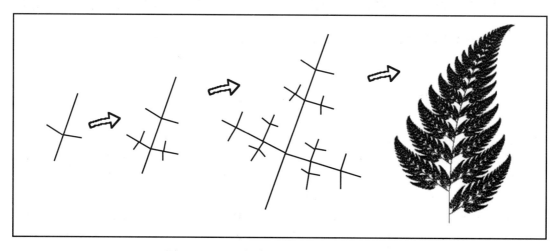

Figure 1.11 *The 'growth' of a fractal fern*

application extensions which can be used to create an astonishing array of textures, patterns and even fractal terrains and moonscapes.

Also deserving mention is a uniquely interesting fractal generator from a small company called Cedar Software in Vermont, USA. Fractal Grafics provides a library of simple graphic templates with which the user can create, manipulate and save an endless variety of fractal patterns. Fractint, the now famous Fractal Freeware program from the Stone Soup Group, is another excellent vehicle for generating a wide range of fractal types as well as landscapes, planets and cloud formations.

Microscopic images

Continuing the theme of graphics from nature, another rich source of interesting images can be found on the end of a microscope! An endless range of samples placed on microscope slides can be photographed using a conventional 35 mm single lens reflex camera attached to the microscope by a fixture which replaces the normal eyepiece. The images captured can then be digitised either by transparency scanning or conversion to PhotoCD as described earlier.

Examples of such images—photographs of crystal sections—from Corel's 'Creative Crystals' PhotoCD—are shown in Figure 1.12.

Figure 1.12 *Microscopic images of Agarose (left) and Benzimidazole (right)*

Electron microscope images

Images even more dramatic than those that can be viewed through the eyepiece of an optical microscope are those revealed by the awesome power of an electron microscope—a remarkable instrument which uses the extremely short wavelength of an electron beam to capture details in an image which would be totally invisible in a conventional optical microscope. Such images are available from makers of such microscopes or from government, commercial or academic laboratories.

Downloaded images

The much vaunted super-highway offers swift transport to an increasing number of graphics destinations (image newsgroup transmissions account for as much as 50% of current Internet traffic). The user needs only a modem, appropriate telecommunications access software, an offline message reader, a Web browser, an FTP (File Transfer Protocol) downloader and a subscription to one of the growing number of 'providers', to gain access to the worldwide Internet.

Normally the provider supplies the various items of software in return for an initial subscription in the region of £20 ($30) and then makes a monthly charge for connecting to the Internet via the server. This charge covers a cumulative monthly connection time of a specified number of hours. In addition, there is, of course, the cost of using the phone line while connected to the Net, a cost which has been a deterrent to many potential users in Europe since connecting to the nearest provider access point has involved calling long distance. This deterrent is steadily diminishing, however, as more and more access points become established, reducing the telephone cost to that of a local call.

Figure 1.13 shows the user interface for Free Agent, the kind of application needed to work effectively on the Net. Free Agent is an application

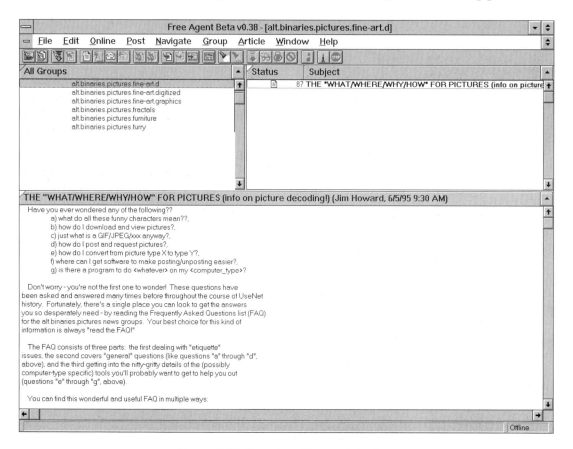

Figure 1.13 *Free Agent's user interface*

designed to permit easy interaction with Internet interest groups, of which there are thousands. Among this mind-blowing range of Internet topics, both technical and non-technical, the graphic designer can find extensive clipart libraries, fonts, technical information—from vendors and users—on major graphics applications and the opportunity to become a member of specialist groups covering anything from fine arts to pre-press developments. Examples of groups relevant to graphic designers include 'alt.binaries.clipart', 'alt.graphics' and 'alt.3D'. Subscribing to such groups can provide access to a useful graphics expertise, as well as to picture files, which can be downloaded.

For the newcomer, the principal obstacle to be overcome is that of finding a map showing how to access the appropriate network nodes. Fortunately, help is at hand either by using pointers to appropriate newsgroups given by Usenet, the Internet global bulletin board, or by using 'browsing' software like Mosaic or Netscape to search for graphics 'jump points'—Internet-speak for access points to sources of graphics information. Figure 1.14a shows the Netscape screen opened at the Internet directory page. Clicking on any item on the list opens the corresponding sub-index, such as the 'Art' sub-index in Figure 1.14b. From this sub-index, clicking on 'Computer Generated' takes the browser into an index of pages of graphics and supporting text from a wide range of sources. Graphics are normally displayed as relatively small thumbnails, but clicking on a thumbnail causes the graphic to display full size.

In addition to software for accessing interest groups and browsing the Web, the graphics user will need an application for accessing and downloading from FTP sites. These are sites maintained by business, educational and government establishments, many of which allow free access to the user. Figures 1.15a and 1.15b show the access screens of such an application—in this case WS_ftp. Via the screen in Figure 1.15a, the user can define the FTP site to be accessed. When connection to the site has been achieved, files available at the site are displayed on the right-hand side of the screen in Figure 1.15b. Double clicking on one of these files causes it to be downloaded to the user location specified on the left-hand side of the screen.

Some FTP sites that hold interesting graphic information are 'ftp.pasture.ecn.purdue.edu' (bitmapped GIF and Tiff images), 'ftp.ccu1.auckland.ac.nz' (architectural graphics and textures) and 'ftp.sumex-aim.stanford.edu' (mixed graphic images).

Last, but not least, in the portfolio of Internet applications is the e-mailer, for transmitting and receiving electronic mail, which can include graphics files as attachments. Figure 1.15c shows the interface for the Eudora e-mail application, currently one of the most popular available; sending mail with such an application could not be simpler. After typing the message and Internet address of the addressee off-line, clicking 'Send' initiates automatic connection to the Internet and sends the message.

(a) The Internet directory

(b) The index of art topics

Figure 1.14 *Bowsing the Web with Netscape*

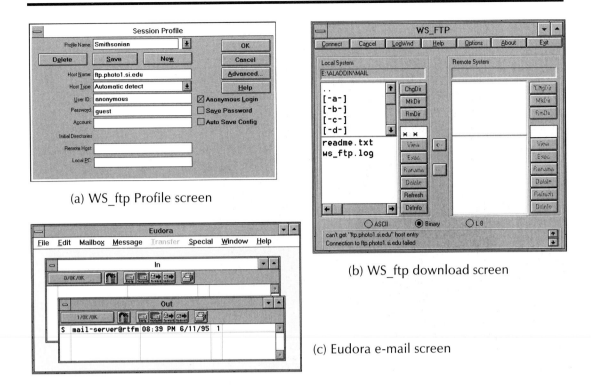

(a) WS_ftp Profile screen

(b) WS_ftp download screen

(c) Eudora e-mail screen

Figure 1.15 *File transfer and e-mail applications*

Public domain art

In accordance with long established laws of copyright in the UK, original works of art remain the exclusive property of the originator and his or her heirs until 50 years after the originator's death. After that time, the copyright lapses and the work moves into the public domain—i.e. it can be reproduced without infringement of copyright. In the UK, for example, such material is readily available at the British Library in London, where photographic copies or 35 mm slides can be purchased for a fee. The address is:

British Library Reproductions,

Great Russell Street,

London WC1B 3DG

Digital photographic images

Digital images can be captured either by using one of the high quality (and high cost!) digital cameras on the market, such as the Kodak DCS 420 (Figure 1.16) or at a lower quality (and cost) using a camera like the Canon ION 260 (Figure 1.17). While static images can be captured successfully, this is still an evolving technology which is not yet capable of satisfactorily capturing moving images. The latter is possible by using frames from composite, Super

VHS or Hi8 output from camcorders. Downloading from camera to workstation is via a frame-grabber card supplied with the Canon ION and via connection to a video-grabbing plug-in card in the case of the camcorder.

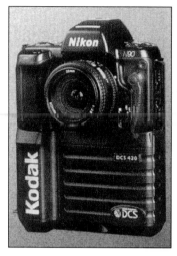

Figure 1.16 Kodak DCS 420

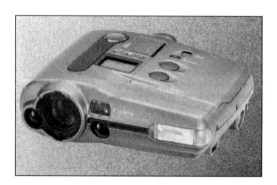

Figure 1.17 Canon ION 260

Summary

In this chapter, we have touched briefly on the glittering array of raw materials which now lie at the disposal of the graphic designer. Based on the experience of the last decade and taking even a conservative look ahead to the future, it can be confidently predicted that the costs of these materials will continue to decline in real terms, while their quality and breadth of choice will continue to increase.

But then, after all, clay is just clay and the materials are just materials. Without tools, the potter could neither form raw materials into functional objects nor the sculptor create works of enduring form and beauty. So it is in any field of design. So let us move on, in the next chapter, to look at examples of the tools which are now available to the digital designer.

2

Drawing Tools

The purpose of this and the next four chapters is not to provide detailed descriptions of the features available in all the leading drawing, painting, photoediting and three-dimensional applications—such details can be found in the application manuals—but to summarise generically the working environments, tools and techniques offered by these applications as a prelude to presenting, in Part 2 of the book, the results which they can be used to produce.

In a conventional design office, designers would do most of their work on and around the drawing board—their working *environment*. They would employ a number of specialised drawing instruments or *tools*—pens, pencils, setsquares etc.—with which to create drawings, and then, in many cases, they would use special *techniques*—masking, paste-up, lighting effects, for example, to achieve the required final result.

Up to a point, digital application design has mimicked this traditional view, as vendors believed this to be the user-friendly approach most likely to entice designers away from their drawing boards. In order to optimise the drawing metaphor, drawing applications are object oriented, i.e. objects created on screen are described precisely, in mathematical terms. Vendors differ, however, in their use of the traditional metaphor: in deciding whether to make the colour palette a fixed feature on the screen or a menu-selectable item; in deciding what tools to include in the toolbox; in choosing whether to provide techniques via 'rollup' or conventional menus; and in deciding what information to display on ribbon bars or status lines. The recent trend is towards customisation—allowing users to create their own preferred configurations, just as their traditional counterparts could select and arrange their most used tools within a work area.

As today's generation and the next grow up in an increasingly digital world, the need to cling to the old conventions will diminish and new design interface protocols will evolve, allowing designers to work more intuitively as well as more efficiently. For the present, however, for the purpose of making a broad assessment of the capabilities of today's applications, it is still useful to relate to the conventional view of working environment, tools and techniques.

Environment

The working environments of drawing applications like Adobe Illustrator, Macromedia Freehand, CorelDRAW and Micrografx Designer bear a close resemblance to that found in a typical drawing office.

Typical characteristics include the following:

Horizontal and vertical scales, with selectable units

Horizontal and vertical guides which can be dragged into position anywhere in the work area. In some applications, there is a separate guide layer, on which lines of any shape can be drawn and used as non-printing guides

An XY grid with adjustable pitch to assist in positioning items. A 'snapping' feature, which can be turned on or off, to allow a selected object to be snapped to the grid, a guideline or to another object. For precise placement, a dialog box provides the means of entering object coordinates directly. Further assistance in placement is provided by a 'nudge' facility which allows use of the arrow keys to move a selected object vertically or horizontally in small preset increments

The cursor position is also displayed on a ribbon bar as it moves on the screen either in the form of an arrow or cross-hairs. The ribbon bar also provides information about an object (e.g. dimensions of a rectangle or angle of a sloping line) as it is being created or when it is subsequently selected.

A zoom facility allows magnification of a selected area of the drawing. Options allow the drawing in process to be viewed either in full colour (slow redraw) or wireframe (faster redraw)

Layers, like transparent overlays in traditional drafting, provide the means of isolating different parts of a composition, e.g. in an office layout, the walls, doors and windows may be on one level, the office furniture on a second level and the services—telephone and power—on a third level. Objects, or whole layers, can be locked, to avoid accidental movement and individual layers can be hidden or made visible while the active layer is being worked on

A colour palette provides grey tones and colour sets for colouring object strokes and fills

Examples of two popular drawing environments are shown in Figures 2.1 and 2.2.

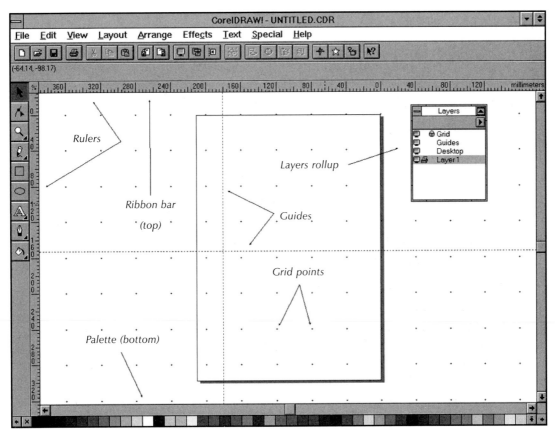

Figure 2.1 *The CorelDRAW working environment*

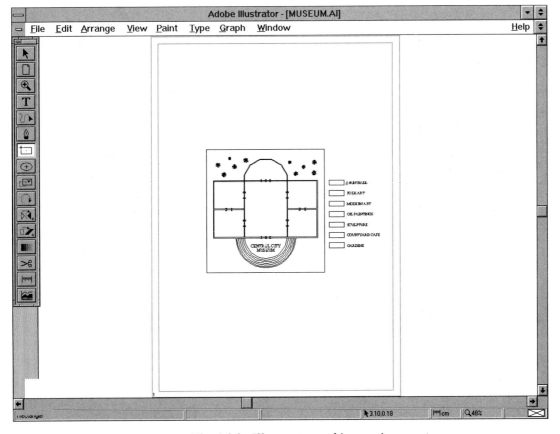

Figure 2.2 *The Adobe Illustrator working environment*

Application tools

Having looked at a typical environment, we now need to examine the tools and techniques available for use within such an environment. For the purpose of this assessment, we shall define an application tool as a software device used to create an object on the drawing surface in its initial form, as distinct from a technique, which is defined as a means of modifying an object once it has been created.

As object-oriented drawing programs have evolved, it has become conventional to provide the user with a set of on-screen tools—selectable icons, grouped together in a form of toolbox (see Figures 2.1 and 2.2). Variations on the default tools displayed are often available via flyouts (Figure 2.3a)—which are activated by clicking and holding down the mouse on the default tool—and/or rollups (Figure 2.3b)—which, as the name suggests, can be rolled down to reveal further options, by clicking with the mouse, or rolled up when not in use.

Applications vary as to which tools they include in the toolbox. The common toolset consists of:

A line tool to create freehand, straight or smoothly curved lines. (Note: closed shapes can also be produced by joining the last in a series of connected segments to the first)

A shape tool to produce basic geometric shapes, such as rectangles and ellipses

A magnification tool to control level of magnification

A text tool for placing text directly on the drawing area

Figure 2.3

(a) Adobe Illustrator flyout

(b) CorelDRAW rollup

(a) (b)

In addition, as can be seen from the examples in Figure 2.3, ancillary tools may be included, e.g. to,

Carry out node editing

Alter the stroke or fill attributes of a line or shape

Adjust the scale, skew or rotational angle of an object

As well as varying in *where* they place tools, applications also differ in the *options* they provide for a particular tool. Micrografx Designer offers a particularly comprehensive selection of tools for line and shape drawing (Figure 2.4). When any one of the top-left group of five drawing icons is selected, a secondary box of options for that selected tool opens up to the right. Figure 2.5 shows the 25 different options which are available when each of the option boxes is opened in turn.

Unlike the other popular applications, Macromedia Freehand provides a pressure-sensitive line tool option, producing lines varying in width according to stylus pressure applied to a pressure-sensitive tablet. In addition to the

Figure 2.4 *Tool selection in Designer*

Figure 2.5 *Designer's extended tool options*

standard line options, CorelDRAW offers a set of preset 'Powerlines' which are also lines of varying width, as well as an editable calligraphic option.

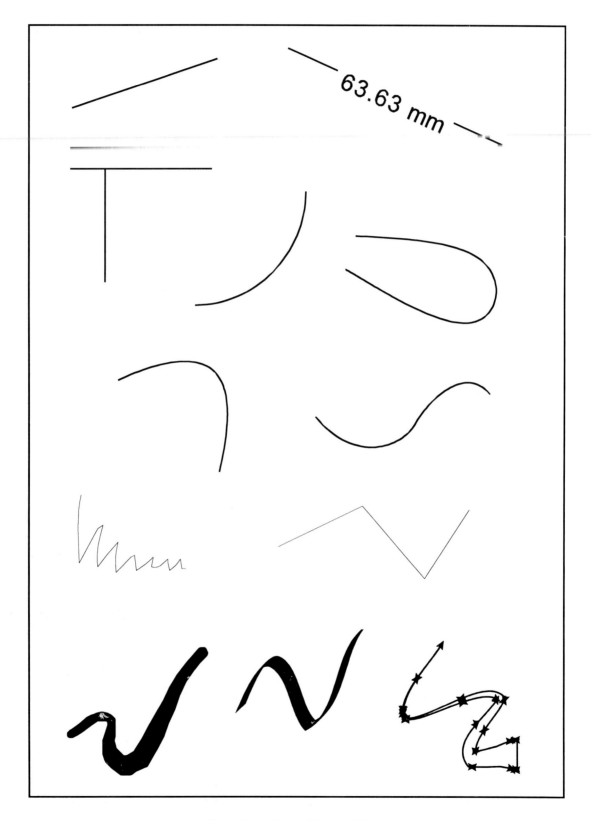

Figure 2.6 *Vector line variations*

Figures 2.6 and 2.7 show examples of lines and shapes which can be produced by these vector applications.

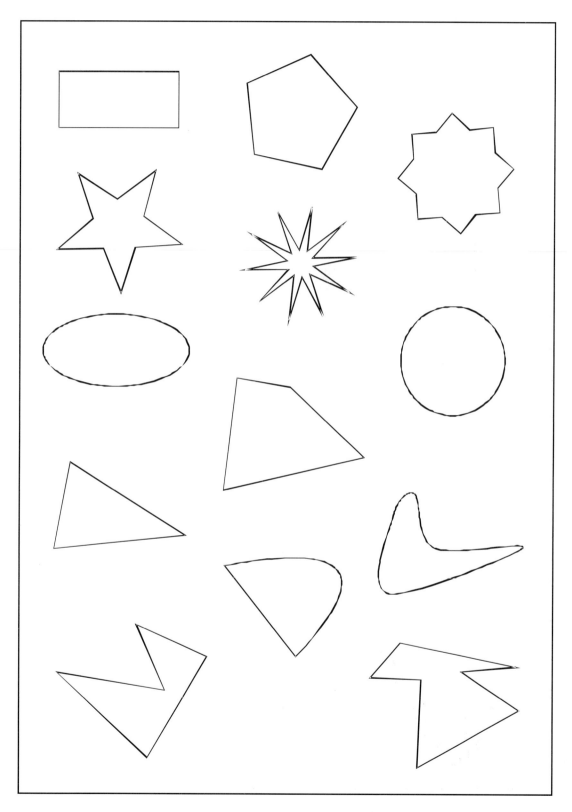

Figure 2.7 *Vector shape variations*

An enormous range of good quality Truetype and Adobe Type 1 typefaces are now available for use within graphic applications. Their vector construction allows scaling to virtually any size without loss of quality and, with a little help from Adobe Type Manager, where appropriate, they will both display and print at high resolution.

Until recently, most application text tools required that text be entered first into a dialog box, before being placed in its required position. Recent upgrades, however, allow text to be entered and edited directly in position on screen. Type can also be converted to curves for the purpose of creating masks or to allow node editing of individual characters. Using the node editing principle, a number of font generation applications (e.g. Fontographer or FontStudio) now give the user the tools to design a completely original typeface, although few users possess the skills to do so successfully.

In addition to the standard set of tools described above, another tool useful to the graphic designer is one which creates a pseudo three-dimensional object by rotating or 'lathing' a two-dimensional shape through 360°. Access to such a tool normally requires use of a CAD program, but a simple lathing tool is included with Micrografx Designer 4.0. Lathing the profile shown in the lower centre screen produced the three-dimensional wireframe object above it. Applying coarse and fine shading produced the copies on the left and right respectively.

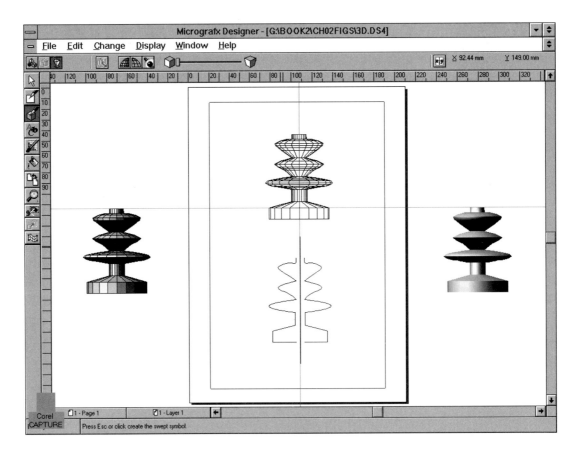

Figure 2.8 *Designer's lathing tool*

Application Techniques

As defined in the previous section, a technique is the means by which an object is altered after being created with one of the application tools. (Note: with the positive aim of improving user productivity, some applications make commonly used techniques—like node editing—available from within the toolbox.) Any one or a combination of the following techniques can be applied to objects to alter their appearance.

Adjustment of stroke weight, style and colour

Applying process or spot colours or tints, textures or pattern fills

Node editing—adjusting object shape by moving nodes/handles

Scaling—proportionally or non-proportionally

Rotation—in fixed increments or freeform

Skewing or shearing—about a fixed point

Mirroring—vertically or horizontally

Extruding—giving an object a three-dimensional appearance

Blending—directly or along a path

Contouring—internally or externally to the object

Duplicating—copying with same attributes

Cloning—making a slave copy which follows changes to original

Aligning—vertically, horizontally or centred

Grouping—creating a set of objects to be manipulated together

Combining—joining two objects to create a mask

Enveloping—constraining an object to fit within an envelope

Perspective—adjusting the object's perspective

Welding—joining object paths at the points where they intersect

Intersecting—creating a new object from overlapping ones

Trimming—using one object to trim off part of another

Powerclipping—placing one object inside another

Applying lenses—making an object seem to be seen through a lens

3

Painting Tools

Like the designer we visualised in a conventional drawing office at the beginning of Chapter 2, we can similarly visualise an artist in a conventional *environment*—the typical artist's studio with its easel and canvases. Around the studio would be the artist's *tools*—palettes, brushes, paints and thinners. In order to achieve the results required, our artist would have learned to use specific *techniques*—to convey a sense of distance in a landscape, to capture skin tones in a portrait or to communicate movement and excitement in a painting of a steeplechase.

Digital painting applications, like their drawing counterparts, have tried to emulate this familiar environment, with canvas, brushes, palettes and paints—even a pasteboard, where preliminary thoughts can be tried out before being applied to the main canvas. As distinct from drawing applications, a painting application addresses individual pixels—the digital analogue of the artist's dab of paint—and stores and manipulates information about the attributes of each pixel.

The first applications were limited in the functions they offered and slow in executing them, as the early microprocessors struggled to manipulate the large bitmap files within a confined memory workspace. Also, trying to 'paint' on screen with a mouse was frustrating enough to deter all but the most determined—and steady handed—pioneering digital artists.

As processor power and memory sizes have increased, and as pressure-sensitive tablets have arrived on the scene, application developers have been quick to improve performance of the basic functions and have also introduced some quite remarkable innovations into the latest program releases, transforming the environment from a pale imitation of the conventional one to a panorama crammed with exciting possibilities.

Whereas in the domain of drawing applications a number of competitive products continue to play leapfrog for market leadership, in the digital painting world one application—Fractal Painter—has achieved at least a temporary edge over its competitors by offering an unequalled range of superbly

conceived tools. Its designers are equally innovative with the unusual interface, which continues to change from release to release. Adobe Photoshop, the undisputed leading bitmap program on the Mac also has an impressive set of painting tools, but is oriented more towards photoediting than painting.

As well as those two, there are several other serious competitors vying for the artist's attention, creating a climate of constantly evolving function and constantly declining (in real terms) prices.

Environment

The working environments of painting applications typically include the following characteristics:

Horizontal and vertical scales, with selectable units

An image work area with configurable dimensions, resolution and mode (e.g. greyscale, indexed colour or RGB colour)

A 'canvas' area adjustable independently of the image area

An XY grid with adjustable pitch to assist in positioning items. Further assistance in placement is provided by a 'nudge' facility which allows the arrow keys to move a selected object vertically or horizontally in small preset increments

An information panel which provides details about the image size, resolution and colour depth

A zoom facility which allows magnification of a selected area of the painting

A status bar or ribbon which provides information about the currently selected tool

Layers, which provide the means of isolating different parts of a composition

A colour palette providing grey tones and colour sets

Channels—for separation of, for example, RGB colour components of an image

Layers—to separate different features of a composition

As in the case of drawing applications, the trend is towards customisation of the painting environment—allowing the user to create a preferred configuration, keeping open just the rollups, custom brushes and library selections required for the project in hand. Examples of two popular painting environments are shown in Figures 3.1 and 3.2.

Figure 3.1 *The Fractal Painter working environment*

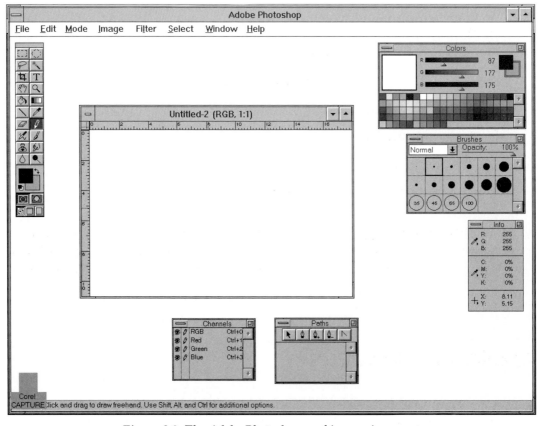

Figure 3.2 *The Adobe Photoshop working environment*

Application tools

Like their drawing counterparts, most painting applications provide the user with a set of tools, usually housed within a toolbox, although the analogy with traditional painting tools is more tenuous, as there is no traditional analogue for the 'selection tool' or the 'quick mask tool', for example. The following lists the contents of a typical toolbox:

> A brush tool to create freehand brushstrokes
>
> A line tool to produce straight lines
>
> Selection tools to select geometric areas, such as rectangles and ellipses
>
> A magnification tool to control level of magnification
>
> A text tool for placing text directly into the painting area
>
> An eye-dropper tool to sample a colour in an image
>
> A fill tool to flood a designated area with colour, a gradient fill or a texture
>
> An eraser tool to remove colour from selected pixels

In addition to these fairly standard items, there are many other tools supplied with different applications:

> A cropping tool
>
> Specialised selection tools and masking tools
>
> Additional painting tools, such as an airbrush
>
> Hand tool for repositioning images within preview windows
>
> Dodge and burn tool
>
> Local smudge and sharpen tool
>
> Manual or automatic clone tools

As in the case of drawing applications, the trend is towards the use of rollups to house the wide range of options becoming available with some tools. Figure 3.3, for example, shows the Corel PHOTO-PAINT toolbox on the left-hand side of the workspace and various open rollups.

Application techniques

As the following list shows, many drawing tools have counterparts in painting applications, even if the means of implementation differ in some cases.

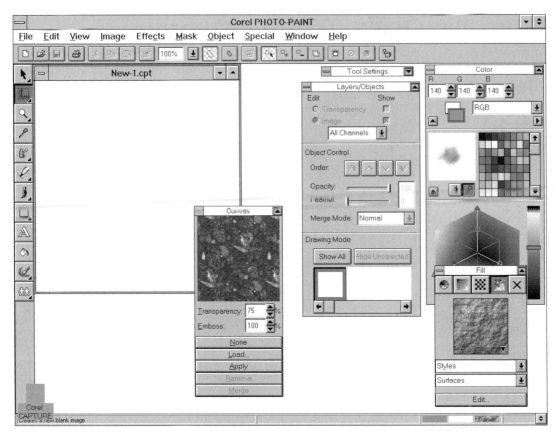

Figure 3.3 Corel PHOTO-PAINT *toolbox and rollups*

Adjustment of stroke weight, style and colour—via a dialog box and colour palette

Applying process or spot colours or tints, gradients, textures or pattern fills

Painting with patterns

Path editing—adjusting path shape by moving nodes/handles

Scaling a selection—proportionally or non-proportionally

Rotation—in fixed increments or freeform

Skewing or shearing—about a fixed point

Flipping—vertically or horizontally

Distorting—giving an object a three-dimensional appearance

Perspective—adjusting the selection's perspective

Feathering—reducing hardness of selection edges

Opacity control—adjusting transparency of selections

Layer masking—used to adjust transparency of layer

Lighting—creating directional flood or spot lighting effects

Applying drop shadows

Creating mattes

Compositing images

Filters

This is one area where painting applications have a major innovative lead over drawing applications. Filters, which can be applied to the whole document or just to a selection, are now provided as a standard feature of leading painting applications. Additional filters—of an increasingly spectacular and sometimes bizarre nature—can be purchased as extensions or plug-ins to the main program. The standard filter set normally includes the following:

Blur—gaussian, motion, radial

Sharpen—unsharp mask, sharpen edges

Distort—pinch, ripple, spherise, wave, zigzag

Noise—add, remove

Crystallise

Diffuse

Emboss

Facet

Find edges

Mosaic

Solarise

Wind

Artistic—Pointillise

4

Scanning and Photoediting

Scanning

As pointed out in Chapter 1, scanned images represent one of the designer's most valuable resources. To create good scans, however, requires knowledge of, and adherence to, some basic scanning principles which are covered in this chapter.

Few designers are fortunate enough to have access to the Rolls-Royce among scanners—the high resolution and high cost drum scanner. On the other hand, with the recent rapid fall in prices, many can now afford to install their own dedicated flatbed scanner (Figure 4.1) which retails for around £700 ($1000). A true resolution of 600 by 1200 dpi and interpolation via software up to 2400 by 2400 dpi produces excellent line art scans. As well as line art, output options include halftone, greyscale and full 24-bit colour. An optional adapter further extends the scope of the scanner to include 35 mm transparencies.

Figure 4.1 Flatbed scanner

Increasingly, scanners are being designed to use the SCSI interface, which enables simple 'plug-and-play' connection either directly to an external SCSI port or to an existing daisy chain. Software installation is normally straight-forward, involving loading of the scanner driver and any image manipulation software provided with the scanner. The latter can range from simple editing software proprietary to the scanner manufacturer—providing features like image cropping, adjustment of exposure and sharpness for example—to fully featured photoediting applications which control the scanner via a standard TWAIN (Technology Without An Important Name!) interface.

Fundamental to successful scanning is an understanding of resolution in its different forms—input resolution, display resolution, output resolution and screen resolution.

Types of resolution

Input resolution

Input or 'sampling' resolution is a measure of the degree of detail captured when an image is scanned and is measured in horizontal and vertical spots per inch or dots per inch. An image scanned or 'sampled' at 300 by 300 dpi contains four times the detail collected from an image sampled at 150 by 150 dpi and the file size is consequently four times larger.

Display resolution

A function of the display monitor hardware, display resolution is determined by the number of scan lines traced by the monitor's cathode ray tube electron beams as they build up the picture on the viewing surface. A typical monitor resolution is 72 dots per inch.

Output resolution

The resolution of the output device—for example an imagesetter, printer or image recorder—is a measure of the precision with which the device can create a facsimile of the scanned image, using the data sampled from the image. Output resolution varies widely from around 100 dpi for a low end inkjet printer to as high as 8000 lines per inch for a high end image recorder.

Screen resolution

Before a conventional continuous tone photograph can be printed using the traditional offset printing process, the original has to be rephotographed through a finely ruled screen or grid, the effect of which is to break up the continuous tones into discrete dots of varying size. Screen resolution refers to the fineness or coarseness of the screen used in this process. Most offset printing uses screen rulings of 120, 133 or 150 lines per inch or lpi.

Selection of the correct scanning resolution and mode (line art, halftone, greyscale or colour) depends on the type of image being scanned, the resolution of the device to be used for output and the screen ruling to be used for printing.

Scanning an image

Line art

Line art images tend to be made up of straight lines and smooth curves, which will appear jagged if not scanned at high enough resolution. Best results are obtained by scanning at, or close to, the

resolution of the output device. The scanner recognises each point in the image as either black (>50% grey) or white (<50% grey) and the image is saved as a 1-bit file.

Halftone

This option works well for scanning photographs or images with graduated tones which will be printed on a low resolution printer. The scanner recognises each point sampled as either black (>50% grey) or white (<50% grey), or coloured (high colour value) or not coloured (low colour value). When the image is displayed or printed, dark areas (areas where the scanner has detected a con centration of points >50% grey or of high colour value) are represented by many black or coloured dots, while lighter areas (areas where the scanner has detected a concentration of points <50% grey or of low colour value) are represented by fewer black or coloured dots. Selection can be made from a number of halftone types, each using a different algorithm to arrange the dots in the image. A black and white halftone is saved as a 1-bit file; a colour halftone is saved as an 8-bit file.

Greyscale

Select this option for black and white photographs or images with graduated tones which will be output to an imagesetter or edited in a photoediting application before outputting to a low resolution printer. The scanner recognises each point in the image as a shade of grey. Images are saved as 8-bit files.

When scanning photographs, it would seem logical to provide one scan line for each output screen line, e.g. a 75 dpi scan for a 75 lpi output screen. However, the software which applies the screen to the image can do a certain amount of 'averaging' of additional scan information and experience has shown that a good rule of thumb is to scan at double the screen resolution, e.g. when outputting at 75 lpi, scan at 150 dpi. This guideline applies if the scanned image is to be printed at its original size. If the size is to be increased, then the scan resolution should be increased and vice versa if the final image will be reduced in size.

When scanning images which include graduated tones, the same guidelines apply as for photographs, as halftone cells are used to simulate the various shades of grey in the graduation. The smoothness of the graduation will depend on the number of grey shades which can be printed. Too few greys will result in 'banding' appearing within the graduation.

Colour

With this option selected, the scanner will sample the colour value of each point in the image and save the image as a 24-bit RGB file.

Displaying an image

Line art

The illusion of a black line is created when the three electron guns of the monitor's CRT are set to colour value zero (R=0, G=0, B=0) for the screen pixels which should appear black (i.e. emit no light) and to colour value 255 (R=255, G=255, B=255) for the surrounding screen pixels, to cause them to emit white light. A line art image will appear jagged or stepped if scanned at low resolution, but relatively smooth if scanned at high resolution (Figure 4.2).

Halftone

To create the illusion of grey shades, the information in the scan file is used to vary the concentration of black screen pixels in relation to the darkness of the original image i.e. few pixels appear black in light areas of the image, while many appear black in darker areas of the image. To the eye, this varying concentration of black is perceived as shades of grey (Figure 4.3).

Greyscale

To create grey shades on the monitor screen, the three electron guns of the CRT can stimulate the screen phosphor to emit equal amounts of red, green and blue light from the same spot to produce any one of 256 levels of grey.

Colour

To reproduce a scanned 24-bit colour image, the monitor must be driven by a graphics card capable of displaying such an image. Such a card allows the CRT's three electron guns to stimulate the screen phosphor to emit red, green and blue light in proportions corresponding to any one of 16.7 million colours.

Printing an image

Line art

To achieve the smoothest printed output, as mentioned previously, scanning should be at the resolution of the output device when that device is a laser printer, e.g. a 600 dpi scan should be used for output to a 600 dpi printer for output to a 600 dpi laser printer. When outputting to an imagesetter, scanning at 800 to 1000 produces a good quality result without creating an unnecessarily large file.

Halftone

The same scanning guidelines as described above for line art can be used also for halftones.

Figure 4.2 *600 dpi scan (left) and 75 dpi scan (right)*

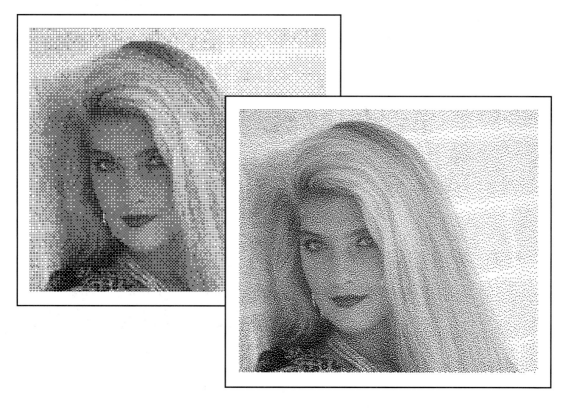

Figure 4.3 *Regular pattern halftone (left) and diffusion pattern halftone (right)*

Greyscale

From observation of the relatively high quality of an 8-bit greyscale image displayed on a monitor at the typical monitor's resolution of 72 dpi, one could easily be deceived into thinking that an image printed at a similar resolution should give a similar result. The flaw in this assumption is that, while the three electron guns of the CRT can stimulate the screen phosphor to emit equal amounts of red, green and blue light from the same spot to produce any one of 256 levels of grey, a laser printer, for example, cannot print grey dots but can only print (or not print) a black dot each time the laser is 'fired'.

In order to simulate grey tones in a printed image, a laser printer or imagesetter has to arrange the dots into halftone cells. Figure 4.4 shows samples of 12 such cells. In this example, each cell is divided into 8 ∞ 8, or 64 elements, each element corresponding to the position of a laser dot which can either be printed or not. This gives 65 possible tones—from all elements white to all elements black. For example, when 16 elements are black, the cell is 25% grey; when 32 elements are black, the cell is 50% grey and so on.

In this way, the laser printer or imagesetter converts the information provided by the scanner to print black toner dots in such a way that the eye is tricked into seeing the illusion of an image consisting of grey tones. This trick comes, however, at a high price in terms of resolution. In the example shown in Figure 4.4, each halftone cell—equivalent to each grey spot on the image as viewed on our monitor—consumes eight of our available printer dots in each of the horizontal and vertical printing directions.

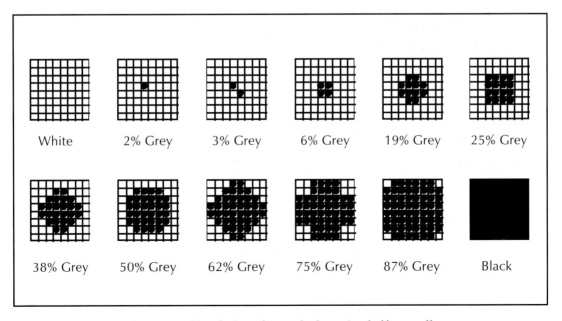

Figure 4.4 *Simulation of grey shades using halftone cells*

In the case of a 600 dpi laser printer, this means that our '65 grey-scale' image will print with a screen frequency of only 600 ÷ 8, or 75 lpi. If we were to use a halftone cell with a 16 ∞ 16 array, to provide the full 256 (actually 257) range of greys seen on our monitor, then our screen frequency drops to 600 ÷ 16, or 37 lpi— approximately half the monitor 'screen frequency'.

This relationship between grey levels, printer resolution and screen frequency is expressed by the simple equation

$$\text{Grey levels} = (\text{printer resolution} \div \text{screen frequency})^2 + 1$$

For a 300 dpi laser printer, the default screen is set at 53 lpi, giving 33 different shades of grey, although a finer screen than this de-fault can be used for images consisting only of solid tones. For a 600 dpi printer, as indicated above, a line screen of 75 lpi provides 65 shades of grey. 75 lpi is the kind of screen used for printing newspaper halftones, while glossy magazines typically use a screen of 133 lpi. Using such a screen, the much higher resolution of an imagesetter—typically 2400 dpi—will produce 326 different shades of grey. This is actually more than the 256 that PostScript is able to handle, so the surplus will be discarded.

While the above fairly describes normal conditions governing printing from laser-driven devices, rapid progress is being made in developing ways of improving the perceived quality of printing both text and greyscale images by enhanced software control of the print process. Hewlett Packard's RET (Resolution Enhancement Technology), for example, detects the jagged edges and corners of text outlines and uses greyscale to give them a smoother appear-ance. More advanced techniques involve the use of additional hardware and software to modulate the normal laser waveform to create the effect of smaller dots. Using such technology, companies like XLI Corporation claim to be able to achieve 1200 dpi text and line art printing and a resolution equivalent to 2400 dpi for print-ing halftones.

Images printed with the full range of grey shades simulate photo-graphic quality. The accuracy of the simulation depends, however, on factors like the smoothness of the paper on which the image is printed and on what inks are used for printing. (A typical offset press is only capable of printing about 100 shades of grey, using only black ink; for higher quality, a two-colour press is used, with black ink in the first stage and grey ink in the second stage, thus extending the total number of greys printed.)

When too few grey levels are available, the result is a posterisation effect (Figure 4.5) in which the greys in the scan are grouped together into bands. While normally very undesirable, posterisation can be used to produce interesting artistic effects, as we shall see later.

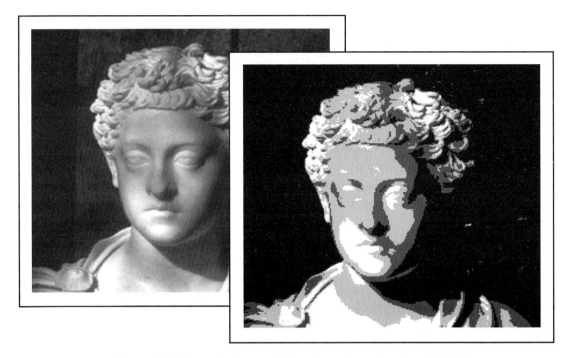

Figure 4.5 Greyscale image (left) and posterised version (right)

Colour

Low resolution printers such as 360 dpi inkjets cannot mix the inks they place on paper to produce the required colour, but instead 'dither' the colours—i.e. print them in halftone patterns controlled by the printer driver. Unable to resolve the individual dots, the human eye perceives the colour which results from blending the adjacent dots together. With print resolution now as high as 720 dpi, the results produced, although not photorealistic, are surprisingly good.

Dye sublimation printers produce photorealistic colour by mixing cyan, magenta and yellow dyes in their vapour state as they are deposited on special paper, so that dithering is not necessary.

Because 24-bit scanning produces potentially very large files, which can take a long time to print, it is important to choose the lowest scanning resolution which will produce an acceptable result. Resolution between 150 dpi and 300 dpi will normally produce such a result. In fact, an image scanned at 150 dpi and sharpened either using the scanner software or an independent photoediting application often compares well with one scanned at 300 dpi.

Resizing versus resampling

Most scanner software provides the option to scale an image or selected part of the image before saving or printing. Scaling at this point is the best

option, in the sense that it reduces the risk of image Moiré effect distortion which may arise when an image is enlarged within a page make-up program. When enlargement takes place in a photoediting application like Photoshop, a technique called 'resampling' can be used to add additional pixels to the image to retain its resolution, rather than simply growing the size of the original pixels, which can give the image a 'blocky' appearance.

A useful technique for increasing the apparent resolution of a piece of artwork is to use an oversize original and scale it down at scan time. A good quality photocopier can be used to blow up the size of the original.

Spot variables

The halftone spots shown in Figure 4.4 are arranged in a regular XY matrix—the normal printing default. For day-to-day printing, this default gives perfectly acceptable results, but if the objective is to achieve special effects, then the spot shape, angle and frequency can all be varied independently of one another. Using a low screen frequency to make the differences easily visible, Figure 4.6 shows some examples.

Spot gain

Spot gain is the undesirable process whereby printed halftone spots spread out beyond their intended dimensions. The final gain in size is due to the cumulative effect of variables in the film and plate making and offset printing processes:

Variation of toner density (the irregularly shaped dots of toner based devices are more prone to gain)

Variation in paper absorbency

Original greyscale

Round spot, 0 degrees

Square spot, 45 degrees

Line spot, 30 degrees

Diamond spot, 60 degrees

Cross spot, 45 degrees

Figure 4.6 *Halftone variations*

Density of the line screen. Gain tends to increase with screen density, setting a limit of about 110 lpi on ordinary paper stock. More expensive coated paper is necessary when printing at higher screen frequencies

Variation in the condition of the offset printing blanket, which transfers the image from printing plate to paper

The effect of spot gain is to cause the darker greys to fill in and to print as black, effectively reducing the number of greys and, hence, the tonal range of the image. Spot variation due to the above effects can also result in the smallest spots failing to print in the lightest image areas, further deteriorating the quality of the image. Close liaison between designer and printer is the best defence!

Halftone versus greyscale

When the objective is to produce an output which most closely resembles an original photograph, using a high resolution printer or imagesetter, then the scanner's 8-bit greyscale option should be used. When output is to be to a low resolution printer (300 dpi or less), then the scanner should be set to halftoning.

For output to an intermediate resolution device (e.g. a resolution-enhanced 600 dpi laser printer), then either option is feasible and the choice depends on the desired effect—at this resolution, a halftone using the "diffused" option, can produce a more pleasing result than greyscale, especially if the output is to be enlarged e.g. to produce a poster. Visual sensitivity to diffused halftoning (or to the dithering of coloured images) diminishes as the size of the image increases, because the eye is taking in a larger area and is less sensitive to detail.

Even if the intention is to produce the final image as a halftone, there are three different stages at which halftoning can be done:

1. When the image is scanned, using the scanner software settings

2. Within a photoediting application when editing of the image is required before printing (in this case the image should be scanned as greyscale)

3. Using the printer's own halftoning facilities

Photoediting

Photoediting is as old as photography itself, in the sense that variations in the photographic developing and printing processes—deliberate or otherwise—could create images of widely differing appearance. Originally the cause of severe frustration to the photographer trying simply to create a printed replica of the original subject, these variations were soon recognised by the more creative exponents of the new technology as an opportunity waiting to be exploited. Thus, since the photographic process was discovered in the 1840s, photoediting has had over 150 years to evolve to its present level of sophistication. Editing, in the sense of altering an image from its natural form, can take place at any or all of three stages:

> Before the photograph is taken—e.g. by the use of special lighting effects

> At the moment when the photograph is taken—e.g. by using special camera lenses or filters, by double exposure

> During the processing of the film negative and print—e.g. by masking out parts of the image or by applying airbrush effects

Historically, the techniques of photoediting have been used either for practical purposes, such as cropping out unwanted material in the original scene, removing blemishes from an image, or to meet an artistic objective, such as creating atmospheric effects through the use of soft focus or by the use of airbrushing to create a vignette effect. Applications of a more amusing nature can also be found in 'photographs' of Loch Ness's famous monster and of various extra-terrestrial visitors, while the notorious case of the incriminating Lee Harvey Oswald allegedly 'retouched' photograph is an example of an altogether more sinister application.

Although the history of digital photoediting is, of course, much shorter, the leading applications like Adobe Photoshop and Micrografx Picture Publisher already offer many of the features developed by photographers over the years, as well as others which are only possible in the digital environment.

Simple editing tools

Figure 4.7 shows the image editing tools provided by Photoshop. Those with perhaps the most general use are the following:

> Adjustment of brightness and contrast. Useful for making gross changes to an overall image. Such gross adjustments should be used only exceptionally, however, as increasing brightness washes

Figure 4.7 *Photoshop's image editing menus*

out highlights and increasing contrast lops off detail in both high-lights and shadows

Adjustment of highlights, shadows and midtones using levels (Figure 4.8a). Black and white points can be set before scanning an image to produce the best tonal range

Adjustment of tonal values using levels (Figure 4.8b)

Adjustment of hue, saturation and colour value (Figure 4.9a)

Adjustment of colour balance (Figure 4.9b)

Variations—useful for removing colour casts (Figure 4.10)

Making selections

Corel PHOTO-PAINT offers a wide range of selection tools which can be used to delineate part or parts of a photograph which are layered above the base image for the purpose of editing (Figure 4.11). Once created, selections can be extended or reduced, by respectively holding down the Shift or Control key while dragging with the mouse.

Selections can be saved in channels and later reselected for further editing. However, as this increases the file size, selections are normally merged with the base image as soon as editing is complete.

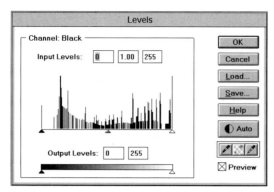
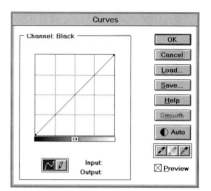

Figure 4.8 Level adjustment (left) and curve adjustment (right)

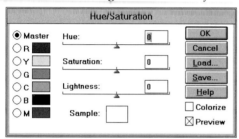
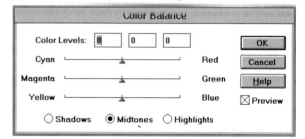

Figure 4.9 HSV adjustment (left) and colour balance adjustment (right)

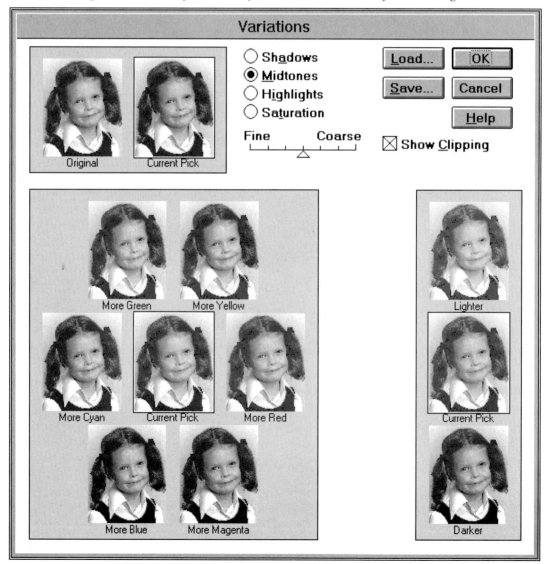

Figure 4.10 Adjustment via variations

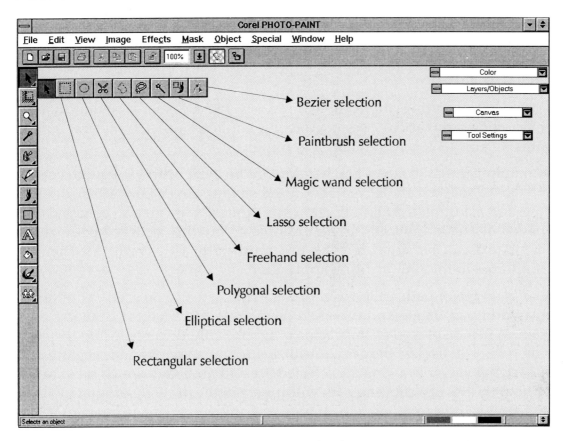

Figure 4.11 PHOTO-PAINT's selection options

The whole range of editing options available for the complete image can equally be applied locally to selections. Selections can also be cut or copied and then pasted into, or behind, other selections within the same or different images.

Using masks

The mask is arguably the most powerful editing facility provided by photoediting applications. PHOTO-PAINT provides a set of mask options equivalent to the set of selection options shown in Figure 4.11. Acting like a stencil, a mask can be used either to alter or to protect a selected area within an image. Subtle alterations to the effect of a mask can be achieved by 'painting' within the boundaries of the mask (painting with black adds to the mask; painting with white erases the mask and reveals the image below; painting with grey thins or partially removes the mask, partially exposing the image beneath. A greyscale mask can have fills, edits and other special effects applied to control how much detail passes through it to affect the image beneath. Alternatively, an existing bitmap can be used to edit a transparency mask.

In Photoshop, compound masks can be created by first creating the individual masks in separate channels and then combining them using the channel multiplication feature. Interesting effects can also be created by sand-

wiching a mask between two images. Examples of the results obtained using these techniques will be shown in later chapters.

Creating paths

Several photoediting applications now provide a Bezier drawing tool—a device long familiar to users of drawing applications—for the creation of paths. Figure 4.12 shows a Painter example.

By manipulating the nodes and handles on the Bezier curves, smooth curves and closed shapes can be created. Closed shapes can be converted to selections and manipulated like any other selections. Paths can also be saved and opened in vector applications, for example, to provide a curved path which vector text can be fitted to. The text, and path if desired, can then be reimported to the photoediting application.

A special type of path, called a 'clipping path', can also be used to define an area within an image and can then be exported to a vector drawing program. When displayed in the vector program, only the area inside the clipping path will display, the area outside being transparent and revealing any underlying vector drawing. (A selected area of an image which is exported without the use of a clipping path will appear in the drawing program within an opaque white rectangle which obscures any vector image beneath it.)

Figure 4.12 *Painter's Bezier path tool*

Using layers

Now available in the leading photoediting applications, layers are useful when working on complex editing projects involving a number of different elements. A simple example would be a project requiring text to be added to a photographic image; the text could be created on one layer while the image was placed on another, facilitating the editing procedure. Items on one layer can be edited independently of items on another and each layer has its own 'layer mask' which can be edited to control the way in which the layer contents interact with one another. Figure 4.13 shows the layer control dialog box in Photoshop.

Painting

As well as providing the tools described above for editing photographs, photoediting applications normally provide a set of painting tools which can also be used to include more subtle editing effects such as airbrushing.

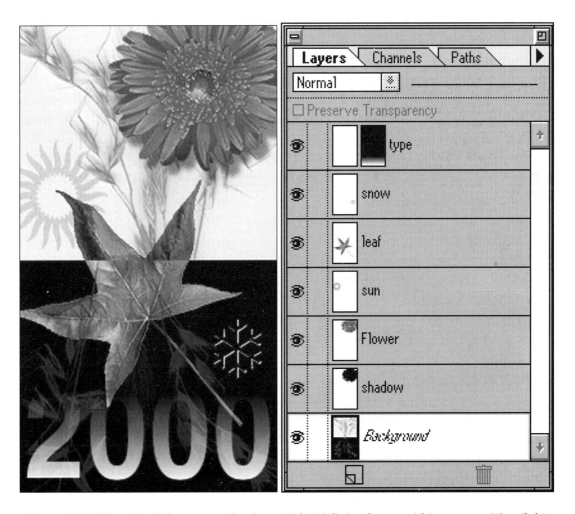

Figure 4.13 Photoshop's layer control palette (right) defining layers within a composition (left)

5

Three-Dimensional Tools

In parallel with the evolution of traditional tools and techniques for drawing and painting, increasingly sophisticated techniques have been devised over the centuries for creating both solid and hollow objects in three dimensions. The initial efforts of the earliest civilisations were aimed at functional objects—the production of simple cooking utensils, shaped from clay by hand and baked hard in the sun. Later, the potter's wheel and charcoal-fired kiln provided the means of producing more repeatable and more durable objects.

Further techniques followed—for example, the discovery of the means of casting objects by pouring low melting-point metal alloys into ceramic moulds; the forming of three-dimensional shapes by pasting layers of papier mâché over wire mesh frames; the development of techniques for forming hollow glass objects by glass-blowing; the invention of wood and metal lathes for the production of axially symmetrical objects like table legs; the development of high pressure techniques necessary for producing complex extruded objects.

As competitive pressure continues to build in the developed economies of the West, modelling of product prototypes to minimise their production costs and optimise their performance has become a multimillion-dollar, high-tech business. While traditional modelling materials and methods persist—such as the building of full size clay models of motor car prototypes—industry is turning more and more to computer modelling as a means of achieving greater precision, control and speed, giving birth to the growing range of CAD and three-dimensional solid modelling products available on the market.

Just as the initial functional applications of early drawing and painting techniques were soon followed by more artistic applications, so the art of sculpting quickly emerged as a means of adapting the artisan's skills for more artistic ends. The pyramids and the Venus de Milo—priceless relics of the Egyptian and Ancient Greek civilisations—stand testimony to the incredible power and the beauty which could be formed from the most primitive of materials and tools. In more recent years the art of sculpting has evolved to embrace new technology, from techniques for precision cutting of diamonds, to computer modelling of modern-day bronzes.

So what does all this mean to the graphic designer who works, after all, in only two dimensions? This question can best be answered by examining the features offered by three-dimensional modelling applications available to the designer in this chapter and then, later, in Part 2, to study how objects created in three dimensions, with all the attributes which that implies, can be effectively rendered in two dimensions and merged with design objects created in two-dimensional applications.

Environment

While the working environments of the leading drawing and painting applications have shown a certain convergence in recent years, three-dimensional applications still exhibit a wide range of variations. In our context of graphic design—as opposed to that of industrial design of products like printed circuit boards, for example—the subset of applications which are of interest include Infini D, Macromedia 3D and Ray Dream Designer. While these products have much in common in terms of the results they can produce, their approaches to producing the results still differ. For the purpose of this section, Ray Dream Designer will be used as an example.

Its principal environmental characteristics are as follows (Figure 5.1):

At startup, four separate windows may be displayed. The first—the Perspective window—is where objects are displayed within a three-dimensional workspace; the second—the Hierarchy window—lists objects and sub-objects appearing in the Perspective window, as well as light being used to illuminate the three-dimensional scene and cameras through which the scene can be viewed; the Objects Browser window which displays objects which can be dragged into the Perspective window and the Shaders Browser window, from which colours and textures can be dragged and applied to objects in the Perspective window. Double clicking on an object in the Perspective window also opens a Modelling window (Figure 5.2) which provides special tools with which the object can be edited

The size of the Perspective workspace and the units of measure on the X, Y and Z axes can be customised

A zoom facility is provided when working in either the Perspective or Modelling windows

Objects can be viewed in Wireframe mode or in Preview or Better Preview modes, which provide progressively greater surface detail

A ribbon bar at the bottom of the Perspective window provides information about current magnification and status of drawing or shading activity

Figure 5.1 The Ray Dream Designer working environment

Figure 5.2 Ray Dream Designer's modelling window

Application tools

The tools provided in the toolset at the top left of the Perspective window (Figure 5.1) comprise:

A pointer tool used to drag objects around and to adjust object handles

A virtual trackball tool to allow rotation of objects within three-dimensional space

A magnification tool to control level of magnification

A hand tool for adjusting the part of a scene appearing in a window

A tool to select a small sample area to test rendering

Three tools to allow painting on a three-dimensional surface, either with geometric shapes or in freehand mode

An eyedropper tool to pick up the colour of an object

Additional tools provided at the top left of the Modelling window (Figure 5.3) are:

A pen tool for drawing lines or Bezier curves

A tool for manipulation of Bezier curves, allowing addition or removal of Bezier points

A shape tool for creating rectangles, ellipses or polygons

Shapes created with the use of any of these tools can be extruded to produce three-dimensional objects, as shown by the examples in Figure 5.3.

Among the objects contained in the Objects Browser window is a text object, which acts as a powerful three-dimensional text tool. Dragging the text object into the Perspective window causes a text dialog box, shown in Figure 5.4, to open. The required text is typed into the lower window of the dialog box and the controls provided are then used to set the various type attributes, like typeface and size; if required, a bevel can also be added to the front and/or back of the text characters. When the attributes have been set, the Done button to the lower left of the screen is clicked and the type appears in the Perspective window (Figure 5.5), where it can be manipulated like any other three-dimensional object.

To ease the work of generating new three-dimensional objects, Ray Dream Designer provides a tool called a Wizard in the form, essentially, of a flow chart. Dragging the Wizard icon from the Objects window into the Perspective window opens the first level dialog box shown in Figure 5.6. Clicking, for example, on the Lathing option and selecting Next displays the dialog box in Figure 5.7. Clicking the vase shaped option and then Done places the object in the Perspective window (Figure 5.8) where it can be edited as required.

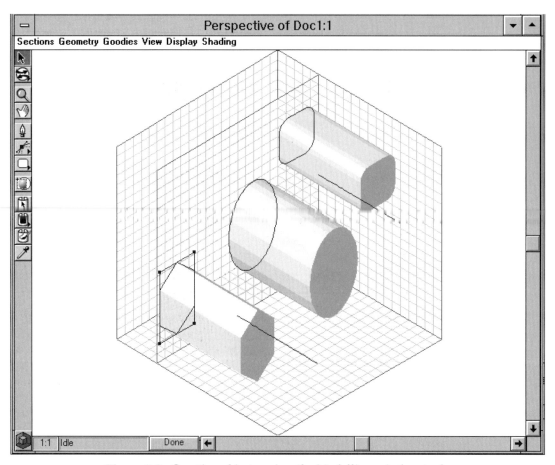

Figure 5.3 Creating objects using the Modelling window tools

Figure 5.4 The text creation dialog box

Figure 5.5 *A text object displayed in the Perspective window*

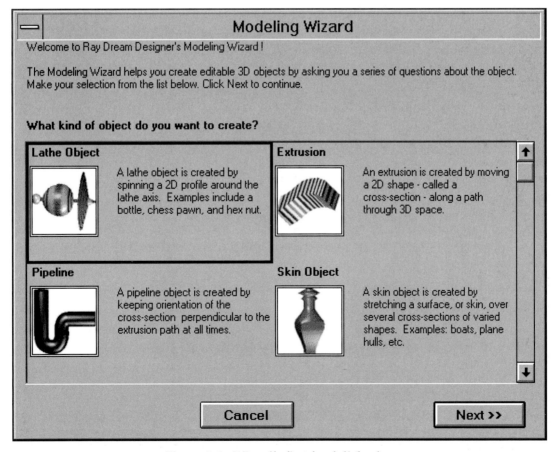

Figure 5.6 *Wizard's first level dialog box*

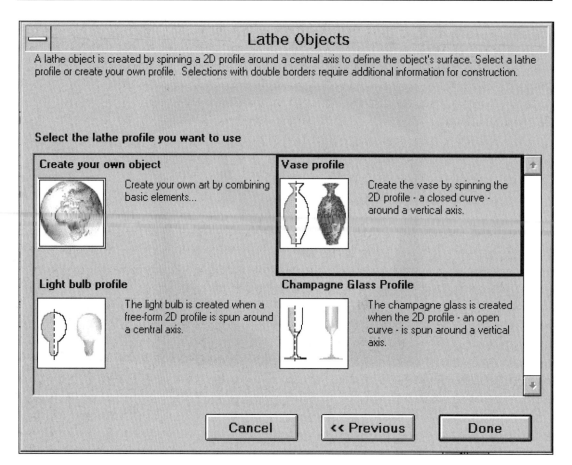

Figure 5.7 One of Wizard's second level dialog boxes

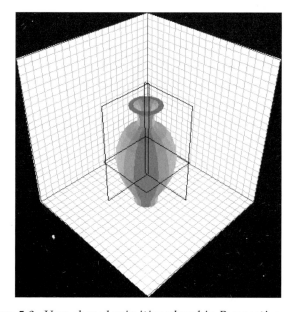

Figure 5.8 Vase-shaped primitive placed in Perspective window

Finally, Ray Dream Designer provides a tool called a Shader Editor (Figure 5.9) which is used to edit the surface characteristics of objects placed in the Perspective window. The shader editor is opened by double clicking a shader from the Shader Browser window. Seven variables—colour, highlights, shininess, bump map, reflection, transparency and refraction—can be manipulated to alter the appearance of the shader, which is displayed in a small preview window. When a satisfactory result has been obtained, the shader characteristics can be transferred to a selected object just by clicking Apply at the bottom of the editor dialog box.

Figure 5.9 *Shader editor dialog box*

Application techniques

Using the same definition as for other applications, a three-dimensional technique is defined as the means by which an object is created or altered with the use of the three-dimensional application tools:

> Extruding—creating a three-dimensional object by moving a two-dimensional object along an axis perpendicular to the object
>
> Lathing—creating a three-dimensional object by rotating a two-dimensional profile around a fixed axis
>
> Skinning—forming a three-dimensional object by stretching a 'skin' over a series of cross-sections
>
> Node editing—adjusting an object's shape by moving nodes/handles
>
> Scaling—altering size proportionally or non-proportionally
>
> Rotation—in fixed increments or freeform

Mirroring—vertically or horizontally

Duplicating—copying with same attributes

Aligning—vertically, horizontally or centrally

Grouping—creating a set of objects to be manipulated together

Rendering—ray tracing a three-dimensional object or scene to create a photo-realistic printable image

Lighting—creating the effect of the object or scene being illuminated by both ambient and directional lighting

Composing—Setting camera positions and angles to create the required view of an object or scene

Applying gels—projecting shapes or patterns on to three-dimensional objects or whole three-dimensional scenes

Creating atmospheric effects—making distant objects appear to disappear into a fog or haze

Part 2

Workshop

Lines and Shapes

Blends and Contours

Perspective and Enveloping

Three-Dimensional Effects

Type

Image Manipulation

Filters and Special Effects

Painting

6

Lines and Shapes

According to a market report in *Computer Graphics World*, the global computer graphics market will increase from $36 billion in 1993 to $68.9 billion in 1998. This growing market can be divided into a number of different general categories (Figure 6.1), creating demand for a wide variety of graphic products (Figure 6.2) and exciting new opportunities for designers with the necessary skills and talent to participate.

In the early chapters of *Digital Graphic Design* we have looked at the growing array of resources available to the digital designer and at the increasingly sophisticated capabilities of drawing, painting, photoediting and three-dimensional applications. In this chapter we shall explore ways in which these resources and application techniques can be used to produce a wide spectrum of graphic results.

In an earlier book—*Creative PC Graphics*—emphasis was mainly on the ways in which basic graphic design elements could be integrated to produce examples of such graphic products, i.e. the emphasis was mainly on commercial application. The more advanced results in *Digital Graphic Design* can also be applied to many of the products considered in *Creative PC Graphics* and listed in Figure 6.2, but equally, in the hands of the artistically skilled user, they can be developed to produce fascinating results of a purely aesthetic nature.

Instead of jumping straight into complex examples of the results which can be achieved, the approach used in this workshop is to start by producing simple results using basic tools and then gradually moving on to show how these simple results can be combined to produce more complex and interesting effects.

Line art

As we saw in Chapter 2 (Figure 2.6), vector drawing programs offer a wide range of line drawing styles as well as tight control over line placement and shaping. For this reason, they are ideally suited to the creation of technical

Figure 6.1 Market requirements

PRODUCT TYPES

Business cards	Certificates	CVs
Invitations	Logos	Signs
Menus	Calendars	Maps
Music	Leaflets	Mail shots
Brochures	Catalogues	Documentation
Directories	Procedures	Articles
Analyses	Reports	Speeches
Presentations	Educational material	Magazines
Books/Fiction	Books/Non-Fiction	Newspapers

Figure 6.2 Product types

drawings in which line angles, weights and positional coordinates must be accurately specified. At the bottom of Figure 2.6, however, can be seen three lines with styles which seem to offer more artistic potential. The following examples illustrate how such styles can be applied.

Among its many line styles, CorelDRAW includes one called Powerline. Figure 6.3a shows the Powerline dialog box, from which any one of a range of Powerline types can be selected (Woodcut 3 shown). Drawing lines with the Powerline option selected produces not lines, in fact, but closed shapes as shown in the examples of Figure 6.3b.

To see the effect which can be obtained using Powerline, a sample drawing has first been selected from Beeline's Artprofile CD and placed at bottom

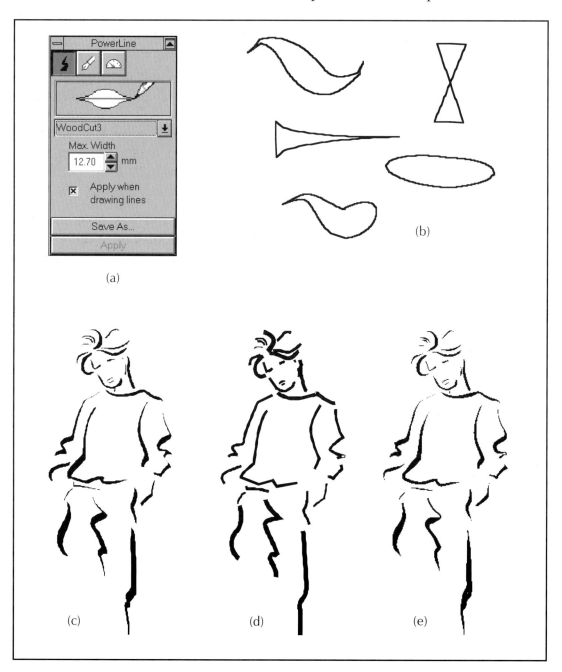

Figure 6.3 *Use of CorelDRAW Powerlines*

left of the Figure 6.3. (Beeline's excellent clipart drawings will be a resource used several times in this chapter.)

Figure 6.3d shows a copy of the original drawing using just Bezier lines of differing stroke weights, while Figure 6.3e shows a copy produced with a number of different Powerline types (Woodcut, Trumpet, Bullet and Teardrop). As comparison shows, the Bezier version is a pale imitation of the original, lacking style or impact, while the Powerline version conforms more closely to the subtly varying line weights of the original.

Powerline can be scaled and node edited after drawing, just like other vector shapes. Also, line weight and shape fill can be altered to produce different effects (Figure 6.4). The Powerline effect can be added retroactively to an object which has been drawn conventionally, by selecting the object and clicking on Apply in the Powerline dialog box, but be prepared for some bizarre results!

Both CorelDRAW and Macromedia Freehand provide another technique which simulates variable line width drawing, namely the pressure-sensitive line. With either application, a stylus and pressure-sensitive tablet can be used to produce such lines. In Freehand, double clicking on the freehand drawing tool in the toolbox—Figure 6.5b—opens the dialog box in Figure 6.5a. In the dialog box, the maximum width can be set for lines drawn with a stylus on a pressure-sensitive tablet.

Figure 6.5c shows examples of pressure-sensitive lines, which, like Powerlines, are really closed shapes of variable width. Figure 6.5d is another original Beeline drawing. The copy in Figure 6.5e was created in Freehand using pres-

Figure 6.4 *Powerline editing*

sure-sensitive drawing, with maximum line width adjusted as required. Once drawn, pressure lines can be manipulated like any other vector shape.

While effective results can be obtained using Powerline or pressure-sensitive lines, practice—and careful adjustment of the stylus/tablet pressure sensitivity—will be required to develop proficiency in order to obtain such results. Node editing, of course, can be used to tweak wayward lines, but, for any but the simplest of drawings, this can be very time-consuming.

Similar results, plus some interesting variations, can be obtained using painting applications. Figure 6.6 shows an example created in Photoshop, using the airbrush tool, selected from the toolbox, Figure 6.6 (a), with parameters

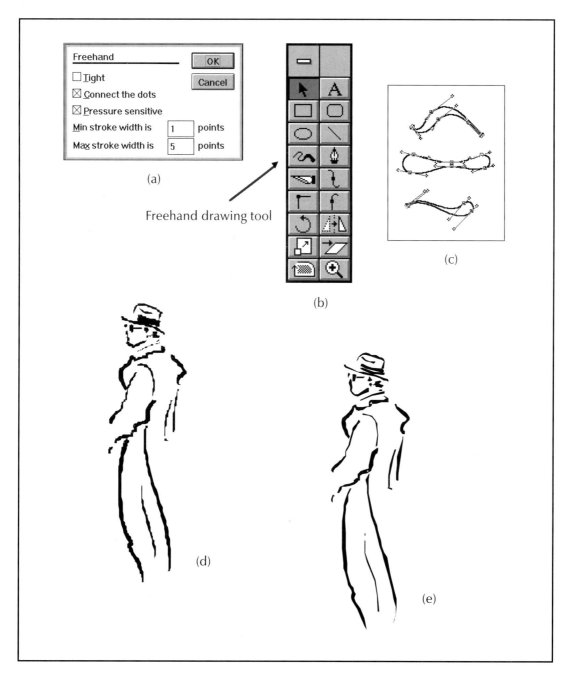

Figure 6.5 *Freehand pressure sensitive lines*

set in the dialog box—Figure 6.6b. Photoshop also supports the use of a pressure-sensitive tablet, so that the width of the airbrushed line in Figure 6.6c can be controlled by varying the pressure applied to the tablet by the stylus. In operation, however, precise control is difficult using only this method and experience will show that, to create the image in Figure 6.6d similar to the original in Figure 6.6e, it is easier to build up the final lines by using several strokes of the airbrush, in some cases using different brush sizes from the dialog box. While node editing is not possible in this case, excess paint can be removed by toggling the airbrush from black to white and brushing out the excess. While altering the detailed shape of a line after drawing requires additional brushwork, fill colour can be changed by selecting the line with Photoshop's magic wand tool and applying a new fill to the selection.

Figure 6.6 *Pressure-sensitive lines in Photoshop*

Figure 6.7 shows a few examples of the range of line-art results which can be produced with Painter. The original in Figure 6.7a was recreated in Figure 6.7d with four of the options available from the paintbox in Figure 6.7b, namely Chalk, Oil brush, Charcoal and Airbrush. The additional effects in Figure 6.7e were obtained by painting with a brush loaded with different textures selected from the Art Materials palette in Figure 6.7c. Editing techniques are similar to those described for Photoshop.

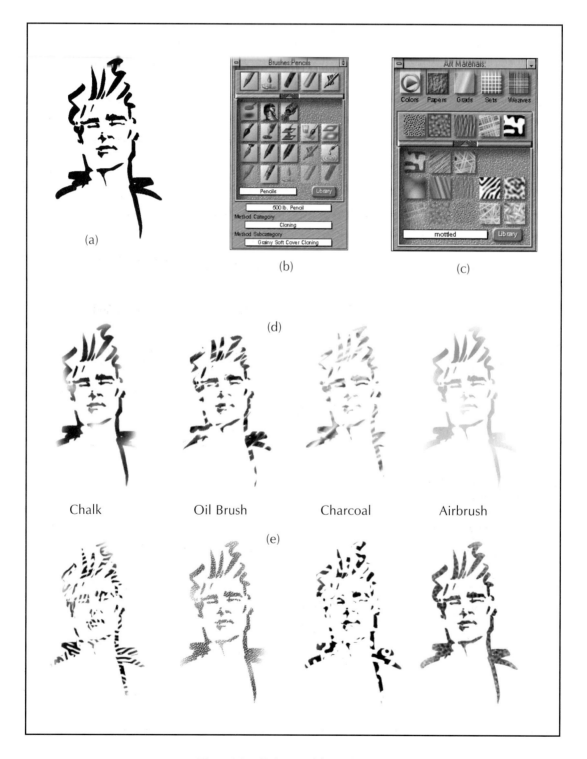

Figure 6.7 *Painter style variations*

The range of painting styles provided by Painter is truly extraordinary, the term 'painting' being used here in a generic sense, as Painter includes a range of graphic tools including most of those used in conventional artwork as well as some which have no conventional equivalent. Figure 6.8 shows just a few examples.

A challenge often faced by the graphic designer is that of creating the illusion of motion within a static image. A prerequisite to the successful achievement of this goal is careful observation and recreation of the essential features of the moving object. Figure 6.9 shows three simple ways in which this can be achieved in a drawing application. The spinning and turbulent motion of a twister can be simulated in Figure 6.9a by careful superimposition and offsetting of either pressure-sensitive lines or Powerlines. In Figure 6.9b, the motion of a runner is captured by a few simple Bezier lines which emphasise the angles of the limbs and torso. The addition of horizontal 'trailing edge' lines on the right further enhances the effect (Figure 6.9c).

Figure 6.8 A few of Painter's tool options

Figure 6.9 Conveying motion

The freehand and straight line tools of painting applications can be used to produce similar results to those in Figures 6.9; in fact, the less regular edges of lines so produced help to enhance the impression of movement. Applications like Photoshop, however, provide additional tricks, in the form of filters, which can produce more dramatic results. The skier in Figure 6.10a was copied within Photoshop. The Radial Blur filter was applied to the copy, using Draft Quality, an amount of 10, the Spin method with rotation about the top-left corner. A copy of the original was then pasted on top, its opacity reduced to 30% so that the blurred version showed through and the copy was offset down and to the left of the blurred copy.

The example in Figure 6.11 uses Photoshop's Wind filter. Once again, the original drawing was duplicated in Photoshop. The opacity of the copy was reduced to 25% and then the Wind filter was applied to it, with Direction from the right. A second copy was pasted on top of the first, offset to the right of the underlying copy by eight pixels, its opacity was reduced to 50% and the Wind filter was applied to this copy. This sequence was then repeated two more times with opacity set at 75% and finally 100%. The Wind filter provided the sense of movement, with the increasing opacity and offset of successive copies giving a left to right direction to the movement.

Figure 6.10 *Conveying motion with Radial Blur*

Figure 6.11 *Conveying motion with the Wind filter*

Shapes

From lines, we progress to simple closed shapes. It is now standard practice for drawing and painting applications to provide tools for the creation of simple geometric primitive shapes like squares, rectangles, circles, ellipses and polygons. For construction of more specialised geometric shapes, including arcs or parabolic segments, for example, a drawing application like Micrografx Designer is superior (Figure 6.12) but both application families provide Bezier tools to create smoothly flowing closed shapes (Figure 6.13)

Figure 6.12 *Creating shapes in Micrografx Designer*

Figure 6.13 *Shapes which can be created with the Bezier tool*

CorelDRAW's Trim/Weld/Intersect feature provides a means of producing interesting compound shapes through the geometric interaction between two independent simple shapes. In the example in Figure 6.14, shape (b)—the letter S—is placed partially on top of shape (a)—the circle—as in (c). The S shape, followed by the circle in (c) are then selected. Applying Trim to the selection trims the overlapping S shape out of the circle, producing the compound shape, shown shaded in (d). Applying Weld to the selection welds the two objects together as in (e), while applying Intersect creates a shape corresponding to the area of overlap of the two objects, as in (f).

Regular geometric shapes can also be created with the aid of selection tools and path tools in painting applications. However, generally speaking, it is easier and more precise to create complex shapes first within a drawing application, save the result in Illustrator EPS format and then import the result as EPS paths to the painting application for further development (more on this later when we look at rendering of imported paths).

Creating freehand shapes is clearly a strong attribute of the painting application, where results of infinite variety can be obtained, for example, in Painter, using any of its wide range of drawing and painting styles, such as those illustrated in Figure 6.8. Drawing application freehand tools can, however, be used to create natural 'hand-drawn' shapes such as those in Figure 6.15—enhanced, in this case by the use of a calligraphic stroke.

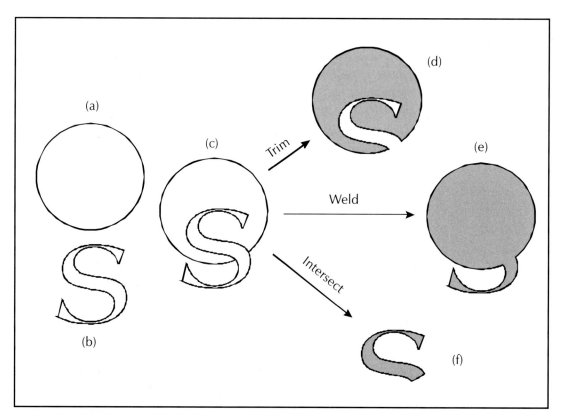

Figure 6.14 *Using CorelDRAW's Trim/Weld/Intersect features*

Figure 6.15 Freehand shapes, using a calligraphic stroke

As well as giving our shapes identity and character through the choice of stroke style, we also have many possibilities—in both drawing and painting applications—to give them substance through manipulation of their fill characteristics. Even the simplest of fills—applying solid colour to a closed shape—creates a silhouette, a simple, but often dramatic element of artistic composition. Figure 6.16 shows a range of examples, the subjects of which are all recognisable from different viewing angles without benefit of further detail. In fact the graphic impact of the silhouette stems from its challenge to the viewer to imagine and supply the information missing from the object being observed.

In the examples in Figure 6.17, a little more information is revealed by the addition of very simple sub-shapes, filled or painted with white, so that they appear reversed against the black background, or, in the case of the rings, by applying a fine white stroke to delineate the edges of the black shapes. In the animal examples, this simple enhancement allows the viewer to make 'eye contact' with them, while subtle variations in the placement and shaping of these highlights can be used to alter their 'personalities'.

Note that the simple white stroking of the rings immediately conveys a sense of visual depth and order, while the white markings on the lips create the illusion of contour.

The use of white in the examples in Figure 6.18 is further increased, but notice that, in the cases where it is allowed to 'bleed' into the surrounding area, the effect is more powerful. This result can be achieved by assigning the colour white to the outline as well as the fill of the 'white' shapes in the drawing or painting them out to the background colour in a painting.

In Figure 6.19, we see examples of the powerful impact which can be created when the drawn or painted white shapes of the subject are reversed out against a black background. The effect works particularly well in the case of the female profile, the elegance of which is captured particularly well using this technique.

Figure 6.16 Basic silhouettes

Figure 6.17 Silhouettes with simple highlights added

Figure 6.18 *White highlighting increased*

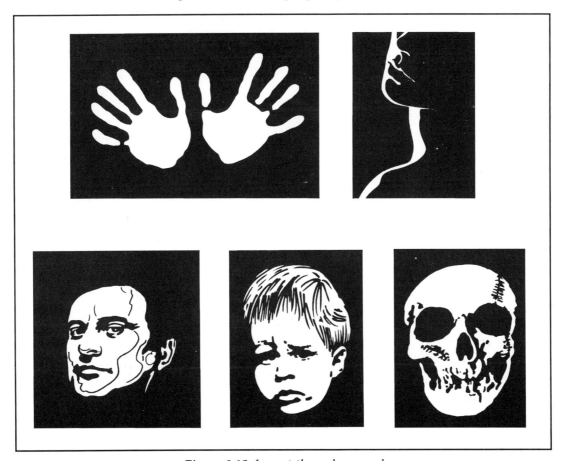

Figure 6.19 *Impact through reversal*

Drawing applications are particularly adept at producing silhouettes, as they can easily create sharply bounded areas, with abrupt changes of tone or colour. As we can see in Figure 6.20, however, a painting application—in this case Photoshop—can also produce interesting two-tone results. The original colour image of the girl was first changed, via Photoshop's Mode menu to greyscale and then to bitmap, using the 50% threshold option, producing the result in the top left of Figure 6.20. The gamma curve corresponding to this black and white image (displayed in Photoshop by clicking on Image/Adjust/Curves) is shown below it. The image mode was then converted back to greyscale (necessary for adjusting the gamma curve) and three copies of the image were created.

The variations seen in these other three images were obtained simply by adjusting the end points and gradients of the gamma curve as shown below each image.

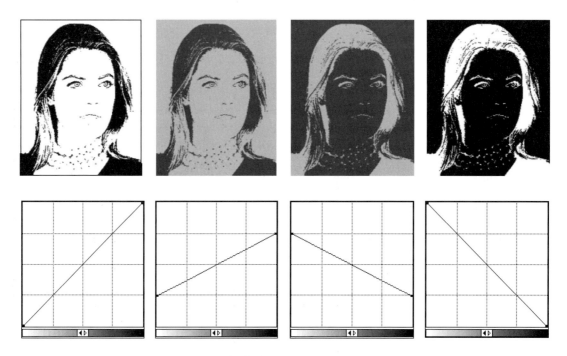

Figure 6.20 *Manipulating gamma curves in Photoshop*

Fills

So many and various are the fill options available to the digital designer that, on their own, they could easily fill this chapter! Coverage in the following sections is limited to distinguishing between the various generic fill categories and presenting examples of creative ways in which they can be applied.

Figure 6.21 summarises the principal fill categories and, under each of these categories, gives examples of sub-categories. For example, in the Colours category, when a shape is filled with colour, that colour can be selected from one of a number of colour systems (e.g. RGB, CMYK, Pantone Spot, Pantone Process, Focoltone) depending on the planned use of the image, the printing method etc. The colour can then be applied with a tonal value ranging from 100% to 0%, i.e. as a solid colour or a tint of that colour.

As we are sadly limited in this book to black and white, let's start by looking at how we might use tones which lie between black and white and then go on to look at examples of the other fill categories.

Figure 6.21 *Overview of fill categories*

Using tones

While we have seen that interesting results can be obtained using only black and white, the ready availability of tones to the digital designer—thanks to the ready availability of affordable graphics cards and monitors which can display up to 256 shades of grey—opens the door to a wide range of new possibilities.

Selection of tones is simple in applications like CorelDRAW (Figure 6.22). The colour palette at the bottom of the screen includes the basic set of 10% multiple tones (10%, 20%, 30%, etc.); a tone is applied to a shape by simply clicking first on the shape to select it and then clicking on the appropriate tone in the palette with left mouse button. Access to the full range of 256 greys is via the Uniform Fill palette; the required tone is selected either by entering appropriate equal values for each of the RGB components, or by using the mouse to move the vertical slider until the required grey appears in the swatch window to the right of the slider. A similar slider approach is found in other applications; Figure 6.23 shows the dialog box in Freehand, for example.

In Figure 6.24, it can be seen how the addition of tone can significantly enhance the sense of substance and depth of a drawn image. The drawn outline of the zebra (a), plus black stripes and highlights (b) produces the result in (c). The addition of tonal areas (d) produce the enhanced result in (e). Figure 6.25 shows another example.

Figure 6.22 *Selecting tones in CorelDRAW*

Figure 6.23 *Selecting tones in Freehand*

Figure 6.24 *Use of tones to enrich an image*

Figure 6.25 *Before (left) and after (right)*

It is important to understand, however, that the success of this simple technique lies in careful observation of the subject, or, if you have a shortage of zebra and pelicans in your neighbourhood, at least of a photograph of your subject, in order to isolate the significant areas of shading from the detail. It is also important, of course, when merging the components of your drawing, to ensure the correct layering order via the Arrange menu of your application.

If used carefully, tones can convey a remarkable sense of depth. However, once again, success lies in their subtle use to simulate the effect of light falling on the subject—from above, in the case of Copenhagen's famous, if irreverent little landmark in Figure 6.26 and from the left of the James Dean lookalike.

Images created in this way, with very few tones, are usually described as 'posterised', a description derived from their likeness to the style of early screen-printed posters. Similar, although less precise, results can be obtained in painting applications; Figure 6.27 shows the results of posterising a greyscale image in PHOTO-PAINT to two levels (black and white), three levels (black and white and one grey tone) and four levels (black and white and two grey tones).

Interesting tonal effects can also be obtained by using a tracing program to convert a bitmapped photographic image to a vector image. Figure 6.28 shows such an original bitmapped image (a), and two copies traced in CorelTRACE using the centreline method (b) and the woodcut method (c). Trace (b) resembles a posterised image, while the woodcut effect in trace (c) has an ethereal, aged appearance. An extra bonus using tracing, of course, is that the traced images are in vector format i.e. they are broken down into vector areas which can be edited like any other vector shape—for example, certain components of the image can be selected and given a bright colour to contrast with the greyscales of the rest of the image—a technique now popular in the creation of corporate logos. When tracing from CorelTRACE—see Figure 6.29—a magic wand tool can be used to select only required features from the original in the left box (note the dotted lines which delineate

Figure 6.26 *Use of tones to give illusion of depth*

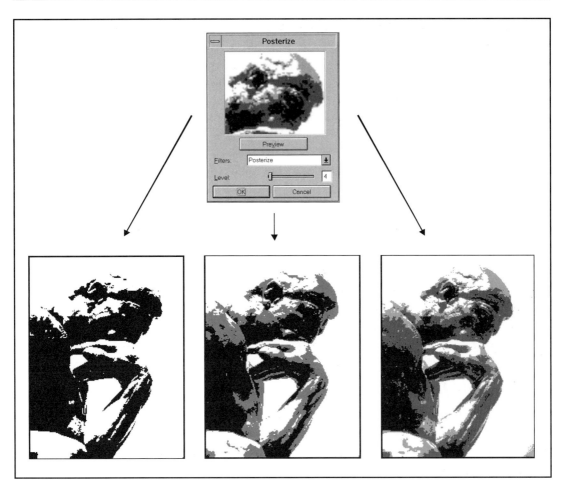

Figure 6.27 Posterising a greyscale image

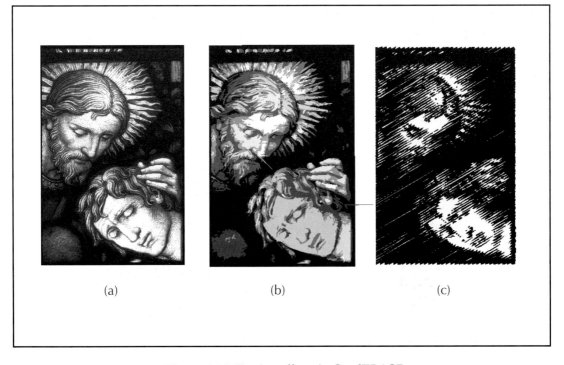

(a) (b) (c)

Figure 6.28 Tracing effects in CorelTRACE

the selected areas) for tracing in the right box. The resulting trace can now be saved in vector format for further editing as required. With some bitmapped images, tracing can produce a traced vector image, comprising relatively few tones which has almost a 'painted' look—see Figure 6.30.

Producing such results in CorelTRACE is very simple; after the opened image appears in the left-hand window, tracing parameters are set from within the dialog box called up from within the Trace menu and clicking on one of the trace option buttons causes the resulting trace to be drawn in the right-hand window. Different parameter settings can be experimented with until the desired result is obtained and the result can then be saved as an editable vector file.

Figure 6.29 Tracing a selected area

| Original bitmapped image | Traced vector copy |

Figure 6.30 Tracing a whole image

Similar results can be obtained using Adobe's Streamline tracer which offers easy control over the number of greys in the traced image. Its toolbox also includes a Lasso tool, which makes selection of irregular areas of an image for tracing very simple.

Before moving on from the use of tones, it is worth finally looking at how they can help to express movement in an image. Figure 6.31 shows two simple examples. In the case of the clock, copies were first made of the minute hand in CorelDRAW. In the preferences dialog box—Figure 6.32a—the rotational angle was set to 10°, the hand was double selected to display its rotation point—Figure 6.32c—which was dragged down to align with the centre point of the clock face. When the Duplicate command was applied, the copy was rotated 10° with respect to the original, about the centre of the clock face. The *Repeat* command was then used to produce two further copies. Each copy was then selected in turn and progressively increasing tone percentages (20%, 50%, 70%, 100%) were applied. The same process was then repeated with the hour hand.

In the cyclist example, the original black image was selected, the horizontal displacement value in the Preferences dialog box—Figure 5.32b—was set at +10 mm and the Duplicate command was used to create four copies. As in the case of the clock hands, each of the copies was then selected in turn and filled with increasing tone percentages.

Figure 6.31 *Using tones to create the illusion of motion*

Figure 6.32 *Creating the moving hands*

Using patterns

Since their relatively high cost limited the use of early computers to the business sector, application developers naturally focused on the needs of business users. Prominent among those was the need for presentation of business results—financial and production data—in a graphical way, which was easy for the viewer to assimilate, rather than in the form of rows and columns of numbers. Charting applications evolved rapidly to satisfy this need and a standard feature of such applications was provision of an on-screen library of simple geometric fill patterns. Such patterns (Figure 6.33) could be used, for example, to fill the slices of a pie chart, providing easier visual separation and identification of the chart's elements. The inclusion of such libraries carried over into the development of drawing applications, allowing their use in more general artwork rather than just for business purposes.

The examples shown in Figure 6.33 are taken from the Macromedia Free-hand library. CorelDRAW includes more exotic patterns created in both vector and bitmap formats (Figure 6.34) and also provides an editor for modifying the supplied patterns or designing and saving the user's own new creations (Figure 6.35a). Using a second editor—Figure 6.35b—found under the Special menu, it is also possible to create a new pattern based on either part or all of a drawn vector image or an imported bitmap image. Figure 6.35c shows a simple imported bitmap of a bird used to create such a pattern which was then used to fill an outline shape of the same bird in Figure 6.35d.

Figure 6.33 Freehand pattern fills

Figure 6.34 CorelDRAW pattern fills

Although useful as elements within business graphics, as mentioned above, pattern fills have limited uses in more artistic projects, although in some cases, with the tone reduced to 20–30%, they can be used to provide a backdrop to other graphic elements. They can also be used to alter the white background of a black and white bitmap (Figure 6.36), the pattern replacing all of the white pixels. If it is preferred that some of the white areas remain white, this can be accomplished by drawing an outline around these areas and assigning them an outline of None and a fill of White.

It should be borne in mind that, while pattern fills can be scaled within their host shape, they will not respond to changes to the perspective of the host. Printing graphics which include patterns can also be a cause of problems, with pages taking an excessive time to print or failing to print at all. Therefore, before using such fills in a project, it is wise to test printing at the early stages to avoid surprises at the last moment.

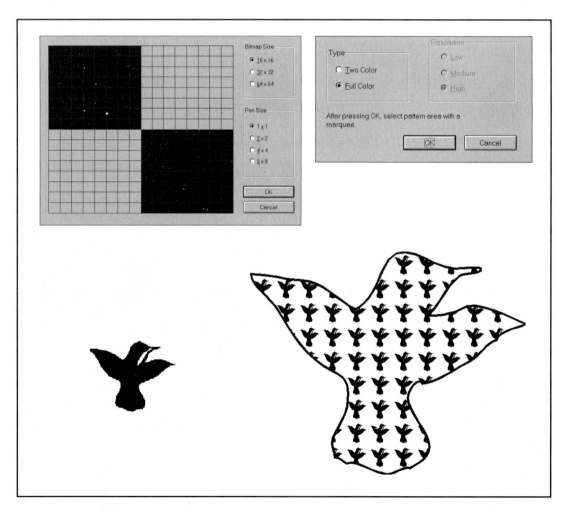

Figure 6.35 *Editing and creating new fills*

Figure 6.36 *Original bitmap (centre). Background replaced with patterns (right and left)*

Screened fills

As discussed in Chapter 4, laser printers and imagesetters reproduce continuous tone originals using a halftone process. Thus, when printing a photographic image on a low resolution output device like a 300 dpi laser printer, the halftone dots can be clearly seen with the naked eye. This is generally regarded as an undesirable effect, which can be overcome by printing at higher resolutions. However, for some purposes the screen itself can become a positive element within a graphic design. Figure 6.37, for example, shows the effect of applying three different screen types to an original black and white bitmap, using CorelDRAW. The screens were applied by first selecting the original image, then opening the outline colour dialog box and selecting the Pantone spot colour option (Figure 6.38a). For the examples shown, black was chosen as the spot colour and the tint was set at 50%. Clicking the PostScript button opened the dialog box in Figure 6.38b, within which the screen attributes can be set. The effect of the selected screen is not seen on the monitor, but appears when the image is printed on a PostScript printer.

Figure 6.39 shows the effect of applying three different screen types in Photoshop to the original image at the top of the figure, via the halftone dialog boxes shown in Figure 6.40. Using Photoshop's Calculation function, it is also possible to blend screened images back into the original image (see bottom row in Figure 6.39). The Custom Pattern button in the left-hand dialog box in Figure 6.40 can also be used to screen an image using a simple bitmap pattern (Figure 6.41).

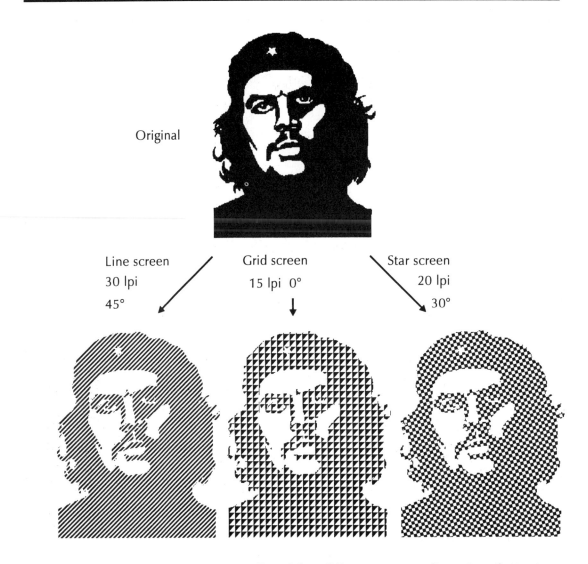

Original

Line screen
30 lpi
45°

Grid screen
15 lpi 0°

Star screen
20 lpi
30°

Figure 6.37 Original bitmap (top). Effect of three different screen configurations (bottom)

(a)

(b)

Figure 6.38 CorelDRAW's outline colour dialog box (a) and halftone screen selection dialog box (b)

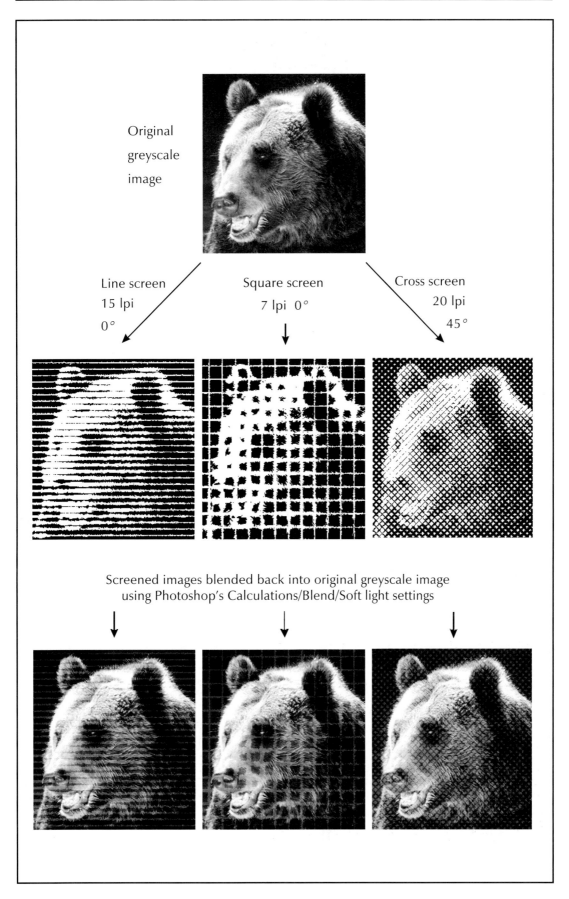

Original
greyscale
image

Line screen
15 lpi
0°

Square screen
7 lpi 0°

Cross screen
20 lpi
45°

Screened images blended back into original greyscale image
using Photoshop's Calculations/Blend/Soft light settings

Figure 6.39 Original image (top). Effect of three different screens (centre). Effect of blending screened versions back into original image (bottom).

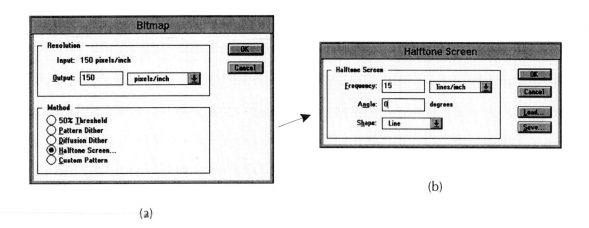

(a)

(b)

Figure 6.40 *Photoshop's screen method selection dialog box (a) and screen configuration dialog box (b)*

Figure 6.41 *Using custom bitmap patterns to screen an image*

In some circumstances, the simple Diffusion Dither method—one of the standard screening options offered by Photoshop and most other applications (see Figure 6.40a)—can produce attractive results. For example, when an image is to be printed to a low resolution output device which is unable to produce sufficient grey levels to produce a satisfactory greyscale rendering, applying Diffusion Dither can often produce an alternative result with a pleasing 'etched' appearance (Figure 6.42).

The same method can also be used to create images which are reminiscent of traditionally hand-rendered drawings (Figure 6.43). This result was achieved by first using CorelDRAW's line drawing tools to create the simple geometric shape in Figure 6.43a. The drawing was then saved to File in Adobe Illustrator 3.0 (.AI) format so that it could be imported to Photoshop as paths, rather than as a rasterised image. After placing the drawing in Photoshop, faces were selected in turn, using the Magic Wand selection tool, and filled with an appropriate level of grey. (Levels of 80%, 40% and 20% were used for the faces in the three different dimensions.) With the use of the Mode menu, the mode was changed to Bitmap, with the Diffusion Dither method selected, producing the result in Figure 6.42b.

Figure 6.42 *Original greyscale (left) and Diffusion Dithered version (right)*

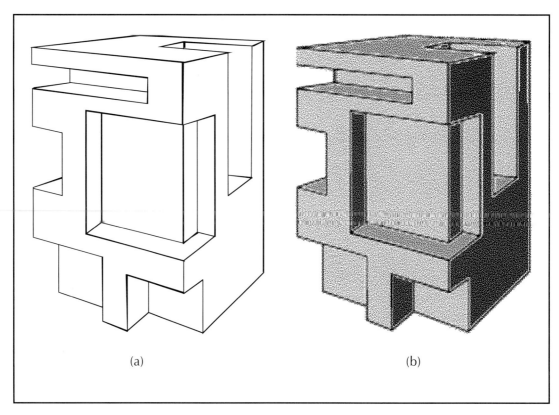

Figure 6.43 Line drawing (a) and Photoshop Diffusion Dithered rendering (b)

Gradient fills

Gradient fills—also referred to as Fountain fills—which are featured in both drawing and painting applications have come a long way since the first software releases offered basically a choice between linear or radial fills. As Figure 6.44 shows, drawing applications like CorelDRAW now include a range of standard types, including Conical and Square fills, selectable from a sophisticated gradients dialog box which also offers the user precise control over variables like the centre offset of the start of the blend, the blend angle, the number of steps in the gradient and, of course, the start and finish colours.

Even more flexibility is offered by provision of a set of 'presets'—more complex, pre-designed gradients—which can be selected from the Preset menu in the dialog box (Figure 6.45). These can be used as is, or modified by dragging the markers above the preview window; the colour at any point within the gradient can be changed by clicking on a marker and selecting a new colour from the palette on the right.

Photoshop's toolbox contains a specific tool for applying gradient fills (Figure 6.46). Selecting the tool opens the gradient dialog box from which the opacity, style, offset and gradient type (linear or radial) can be set. Start and finish point and angle of the gradient are set by dragging the mouse within the selection to be filled.

Figure 6.44 Creating standard gradient fills in CorelDRAW

Figure 6.45 Preset and custom gradients

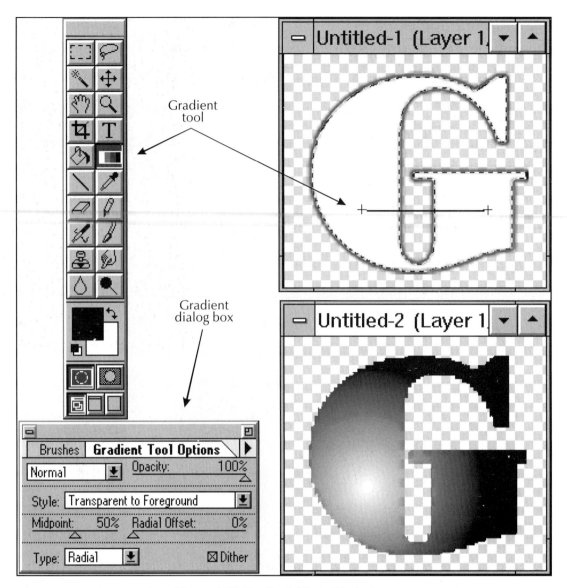

Figure 6.46 Gradient fills in Photoshop

Painter also provides a wide range of gradient options, just a few examples of which are shown at the bottom of Figure 6.47. Clicking the Gradients button in the Art Materials palette opens the Gradients dialog box shown to the left of Figure 6.47. This dialog box offers four basic gradient types—Linear, Radial, Conical and Spiral—and the controls with which to manipulate the gradient angle and order—e.g. from left to right or from inside to outside.

Four preset gradients are also included in the row immediately below the gradients button. By clicking on the downward pointing arrow immediately below the centre of this row, the dialog box to the right of Figure 6.47 appears, offering an extended range of presets. Even this is not the complete range, as further libraries of presets can be accessed by clicking on the library button to the bottom of this dialog box.

Gradient options

Gradient presets

Figure 6.47 *Gradient fills in Painter*

While all of the applications mentioned above provide good gradient fill controls, the gold medal for ultimate gradient control must go to Kai's Power Tools Gradient Designer from Meta Tools, a sophisticated plug-in application which can be used with a variety of applications including Photoshop, Painter and PHOTO-PAINT. A single installation of Gradient Designer allows access by a number of applications. If, for example, KPT is installed in the Photoshop Plugins sub-directory, then it can be accessed from there by the other plug-in compatible programs.

When Gradient Designer is selected from within an application, the user is presented with the unusual interface shown in Figure 6.48, which provides the following controls:

 An Algorithm Control for setting the shape or form that a gradient
 will take

 A Looping Control for determining the number of times the gradient repeats

A Preview window in which the effect of selecting various control parameters can be viewed before the gradient is applied. (When a gradient is to be applied to an underlying image, the image can also be seen in the preview box.) The mouse can also be used to drag the overlying gradient into the required position in relation to the image

A Gradient Angle Indicator, which can be dragged to the required angle using the mouse

A Post Blurring scale which can be used to control the sharpness of tone transitions within the gradient

An Options button providing access to controls similar to those included in Photoshop's Calculations menu

A Gradient Preview window via which colour and opacity adjustments can be applied to the gradient

A Presets menu giving access to literally hundreds of different predesigned gradients. Additions to the presets provided can be designed using the controls described above and saved as additions to the Preset menu

Figure 6.48 The KPT user interface

Just a few examples of the kind of effects which can be obtained when gradients are applied to simple black and white images are shown in Figure 6.49.

These results were obtained by first importing the image to which the gradient was to be applied—the eye or the profile—into Photoshop. Like other Photoshop plugins, the Gradient Designer interface is accessed via Photoshop's Filters menu. The image then appears in Gradient Designer's Preview window, where it is overlayed with the gradient selected. When the desired result has been created in the preview window, clicking on OK applies the effect to the image, or selected part of the image, in the Photoshop window.

KPT's Gradient Designer also provides the ability to apply gradients to paths or selections. The Gradient on Paths user interface is shown in Figure 6.50a. Paths can either be created in an application like Painter or Photoshop or can be imported from vector programs like CorelDRAW if they are saved in .EPS format. The path must first be feathered before the gradient is applied. A few examples are shown in Figure 6.50b. In the case of the girl's head profile, the path was reselected, given a 3-pixel white stroke and superimposed on the gradient path.

Texture Blend
'Full intensity hue spectrum
medium bumps'

Metallic
'Metallic gold sweep'

Frames
'The window'

Framing Effects
'Grayt gray frame'

Burst Gradients
'Glowing red hot'

Metallic
'Radial sweep'

Figure 6.49 *Examples of the effects which can be obtained using KPT's Gradient Designer*

(a) KPT's gradients on paths interface

(b) Gradients on paths examples

Figure 6.50 *Using KPT's Gradients on Paths feature*

As well as providing a creative means of enhancing the appearance of many different types of object, gradients can be used as a fairly crude way of giving objects an appearance of depth. The two objects in Figure 6.51 were created with CorelDRAW's circle, rectangle and line tools. The circle was given a stroke of None and an offset radial gradient from 20% to 100% black was applied, with an Edge Padding of 10%. The front face of the second object was created, given a fill of 30% black, a stroke of 20% black and the shape was then extruded using Effects/Extrude. The 'top' faces, followed by the 'side' faces were then selected in turn and given a linear gradient fill from 20% to 100% black.

In Figure 6.52, The frame on the left was created using KPT's Gradient Designer on a path. The face on the right was selected from Micrografx Designer's clipart library, given a cylindrical gradient fill and then the eyes, nose and mouth were added on top of the gradient fill. Filled vector objects can easily be combined, as in the example in the centre of the figure.

Figure 6.51 Using gradients to give objects depth

Figure 6.52 Gradients from KPT (left) and Micrografx Designer (right)

When using gradient fills on vector objects, it is important to realise that quite different effects can be obtained by changing the way in which the components of a drawing are combined. In Figure 6.53, for example, each of the petals of the flower is an independent object. In the centre example, the four 'north/south and east/west' petals have been combined into a single object and in the case on the right, all petals have been combined.

A wide range of gradient fill effects can also be created in painting applications. The line drawing of the object in Figure 6.54 was first drawn in Illustrator, saved in .EPS format and then placed in Photoshop. Each face was then selected in turn and the linear gradient tool (see Figure 6.46) was used to create the shaded effect.

Figure 6.53 *Effect on gradient fills of combining selected vector objects*

Figure 6.54 *Shading with Photoshop's gradient tool*

Still further interesting effects with gradient fills can be obtained when different gradients are applied to different parts of the same object or when gradient filled objects are subsequently screened. In Figure 6.55, the result on the left was obtained by first using Photoshop's magic wand tool to select the black area of the image, to which a radial gradient was applied and then the white area of the image, to which a linear gradient was applied.

The centre and right-hand images were then obtained by changing the mode in Photoshop of two copies of the left-hand image to black and white and applying to the first a screen of 15 lpi, lines, 0° and 15 lpi, squares, 45° respectively.

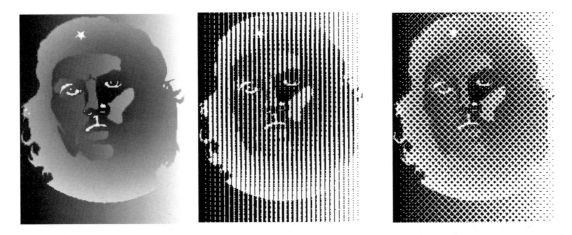

Figure 6.55 Combining gradient and screen fills

Texture fills

Available within both drawing and painting applications, texture fills are provided either in the form of ready-made bitmap files—Photoshop provides nearly 20 Mb of texture files on CD—or through the use of texture bitmap generators—for example, KPT's Texture Explorer. While bitmap file textures are usually based on scans of real life surfaces—for example, marble, leather or wood—those produced by texture generators are created by means of complex mathematical algorithms. Virtually endless variations can be produced by manipulating variables within these algorithms.

CorelDRAW provides over 100 preset textures (also available to PHOTO-PAINT), any one of which can be manipulated using the random number generator, value and colour selectors available from within the texture fills dialog box (Figure 6.56). Bitmap resolution and tile size can be set via the Options button. Applying a texture to objects such as those in Figure 6.57 is simply a matter of selecting the object, clicking on the Fill tool, selecting the Texture Fill option to open the texture dialog box, selecting or modifying one of the presets and clicking OK. Figure 6.58 shows the result of using the same sequence of steps to apply a texture fill to the background pixels of a bitmap.

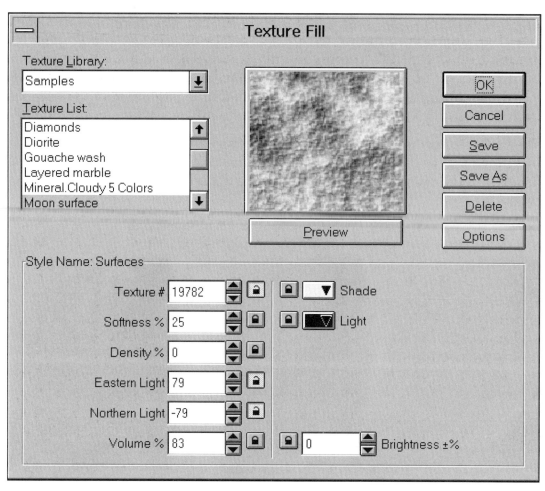

Figure 6.56 CorelDRAW's Texture Fill dialog box

Molecules Red clay pottery Canyon Surfaces 3c

Figure 6.57 Sample texture fills

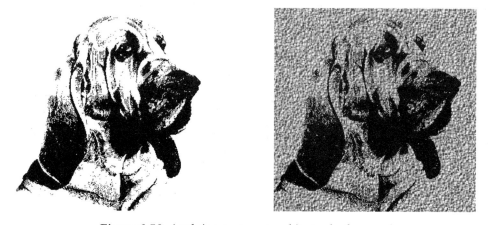

Figure 6.58 Applying texture to a bitmap background

Applying textures in Photoshop can be accomplished by any of three different methods. In the first method, the area of the target image to be filled is selected; from the Filter menu, Render/Texture Fill is selected, opening a file selection dialog box (Figure 6.59a). Selecting the required PSD texture file and clicking OK then causes the selection to be filled with the chosen texture. Figure 6.60 shows a few examples of the greyscale textures provided with Photoshop.

More control over the way in which the texture is applied is provided by the second method, in which the PSD pattern file itself is opened and the pattern selected. From the Edit menu, Define Pattern is selected, creating an image of the pattern in a temporary buffer. The area of the target image to be filled is then selected and from the Edit menu, Fill is selected, opening the dialog box in Figure 6.59b. Via this dialog box, both the opacity and the apply mode of the texture can be controlled. Instead of the PSD pattern files provided with Photoshop, any texture file in, for example, PCX or BMP format can be used as a pattern.

In the third method, a new alpha channel is created, using the Channels/New command and this channel is filled with the required texture using the Filter/Render/Texture command. After switching back to the RGB channel, Filter/Render/Lighting Effects is selected, displaying the dialog box in Figure 6.61. The channel containing the texture is then selected from the menu at the bottom right of the dialog box, combining the texture with lighting

(a) (b)

Figure 6.59 Photoshop texture fill dialog boxes

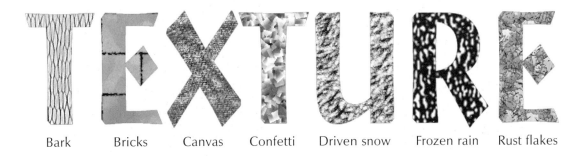

Bark Bricks Canvas Confetti Driven snow Frozen rain Rust flakes

Figure 6.60 Examples of Photoshop textures

effects applied to the image displayed in the window on the left (in this case, a Roman column). The result is shown in Figure 6.62d. The original column image—Figure 6.62a—was saved from CorelDRAW in EPS format and then placed in Photoshop. Figure 6.62b used the first method of simply filling the whole image with texture. To create Figure 6.62c, the second method was used; each facet of the column was selected in turn and the opacity was graded from 20% at the centre to 100% at the outer edges to give a sense of depth.

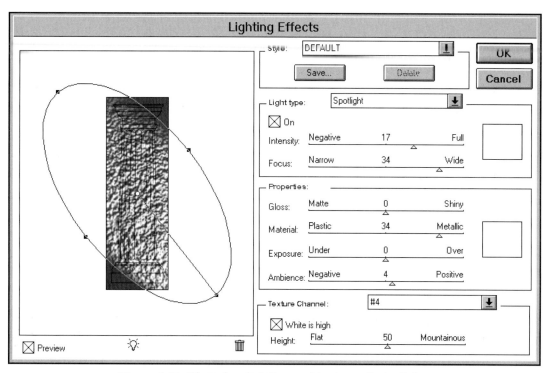

Figure 6.61 *Photoshop lighting and texture effects dialog*

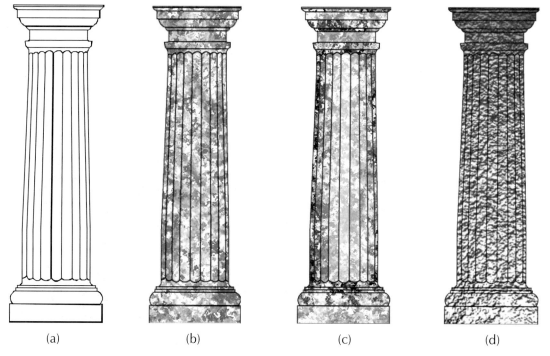

Figure 6.62 *Texture fills using different techniques*

As well as its Gradient Designer, Kai's Power Tools provide a texture designer—called Texture Explorer—which again puts an algorithmic engine at the fingertips of the user to generate and mutate an endless range of textures. Both Texture Explorer and its other stable mate Fractal Explorer can be made to work with Gradient Designer, applying selected gradients to either texture or fractal fills.

The user interface is shown in Figure 6.63. Textures, such as the Fabric/Mexican Blanket example shown, can be selected from the menu at the bottom of the screen. The selected texture appears in the small window to the left and also in the centre of the grid of windows to the right; the smaller windows around the grid display variants of the central image; clicking on any of these causes it to replace the image in the centre. Other controls on the interface allow further mutations of both structure and colour until the desired result is achieved. Clicking on OK then applies the texture to the selection within the host application window.

Figure 6.64 shows a few examples of the hundreds of presets available, together with their rather exotic names. Figure 6.65 shows an outline map of Scotland, with the major counties filled with a selection of textures from the Marbles and Minerals preset libraries.

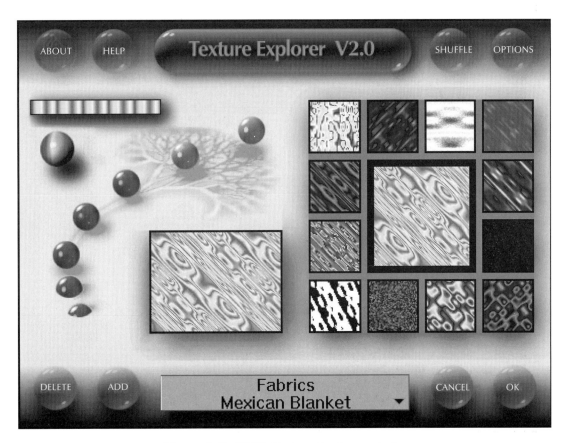

Figure 6.63 KPT's Texture Explorer window

Figure 6.64 *A few of KPT's preset texture fills*

Figure 6.65 *Presets from the Marbles and Minerals libraries*

While not so extensive, Fractal Painter's library of textures—accessed via the Art Materials palette (Figure 6.66a)—provides some attractive options. Clicking on the Papers button in the top row of the palette displays a swatch of available textures. Clicking one of these then readies it to be applied to a selection in the Painter application window. To apply it, Surface Texture is selected from the Effects menu, opening the dialog box in Figure 6.67, in which the lighting angle, amount (graininess) and shininess of the surface can be adjusted and the effects observed in the preview window, before clicking on OK. Additional texture libraries can be accessed via the Library button seen at the bottom right of Figure 6.66a. Figure 6.68 shows four examples of Painter's textures set against drop shadow backgrounds (more of which later).

(a) (b)

Figure 6.66 Painter's Texture dialog (a) and Weaves dialog (b)

Figure 6.67 Editing surface texture

Painter also includes a special category of textures called Weaves. Like Paper textures, Weaves can be chosen from swatches displayed in the Weaves dialog box (Figure 6.66b). Like a Paper texture, the required Weave is selected by simply clicking on the appropriate swatch. Unlike a Paper texture, it is applied to a selection in Painter's application window by means of the Fill tool. In the example in Figure 6.69, four copies of the piper were created and then a selection of the kilt was created in each case and filled with a different tartan. No editing/preview window—like that provided with the Paper textures—is provided for the Weaves, although, of course, Painter's other editing tools can be used to modify the appearance of the weave while its host object remains selected.

Globes Mottled Culture Plaid Fibres

Figure 6.68 Examples of Painter textures

Figure 6.69 Examples of Painter weaves

Postscript fills

This category of vector fill is included here for completeness, however, it is of limited value for a number of reasons:

When applied, a PostScript fill appears not on screen, but only later when the artwork is printed on a PostScript printer, so that the usual designer/screen 'try for fit' interaction is not possible

Printing times can be very long or printing may fail altogether as some patterns are very complex

The appearance of a pattern can change radically with the shape of the object to which it is being applied

For these reasons, using a PostScript fill is something akin to engaging in a game of chance! Inevitably, however, there will be the project for which no other solution is available and it also has to be admitted that some striking effects can be obtained.

CorelDRAW provides a wide selection of PostScript fills and helps obviate the first of the above limitations by providing hard copy samples of nearly 50 different fill types. After selecting the object to be filled, clicking on the PostScript option on the Fill tool flyout opens the dialog box in Figure 6.70. The required texture is then selected by scrolling through the menu. Clicking on OK applies the fill, using the default settings or, alternatively, the four variables shown in the lower half of the dialog box can be adjusted to give different effects, on a trial and error basis. (The Corel manual does include samples of each fill created using four different settings of the variables.)

Figure 6.71 shows just six examples of the many styles available. The fills can be used either purely for decorative effect to fill either objects and decorative backgrounds or can be used as elements of graphic construction in their own right. In Figure 6.72, for example, Tree Rings, Cracks, Bubbles and Spider's Web fills have been used to create the simple compositions shown. In the fishbowl example, the fish was placed behind the bubbles, while in the Spider's Web example, the spider was added on top of the fill.

Figure 6.70 *Choosing PostScript fills in CorelDRAW*

Bars Crystal Lattice DNA

Leaves Spokes Waves

Figure 6.71 *Examples of PostScript fills*

Figure 6.72 *Applying PostScript fills*

Clone fills

We saw earlier how bitmaps—even greyscale or colour images—can be used as fills, although quality degrades rapidly with increasing complexity of the image used.

Another novel type of fill involves using a cloning technique, in which part or all of a bitmapped image is copied or "cloned" from an original image and then used as a fill within a new image. Figure 6.73 shows an image of Stonehenge imported into Photoshop. In this example, the rectangular selection tool was used to select an area on the face of one of the vertical columns. Edit/Stroke was used to give the selected area a two-pixel black outline (Figure 6.74a) and then, from the Edit drop down menu, Define Pattern was selected, saving the selection in a temporary buffer. A new file was opened and filled, using Edit/Fill, with the Pattern option selected, giving the resulting 'paved area' effect in Figure 6.74b. Image/Effects/Perspective was then applied to the whole of the selection in Figure 6.74 and the resulting foreshortened path was dragged into the Stonehenge image, scaled and positioned in front of the column from which the clone had been created (Figure 6.75).

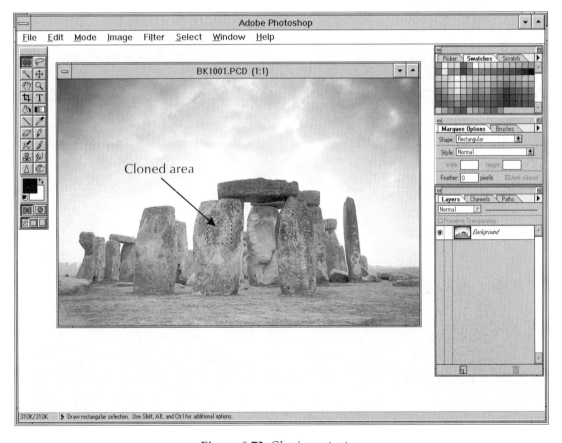

Figure 6.73 Cloning a texture

(a)

(b)

Figure 6.74 *Stroking the clone and then using it as a fill*

Figure 6.75 *Using the clone*

Fractal fills

Unlike PostScript fills, fractal fills display on screen in all their glory, but, like PostScript fills, they are complex in nature and can extend printing times considerably.

Confining a fractal within the bounds of a graphic shape seems almost like locking a beautiful bird in a cage; like birds, fractals seem to soar and swoop and glide, tracing intricately beautiful and endless patterns in a fractal sky. That said, to the practical designer no stone can be left unturned in the search for new graphic expression! Perhaps the secret in using fractals in design (one which we shall explore later) is to blend other design components with the natural flow of the fractal.

The most intuitive fractal generator currently available is undoubtedly KPT's Fractal Explorer. With an interface similar to those of its sister applications (Figure 6.76) it provides a sophisticated set of controls to generate fractals from the Julia and Mandelbrot sets. Figures 6.77a and 6.77b show examples typical of these sets, while (c) and (d) show how different variants can be.

Fractal Explorer comes with a set of dazzling presets, which provide excellent jumping-off points in the quest for the perfect fractal. A preview window in the centre of the interface has zoom, detail and positioning controls,

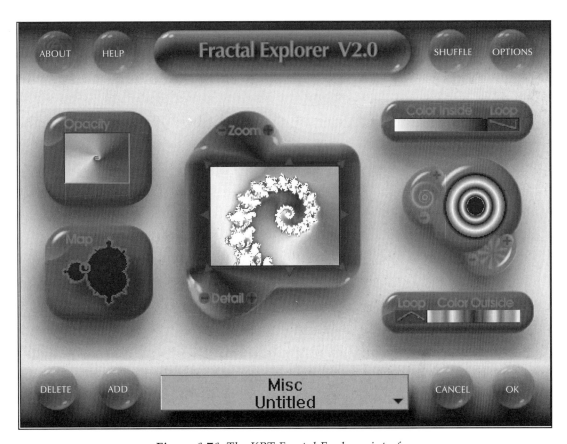

Figure 6.76 *The KPT Fractal Explorer interface*

while a smaller window to the left monitors opacity of the fractal with respect to the underlying image. Other controls allow variation of the gradients applied to the fractal's 'inner and outer space', while the unusual Spiral Wrapping Control adjusts the repetition of the gradient as it applies to the set. The Gradient Designer can be started up to run alongside Fractal Explorer, allowing gradients to be created and manipulated before being applied to the selected fractal, which is then, in turn, applied to the host application selection.

There are many other applications available for the generation of fractal images which can be used as object fills or decorative backgrounds. Fractal Vision is an interesting example of such products in the sense that it allows the user to grow fractal objects from simple 'seed' shapes. Figure 6.78 shows an example of a treelike formation created by progressively iterating the simple seed shape shown to its left. The same basic seed shape was used to create the 'florette' pattern in Figure 6.79a.

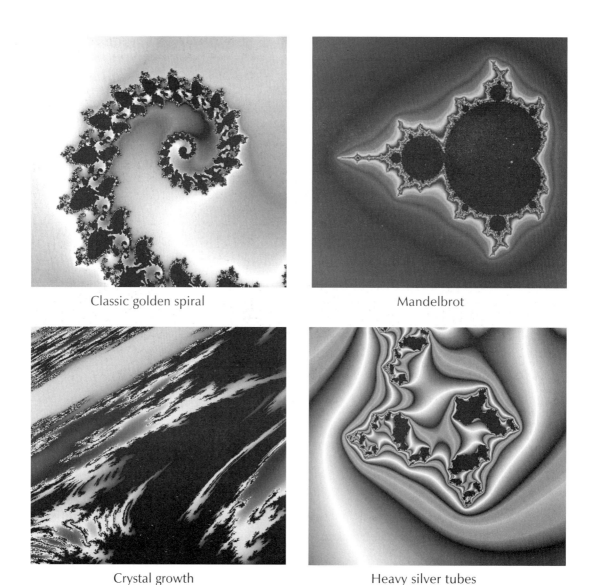

Classic golden spiral

Mandelbrot

Crystal growth

Heavy silver tubes

Figure 6.77 KPT fractal fill examples

One of the most intriguing aspects of fractals as graphic objects is their unpredictability, ranging as they do from images of quite breathtaking beauty to images as sinister as those of any nightmare (Figure 6.79b).

An honourable mention must also be given to Fractint, an exceptional shareware fractal generator from the Stone Soup Group. As well as providing the user with a wide range of controls for generating and manipulating conventional 'two-dimensional' fractal images which can be saved in GIF or BMP format and used as decorative fills, Fractint is also one of a growing number of applications which can generate and render virtual landscapes and moonscapes (Figure 6.80) using fractals to simulate mountains, clouds and extraterrestrial bodies.

Figure 6.78 *Growing fractals from seed—Fractal Vision*

(a)

(b)

Figure 6.79 *'Beauty and the Beast'*

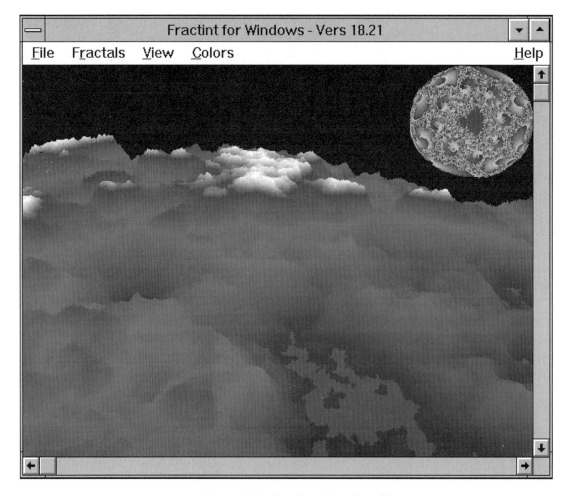

Figure 6.80 *Fractint virtual world*

7

Blends and Contours

Blends

Blending creates a smooth and gradual transition between objects in a composition or between separate parts of the same object. It can be accomplished in a number of ways in either drawing or painting applications and we examine both in this chapter.

In a vector application like CorelDRAW, blending also provides a number of other useful features which offer interesting graphic possibilities. For example, a common graphic constructional requirement is the positioning of an array of like objects at fixed relative positions to one another. Figure 7.1 shows how easily this can be accomplished using CorelDRAW's Blend feature.

Figure 7.1a was created by positioning two copies of the clover leaf to the left and right boundaries of the composition; the two leaves were then marquee-selected and Blend was selected from the Effects drop down menu, opening the dialog box in Figure 7.1b. Entering '6' in the Steps window and clicking Apply caused six identical copies to be placed equidistant between the first leaf—the Start Object—and the last leaf—the Finish Object. After blending, the six new copies are now linked to the Start and Finish Objects in a special type of group called a 'blend group'. Although part of the group, either the Start Object or Finish Object can be selected independent of the rest of the group. If changes are made to either or both the Start and Finish Objects in a blend group, then the group 'reflows', reflecting the changes. Figure 7.1c shows the result, for example, of increasing the size of the first leaf and reducing the size of the last leaf. (Note that the distance between the centres of adjacent leaves remains the same.) In Figure 7.1d, the first leaf was given a fill of white and the last leaf a fill of black, causing the group to reflow automatically with intermediate fills, while in Figure 7.1e, the last leaf was moved upwards and to the left, causing the group to reflow to terminate at that new end point. (Note the overlapping which now takes place as the centres of the intermediate leaves maintain their equidistant spacing.)

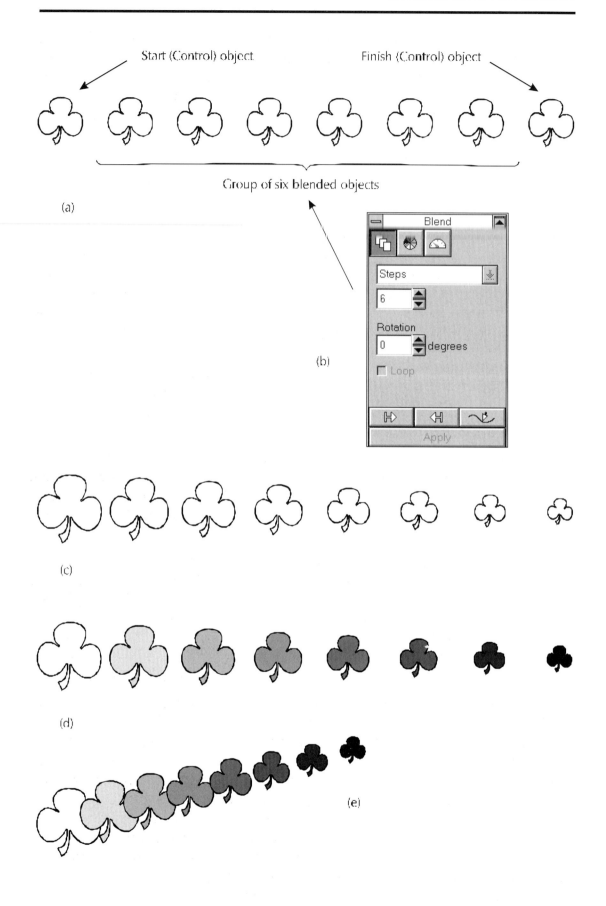

Figure 7.1 *Blending similar objects in CorelDRAW*

Blending can also be used to construct "closed" shapes such as borders from arrays of objects, since either the First Object or Last Object in a blend group can be selected and designated as the First Object in a new blend. For example, in Figure 7.2a, Object A and Object B were first blended, using six intermediate steps; Object B and Object C were then selected and blended using two intermediate steps; Objects A and D were selected and blended also using two intermediate steps and, finally, objects C and D were blended with six intermediate steps, producing a Compound rectangular blend made up of four linear blends.

Objects can also be blended along a curved, rather than a straight, path. Start and Finish Objects A and B are first placed, as in Figure 7.2b and the curve along which they are to be blended (Curve C) is created using the curve drawing tool. The two objects are then marquee-selected and the Curve icon is clicked in the Blend dialog box, in this example with eight steps specified (Figure 7.1c). This causes an arrow to appear; dragging the arrow until it points to the curve and then clicking Apply, causes the blend to follow the shape of the curve (Figure 7.1d). The curve itself can then either be removed by ungrouping the blend, selecting the curve and deleting it, or simply by changing its colour to None. If the result is not exactly as desired after blending has taken place, the curve can be selected and node-edited; the blend then reflows to the new curve shape.

What makes this aspect of the blend technique particularly powerful is that the curve, instead of simply being created in the vector program, can be a path exported from say Photoshop or Painter. After fitting the vector objects precisely to the path, they can be exported back to the photoediting program and placed in exactly the required position.

Further possibilities are offered by the fact that rotation can be applied to objects within a blend. As the example in Figure 7.3 shows, our daredevil pilot can be made to do a full 360° forward roll (Figure 7.3a) by simply setting the angle of rotation to 360° and the number of blend steps to 4 in the Blend dialog box (Figure 7.3b). We can even combine the Blend Along a Path feature with Rotate All and six steps selected (Figure 7.3c) and—hey presto!— our intrepid pilot has executed a fearless 'loop the loop'! (Figure 7.3d).

After a blend has been created, it is possible to split it at a specified object within the blend. The split object remains part of the blend, but now any editing of its attributes (e.g. size, fill or outline) causes the blend to reflow to reflect these changes. An example is shown at the bottom of Figure 7.3. Initially, a blend was created consisting of a horizontal row of six aeroplanes. The blend was then selected and Split was clicked in the Blend dialog box (Figure 7.3e) causing the mouse cursor to change to an arrow. Clicking the arrow on the third aeroplane from the left caused it to be split from the blend, in the sense that it could now be edited. The split aeroplane was then increased in size and moved downwards from its original position. As the blend reflowed, a perspective effect was created, giving the impression that the six aeroplanes were now flying in close formation! (Figure 7.3f).

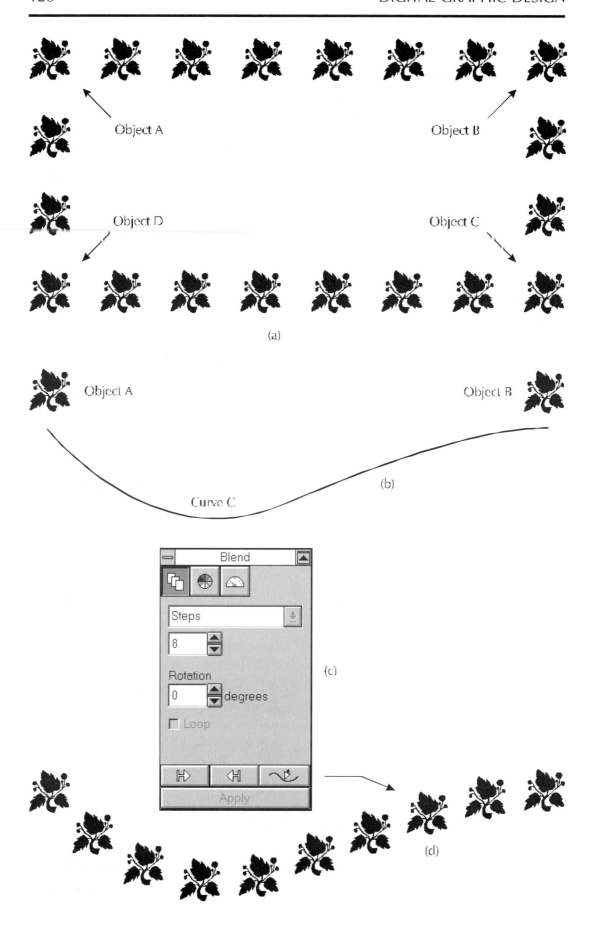

Figure 7.2 *Compound blend (a) and blending on a curve (d)*

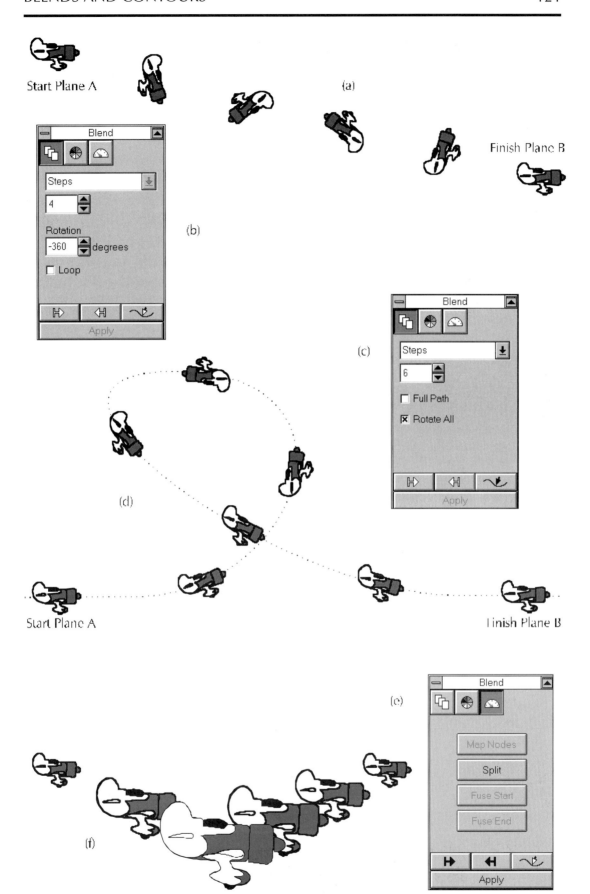

Figure 7.3 'Aerobatic' blending

The objects used in our first two examples—in Figures 7.1 and 7.2—were relatively simple curve objects. However the little aeroplane in Figure 7.3 is in fact a group constructed from eight simpler objects, so we have seen that is possible to create blends between groups as well as between simple objects. This opens up the possibility of creating more complex blends; in Figure 7.4, for example, two separate ornaments (a) and (b) were selected and grouped, using CorelDRAW's Arrange/Group command; two copies of the group were placed to the left and right of the composition, marquee-selected and then a four-step blend was applied, producing the result in (c).

Figure 7.5 shows a more complex group blend. The leaf in (a) was duplicated and rotated and the two leaves were then grouped (b); this group was then duplicated and the copy was offset upwards and to the right and reduced in size. A three-step blend was then applied along a curve joining the centres of the two pairs of leaves and the curve was removed, giving the result in (c). Finally, a Power curve was used to create a stem for the leaves.

Figure 7.4 Blending simple groups

Figure 7.5 More complex group blending

In the examples looked at so far, we have concentrated on blending between two physically separated objects. Figure 7.6 shows examples of blends from an 'external' to an 'internal' shape; in (a), a fifteen-step blend was created between an outer and an inner ellipse; in (b), the letter D was converted to curves and the outer and inner parts separated. The outer and inner parts were given 20% and 60% tints and then a seven-step blend was created between them; in (c), a duplicate was made of the large heart shape and reduced in size to 25%. A radial fountain fill was applied to the smaller heart and a ten-step blend was applied between them; to get the effect in (e), the leaf in (d) was duplicated, reduced in size to 20% and filled with black. The outline of the outer leaf was changed to None and a 20-step blend was applied between the two.

We have seen how blends can be edited by changing characteristics, like fill and outline colour, of any of the Start, Finish or Split objects of the blend. More sophisticated editing is possible by node editing any or all of these same objects. Figure 7.7a was the result of taking a copy of the blend in Figure 7.6a and selecting and dragging to the right the nodes of the smaller ellipse. Applying the same treatment to the a node of the large ellipse produced the result in Figure 7.7b, while splitting the blend and manipulating the nodes of the split object created the more complex form in Figure 7.7c.

This process is shown more simply in the lower half of Figure 7.7. The simple 20-step blend in (d) was first created using a straight Bezier line with nodes at either end. Figure 7.7e shows the upper node of the Finish line being dragged down and to the right. Figure 7.7f was the result of selecting and dragging down and to the right the upper node of the Finish line and then, in turn, selecting and dragging the two nodes of the Start line. Using this method on more complex blends, it is possible to create quite dramatic-looking 'wireframe' surfaces which can in turn be grouped to produce still more complex 'higher assemblies'.

Node editing also extends the artistic possibilities of blends. The wings of the eagle in Figure 7.8 were created using the process just described and then positioned in relation to the body of the eagle on the left. Copies of the wings were then rotated and attached to a duplicate of the body, creating the second image on the right.

Blending can also be forced to occur between completely unlike vector objects, although the results tend to be, at best, unpredictable and, at worst, of no graphic merit whatever! The egg to chick example in Figure 7.9 illustrates this phenomenon. The Start and Finish Objects are so different that the hybrid shapes of the blend simply look ugly and misshapen. More successful blends are likely to occur between similar shapes. To create the space station in Figure 7.10, the three-dimensional wireframe objects were first created in Micrografx Designer and then imported to CorelDRAW, where they were ungrouped and separated. Corresponding faces on the three-dimensional objects were then selected and blended, creating the impression of space tunnels connecting them.

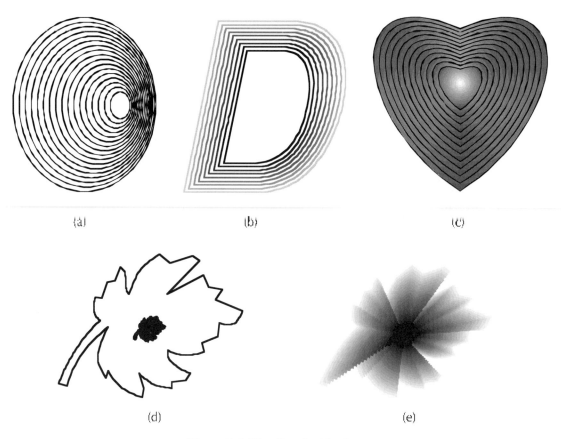

(a) (b) (c)

(d) (e)

Figure 7.6 Blending inside shapes

(a) (b) (c)

(d) (e) (f)

Figure 7.7 Node editing of blends

Figure 7.8 Creating special effects

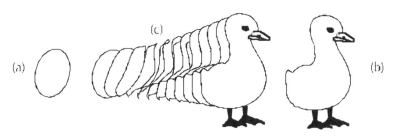

Figure 7.9 Blending unlike objects

Figure 7.10 Blending like shapes in different objects

Perhaps the most common use of blends in vector drawing programs is to simulate an airbrush effect in order to create highlights and shadows. In Figure 7.11a the outline of the glass and drinking straw were drawn and given a thick black stroke. Duplicates were made to overlay the original lines exactly, but this time they were given a fine stroke and a colour of white. A 20-step blend between the thin white and thick black lines created the 'neon' glowing effect shown.

The more complex result in Figure 7.12c was created using exactly the same principle. A shape similar to the first leaf was drawn inside its boundaries (Figure 7.12b) and filled with a 60% grey tone. A duplicate of this shape was reduced in size to 25% and filled with white (outline colour of both shapes was None); a 20-step blend was applied between these two shapes. The same procedure was followed for each of the other leaves and for the stem and then the original image was filled with the same 60% grey tone as the highlight shapes, so that the 'joins' became invisible.

Figure 7.11 Creating simple highlights

Figure 7.12 Creating more complex highlights

In painting applications, there are several techniques which can be used to blend objects smoothly together:

Airbrushing

Using Dodge and Burn Tools

Smudging

Using filters

Feathering

Using Painter's Liquid brush

Morphing

Figure 7.13 shows the extensive range of variations offered by Painter's airbrush. Figure 7.14 shows stages in the construction of a Painter illustration—from the initial pencil outline in (a) to the finished painting in (f)—in which airbrushing is used extensively to blend highlights smoothly into the handle and stock of the brush (b), the bristles of the brush (c) and the paint splashes (d) and (e).

The rose in Figure 7.15a is a vector image filled with a uniform grey tone and with an outline colour of None. A copy of the rose was imported into Photoshop, where it was rasterised—i.e. converted to bitmap format. Photoshop's Magic Wand tool was used to select the first petal (easily done when an object has a uniform colour) and the Burn tool, using a soft brush size of 40-pixels and an exposure of 50%, was used to darken its edges. Each of the other element of the rose was selected in turn and the same treatment was applied, producing the result in Figure 7.15b. The Dodge tool was then selected, with a 5-pixel brush size and an exposure of 75%, and used to 'paint' highlights on to the petals and stem (Figure 7.15c).

Photoshop's Burn and Smear tools were used to liven up the flat vector image of the Elvis lookalike in Figure 7.16a. A copy of the vector image was rasterised in Photoshop and the face was selected and filled with a uniform 20% grey tone. The Dodge tool, using sizes between five pixels and 40 pixels, with exposure again set at 50%, was then used to add shadows to the face, creating a sense of shape and form (Figure 7.16b). The process of rasterising the vector image had created a slightly stepped edge to the outlines of the original image, so the Smear tool was next used to soften these edges, using settings of ten pixel size and 75% pressure.

Figure 7.17 shows another example of the use of the Smear tool and compares its effect with the use of a filter. The simple vector running figure in (a) was duplicated and offset six times, with each copy being given an

Figure 7.13 *Painter's Airbrush options*

Figure 7.14 *Airbrushing highlights*

Figure 7.15 *Creating highlights with Dodge and Burn*

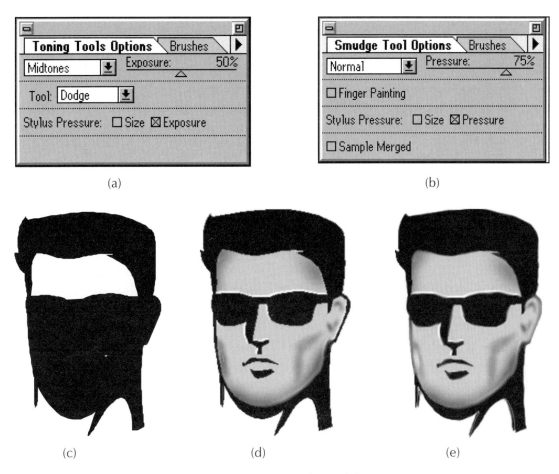

Figure 7.16 *Using Dodge and Smear*

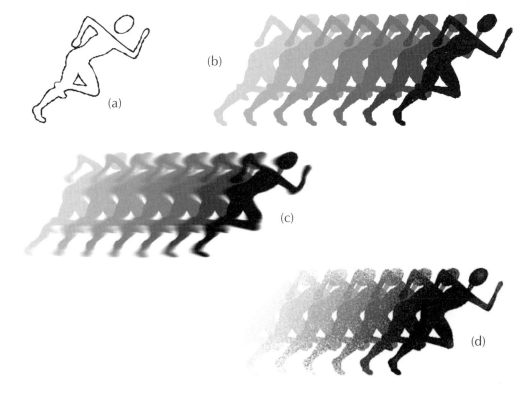

Figure 7.17 *Blending with Smear (c) and Pixel Wind (d)*

increasing percentage of grey fill, producing the result in (b). This image was then rasterised in Photoshop and the Smear tool, with settings of 30 pixels and 75% pressure, was dragged several times horizontally from right to left, blending the copies together and giving the impression of movement.

Certain painting application filters can be useful in helping to blend objects, either used alone or in conjunction with other techniques. Examples are Blur filters, Noise filters or Wind filters. The effect in Figure 7.17d was obtained by applying KPT's Pixel Wind filter to a second rasterised copy of Figure 7.17b. The effect of the filter is to break down the separate images of the running figure, making them visually blend together.

Feathering is another technique which is used frequently to soften the sharp edges of an object which has been selected, using a painting application selection tool. Figure 7.18 shows the effect that feathering has on a simple square selection which has been filled with black. The feathering tool settings ranged from 2 pixels, which is enough to give a small but noticeable effect, to 8 pixels, which, for an object of this size, gives a major effect, almost concealing the shape of the original object. Figure 7.19 shows the effect of selecting one of the roses from the picture on the left and applying different levels of feathering (1 pixel, 3 pixels and 5 pixels) to the three copies of the rose on the right.

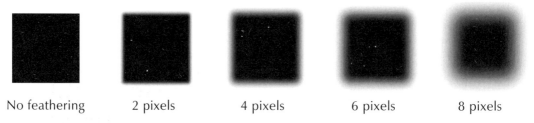

No feathering 2 pixels 4 pixels 6 pixels 8 pixels

Figure 7.18 Feathering

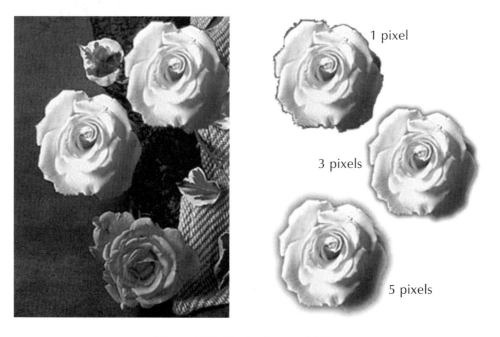

Figure 7.19 Feathering a selection

Although not intended for use as a blending tool, Painter's Liquid brush can be used effectively for this purpose, as shown by the examples in Figures 7.20, 7.21 and 7.22. Figure 7.20a shows the Liquid brush selected in Painter's Brushes dialog box (right-hand end of top row), with settings Distortion and Drip. The settings for brush size and profile can be further refined in a second dialog box, shown in Figure 7.20b. A copy of the vector image of the skier in Figure 7.20c was rasterised in Painter as Figure 7.20d and, using the settings in the dialog boxes, the brush was used to break up the trailing edges of the copy, to create the impression of movement and speed.

Similar settings were used to create the effect in Figure 7.21. In this case, the original vector image in Figure 7.21a was given a fill of white and a heavy black outline before a scaled copy—Figure 7.21b—was imported via the clipboard to Painter. The liquid brush was then dragged from the white fill of the text characters through the black outline to create the effect shown. Various brush sizes were used to give variety to the size of the 'flames'.

The effect of the Liquid/Distortion combination can be particularly effective when applied to a copy of any regular geometric vector pattern, such as the simple XY grid in Figure 7.22a. Dragging the brush through the grid breaks up and spreads the lines of the grid into the swirling 'mole tracks' of Figure 7.22b.

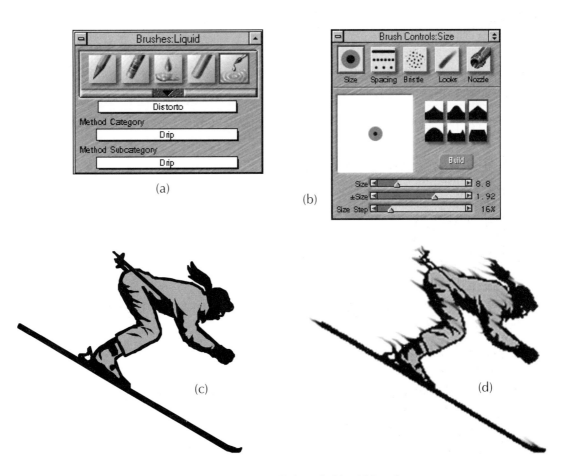

Figure 7.20 *Using Painter's Liquid brush*

 (a)

(b)

Figure 7.21 *Hot text*

(a) (b)

Figure 7.22 *Order (a) into chaos (b)*

Another method of blending which has recently appeared in advertising and in film special effects is 'morphing'—an abbreviation of 'metamorphosing' or 'altering from one state to another'. Morphing shares the technology used for the creation of digital animated sequences and hence is sometimes offered as a feature within an animation program; Figure 7.23 shows the user interface for such an application.

To create a morphing sequence between two bitmap images within CorelMOVE, the user imports the first image (the starting image for the morph) via the File/Import menu; the image—the head of a chimpanzee in this case—appears in the central window. The chimpanzee is then selected using the arrow tool and the Actor window is opened by clicking on Edit/Object. Edit/Add Cels is then chosen from the Actor window menu and one additional Cel is added. Edit/Paste is then used to paste the image of the boy (the finishing image for the morph) into this new cell. Using the scroll bar at the bottom of the floating Tools menu, the first Cel is now reselected and Morph is selected from the Effects menu, opening the dialog box in Figure 7.24. In this box, two parameters are specified; first, the number of morphing Cels to be created between the starting and finishing images and, second, the key points on the two images which should converge as the starting image (the chimpanzee) morphs into the finishing image (the boy). To determine one of these points, the user first clicks on e.g. the tip of the chimpanzee's nose. This automatically creates a selection point in the second

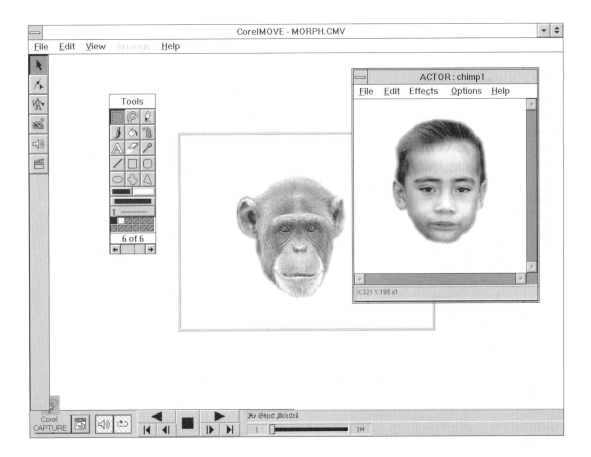

Figure 7.23 The CorelMOVE interface

window which is dragged into position at the tip of the boy's nose. This procedure is then repeated for a number of other points; when all points have been set, clicking on OK starts the process of creating the morphing Cels. When the process is complete, the six Cels (starting, finishing and four in between) can be viewed individually in the *Actor* window, using the scroll tool at the bottom of the floating Tools menu (see Figure 7.23) or can be run as an animation sequence using the video recorder-like controls at the bottom of the User interface window. The six Cels of the example morph are shown in Figure 7.25.

The more cels used to create the morph and the more points of correspondence, the smoother and more accurate the morph will be, but, conversely, the longer time it will take for the application to create the morphing Cels. In the example shown in Figure 7.25, with only four morphing Cels, a degree of raggedness is apparent around the edges of the intermediate images.

Although presently in vogue, the value of morphing to the graphic designer is rather limited, although it can sometimes be used to create a particular 'look' which requires combining the attributes of two separate images. The intermediate Cel most closely meeting the requirements can then be selected and further edited as required.

Reasonable intermediate results can be obtained using two images, like our chimp and boy, which are relatively similar in size, overall shape and tonal composition. Morphing dissimilar objects requires many Cels and correspondence points, requiring processing power beyond the capacity of most current desktop systems.

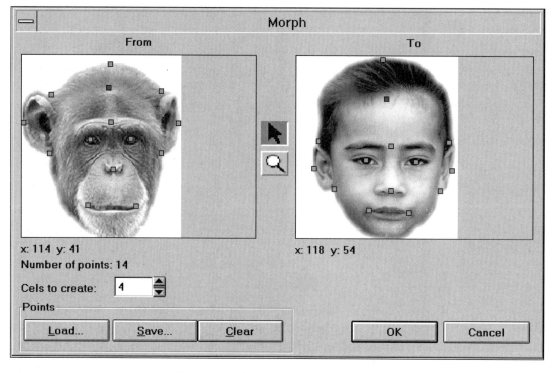

Figure 7.24 Let evolution commence!

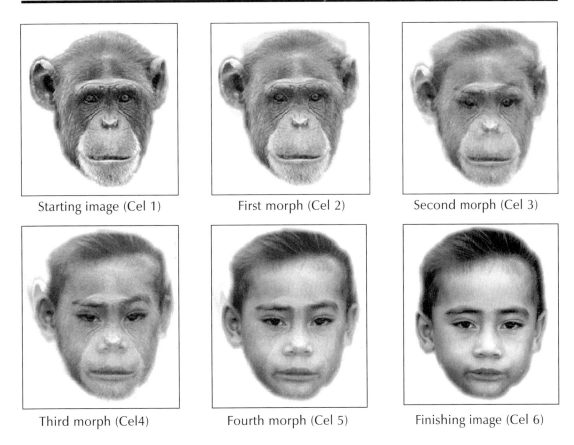

| Starting image (Cel 1) | First morph (Cel 2) | Second morph (Cel 3) |

| Third morph (Cel4) | Fourth morph (Cel 5) | Finishing image (Cel 6) |

Figure 7.25 An evolutionary morph

Contours

Contouring can be considered as an extension to the category of Blending which involves the blend of an object with a larger or smaller copy of itself and sharing a common centre point. In the case of Contouring, however, the user does not create the second copy, but simply specifies the number of copies to be made, their distance apart and whether the copies should be placed inside or outside the original object. The user chooses the outline and fill attributes of the original object and can then specify the same, or different attributes for the contour. The original object remains editable after a contour has been created, but, unlike in the case in Blending, changes to the original object, e.g. a change in line weight, affect the whole contour group uniformly.

At its simplest, CorelDRAW's Contour feature produces the simple contours shown in Figure 7.26. The settings in dialog box (a), when applied to the rectangle in (b), produce the 'external' contour in (c), while the settings in (d), when applied to the ellipse in (e), produce the 'internal' contour in (f). The feature can, however, produce more subtle contours, like those in Figure 7.27. In this case, the closed Bezier object in (a) was first given a fill of 30% grey and blended Outside, with final outline and fill colours set to white, producing the result in (b). A copy of (b) was made and the contour group

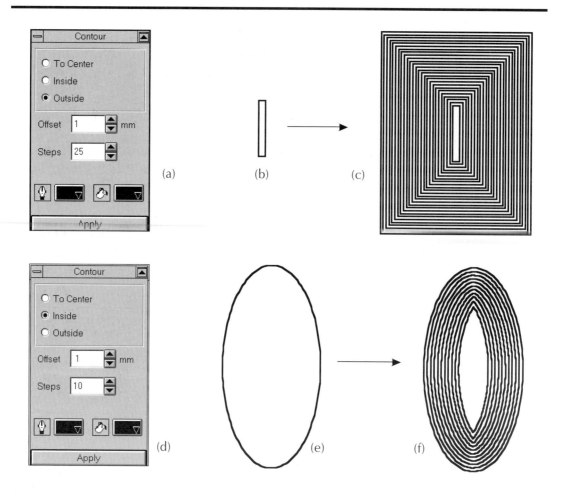

Figure 7.26 Basic contour effects

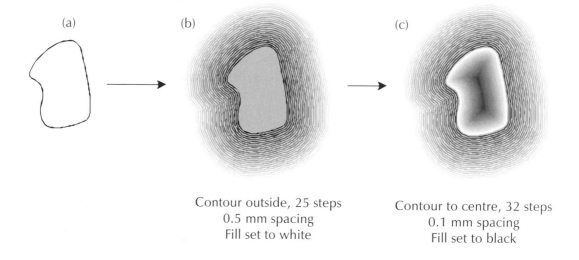

Contour outside, 25 steps
0.5 mm spacing
Fill set to white

Contour to centre, 32 steps
0.1 mm spacing
Fill set to black

Figure 7.27 Applying contours to both the inside and the outside of an object

was then separated using Arrange/Separate and the original central object was reselected and given a fill of white and an outline of None; the outline and fill settings in the dialog box were set to black and the contour type set to *Centre*, giving the result in (c).

It is also possible to apply contours to more complex shapes than those in Figures 7.26 and 7.27. Figure 7.28, for example, shows that even curves which include crossovers and combined objects, like a string of text characters, can be successfully contoured. Although contouring a set of grouped objects is not possible, objects which consist of a set of combined paths can be contoured, although the results can sometimes be unpredictable and some experimentation may be needed to achieve a particular effect. Figure 7.29 shows a number of examples. The original objects are arranged in the first column. Objects in the second column were derived from these in the first column, using the Contour Inside or Contour Centre options, using the settings indicated next to each of the objects. Objects in the column on the right were derived from those in the first column, using the Contour Outside option and using the settings indicated.

Painting and photoediting applications like Photoshop have no directly equivalent function to vector contouring, but borders can be applied to the inside and/or outside selections to give a similar effect. Figure 7.30 shows some examples created in Photoshop. The cloverleaf example in (a) was created by drawing the cloverleaf, feathering the selection to 2 pixels, then giving it a 5-pixel black stroke, using Photoshop's Edit/Stroke command (Figure 7.31a). The selection was then contracted by 5 pixels using the Select/Modify/Contract command (Figure 7.31b) and this time given a 5-pixel stroke of 80% grey. This sequence was repeated three more times, adding strokes

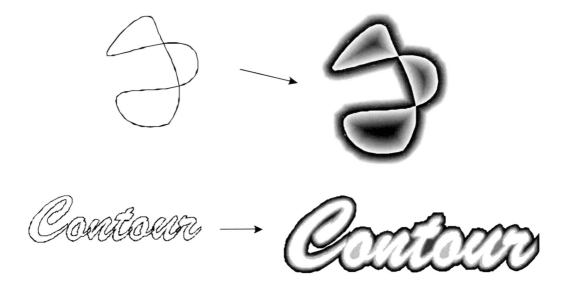

Figure 7.28 Contouring complex curved shapes

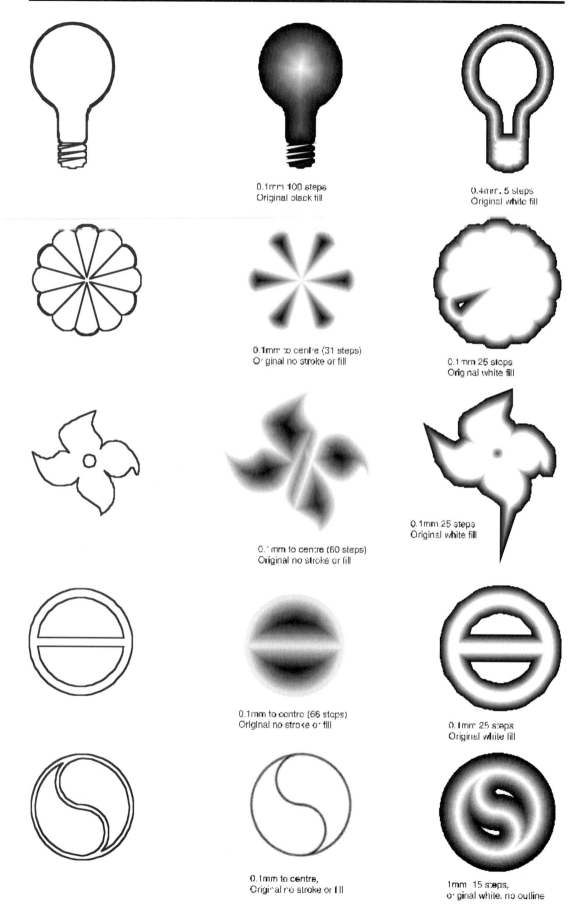

Figure 7.29 *Contouring combined curves*

of 60%, 40% and 20% grey. The initial feathering of the selection helped to merge the strokes together, giving the result shown.

To create Figure 7.30b, a copy of the original cloverleaf selection was feathered to 5 pixels, given a 30% grey fill and then a black stroke of 5 pixels. The result in Figure 7.30c was produced using the reverse of the process used for Figure 7.30a; another copy of the original selection was feathered to 2 pixels, filled with black and given an 80% grey stroke; the selection was then expanded by 5 pixels and given a 60% grey stroke and so on.

The same kind of technique can be applied to more complex objects like the text in Figure 7.30d. In this case the text was first given a 5-pixel black stroke, then the selection was expanded by 5 pixels. A 5-pixel feather was applied to the expanded selection and it was then given a 30% grey stroke of 5 pixels, producing the result shown in Figure 7.30e.

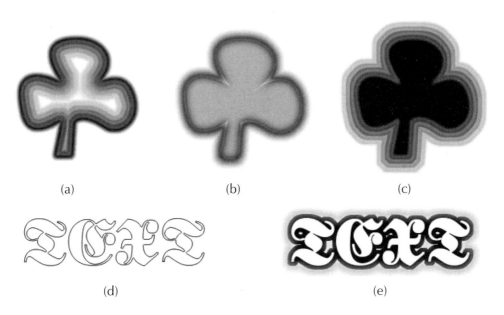

(a) (b) (c)

(d) (e)

Figure 7.30 *Contouring in Photoshop*

Figure 7.31 *Photoshop stroke controls*

8

Perspective and Enveloping

Perspective

Artistic perspective involves the use of special techniques to trick the viewer's eye into 'seeing' three-dimensional spatial relationships on a two-dimensional surface—in our case a monitor screen or printout. The three main categories of perspective are linear perspective, in which lines converge as they approach the horizon; visual perspective, in which depth is implied by overlapping objects and by making 'distant' objects smaller; and aerial perspective, in which distant objects become fainter and outlines gradually fade. In addition to these three categories, or graphic 'cues', the use of shading and shadows to simulate the varying intensity of light reflecting from the different surfaces of an object can create a powerful spatial illusion.

Failure to apply the mathematical laws of perspective—which were developed as early as the beginning of the fifteenth century by the Italian architect Filippo Brunelleschi—is nowhere better illustrated than in William Hogarth's frontispiece to 'Kirby's Perspective', a 1754 engraving (Figure 8.1) which is well worth a few moments study (don't miss the backpacker on the hilltop getting a light from the old lady hanging out of the window!).

Simple projection effects can be created in drawing, painting and three-dimensional applications. Once again, we shall start by looking at the effects obtainable in vector drawing applications. The simplest, but crudest, way of creating a projection is by applying skew or shear to an object. Figure 8.2 shows an example; first, three squares (a), (b) and (c) were drawn in CorelDRAW and aligned as on the left; next, square (a) was double selected in order to display the skew function and the square was skewed 45° south; square (b) was then selected, double-clicked and skewed 45° west, so that its edge aligned with that of (a). With these simple steps, we have created a simple 'oblique' projection, with the appearance of depth, which can be further enhanced, as in the copy on the right, by shading the three 'faces'.

Figure 8.3 shows a slightly more complex object created in a similar way. The end wall (a) was drawn first and then skewed north 30°. Each section of the

roof was then drawn and skewed into position to align with the end wall. The first window was drawn and grouped and the whole group was skewed to align with the angle of the roof. A copy was made and positioned at the other side of the roof, and so on, producing (b). The whole building was then grouped and a copy was scaled and rotated. Grey tone fills were applied to the components of the copy, providing the result in (c).

The above example is the simplest of a whole family of projection types which include axonometric, dimetric, trimetric and isometric—the most common. These projections are created by the application of precisely defined shearing, scaling and rotational characteristics to an object. For example, the parameters required for an isometric projection are shown in Table 8.1. Figure 8.4 shows how simple it is to use these parameters to create an object like a product package. The top, front and side of the object are first laid out in

Figure 8.1 *How not to apply perspective!*

two dimensions (Figure 8.4a). Graphics and text are then added in the correct orientation and each face is grouped with its contents (Figure 8.4b). All three faces and their contents are then selected and scaled vertically to 86.602% of their original height (see Table 8.1). Next the top face is selected and sheared 30° horizontally and then rotated 30° about the centre of rotation (Figure 8.4c). Finally, the front and side faces are selected in turn and each of them sheared 30° and rotated 30°, producing the result in Figure 8.4d.

Such projection techniques produce objects which, at first glance, appear to be in perspective, but, in fact, are not consistent with observation in real life as they have parallel sides. When we stand on top of a building and look down over the edge, the sides of the building appear not to be parallel, but to converge. Micrografx Designer provides a simple way of applying a more realistic perspective to isometric projections, as shown in the example in Figure 8.5; after selecting the three-dimensional tool from the Micrografx toolbox and choosing a three-dimensional object from the library, such as the cuboid to the bottom left, the perspective slider can be used to modify the parallelism of the sides of the object; moving the slider to 25%, 50% and 100% produced the results shown. When a group of objects is created in this way, using a high percentage (Figure 8.6), the convergence of the sides of the buildings towards a vanishing point becomes apparent.

Figure 8.2 *Using skew to create a crude form of oblique perspective*

Figure 8.3 *Using skew to build a simple perspective object*

Designer can also generate extrusions to which a vanishing point perspective can be applied (Figures 8.7 and 8.8). The toolbar at the top of Figure 8.7 shows the extrusion tool selected and the four isometric and one oblique extrusion buttons displayed. In Figure 8.7, two copies of a kitchen cabinet face were made and then the first was extruded to the left and the second was extruded to the right, both in wireframe mode. The same degree of perspective was then applied to each extrusion, using the perspective slider.

In Figure 8.8 a cross-section of a barn was first drawn and extruded to the left. Then, Perspective was applied and shading was added to the appropriate faces to enhance the illusion of three dimensions.

Table 8.1 *Parameters needed to create isometric projections*

Isometric view	θ	φ	Face	Vertical Scale	Horizontal Shear	Rotation
			Top	86.602%	30°	– 30°
	30°	30°	Front	86.602%	– 30°	– 30°
			Side	86.602%	30°	30°

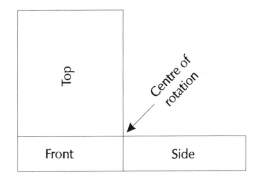

Figure 8.4 *Producing an isometric display box*

More complex extrusions can be created using grouped objects, such as the array of squares or the group of jigsaw pieces in Figure 8.9.

Figure 8.10 shows the perspective technique included with CorelDRAW. A copy of the letter P in (a) was made and Effects/Apply Perspective was selected, causing a dotted outline to appear around it with perspective handles at each of the four corners, as in (b). Using the mouse, the top right-hand handle was dragged upwards and to the right producing the distorted form shown in (c); next, the bottom right-hand handle was dragged upwards and to the right by an equal amount, producing the result in (d).

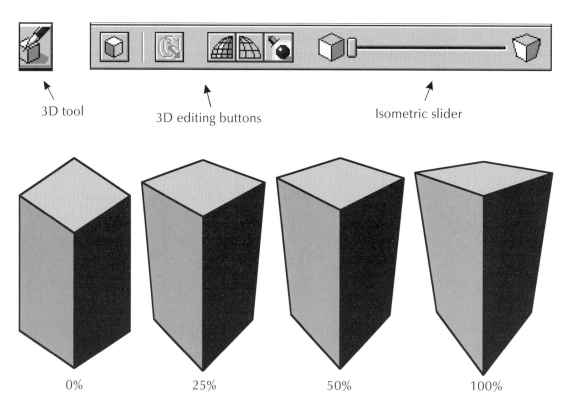

Figure 8.5 *Perspective slider applied to isometric projection in Micrografx Designer*

Figure 8.6 *Exaggerated perspective view*

Another copy of the letter P was made (e) and Effects/Apply Perspective was again applied to produce (f); this time the top right handle and then the top left handle were dragged down and to the right, producing the result in (g).

Using these simple, basic techniques, it is possible to apply perspective to a wide range of two-dimensional objects. In Figure 8.10h, three copies of the

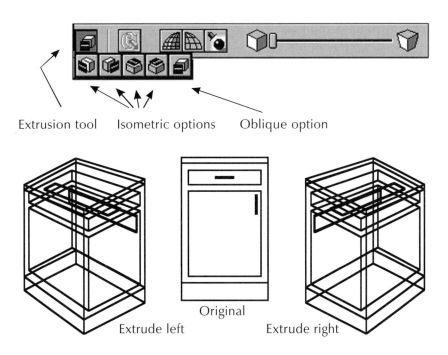

Extrusion tool Isometric options Oblique option

Extrude left Original Extrude right

Figure 8.7 Combining isometric extrusion and perspective

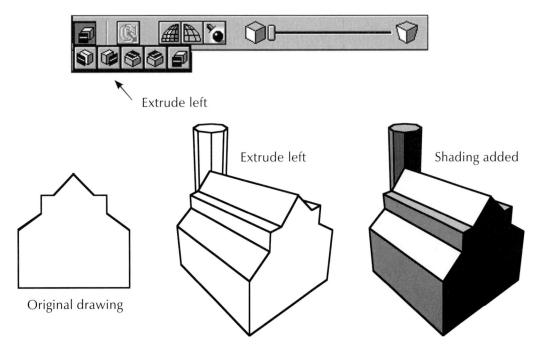

Extrude left

Extrude left Shading added

Original drawing

Figure 8.8 Adding the effect of shading

same letter have been 'mapped' on to three faces of a cube. The edges of the cube were first extrapolated to define the perspective vanishing point x; the copy of the letter on the right-hand face was then manipulated as in the examples (c) and (d) above, care being taken to ensure that the appropriate edges of the dotted bounding box projected towards the vanishing point, such that they also would intersect at that point; similar treatment was then applied to the copy of the letter on the top face of the cube. Figure 8.10 is an example of 'single point perspective', with all straight edges in the drawing converging towards a single vanishing point. Figure 8.11 shows two examples of two-point perspective, in which lines converge towards two different vanishing points.

A valuable aid in the creation of perspective drawings is provided by vector applications which offer layering. Guidelines can be drawn on their own non-printing layer and given a colour which distinguishes them from the colours being used on the main drawing layer, significantly facilitating the construction process.

Perspective can be applied to complex groups as well as to simple objects like the type characters in Figure 8.10. In Figure 8.12, Perspective has been applied to the figure of the dog to achieve two different effects. First of all a copy of the dog was enlarged to fit approximately the area of the projection screen and then Effects/Apply Perspective was applied to the copy. Using the method explained earlier and used to create Figure 8.10, each of the four

Figure 8.9 *Perspective applied to two isometric extrusions*

Figure 8.10 *Applying perspective in CorelDRAW*

handles of the copy was then dragged in turn to adjust the perspective of the dog, so that the appearance of the image became consistent with the angled position of the screen. A second copy of the dog was then made and the fill was altered to 20% grey, with no outline. Perspective was then applied to this copy and first the top right and then the top left handles were dragged until the shape of the copy appeared as shown in Figure 8.12.

Figure 8.11 *Examples of two-point perspective*

Figure 8.12 *Using perspective for alignment and shadowing*

Arrange/Order/To Back was applied to move the grey copy behind the original image of the dog, giving it the appearance of a shadow cast by the dog.

As we saw in the previous chapter—in the aeroplane example—the impression of perspective can be created using the Blend feature. Figure 8.13 shows another example of how this is done. Starting from the single guardsman in (a), two copies were made and a five-step blend was created between them, giving us the row of seven guardsmen in (b). The Split command was then used to split the blend in the centre of the row and the central figure was dragged forward; each of the figures on the ends of the row was then selected and scaled in size to 50% of the original producing the result shown in (c).

Figure 8.14 shows how simple building blocks can be used to produce more complex perspective structure. The Bezier drawing tool was first used to create the irregular looking slab in (a). (Note: the outer perimeter shape was initially given a fill of white so that it would obscure any underlying objects during the building process.) A copy of (a) was then simplified by deleting some lines and reducing the size of the outer perimeter, to create the smaller slab in (b). The abstract structure in (c) was then created step by step by applying perspective to a series of copies of these two components. The main 'terrace' area was first created by applying perspective to an enlarged copy

Figure 8.13 Using Blend to create perspective

of (a) and then the front steps were added by applying perspective to two copies of (b). Each of the top 'boxes' was created using four copies of (a), with each being shaped with the perspective handles and placed in position to align with the same vanishing point as that used for the terrace and steps. Filling the components with different grey tones (and a gradient fill in the case of the terrace and steps) further enhanced the final result. Using such an approach, quite complex structures can be built from simple building blocks.

Figures 8.15 and 8.16 show two simple examples of 'aerial perspective' in which the illusion of distance is created by mimicking what we see in nature—that nearer objects appear more distinct, while more distant objects appear fainter, with less distinct outlines. By exaggerating the effect in Figure 8.15, the progressively lighter silhouetted figures appear to be occupying successively distant rows. Figure 8.16 emulates a more commonly observed example of aerial perspective; diminishing tones have been used here to make the mountains in the background appear more distant than those in the foreground.

Figure 8.14 Using Perspective to build structures from simple building blocks

Figure 8.15 Aerial perspective

Figure 8.16 Aerial perspective–another example

Painting applications like Photoshop also provide the means of applying perspective effects to bitmapped objects. The object to which perspective is to be applied is first selected and then Effects is chosen from the Image menu (Figure 8.17a). From the Effects menu, choosing either Perspective or Distort causes handles to appear at the four corners of the selection. For example, dragging the corners of the image in Figure 8.17b can produce the effect shown in Figure 8.17c (in this case using the Distort option). More controlled results can be obtained by first creating a template with the desired perspective effect, such as the example shown in Figure 8.17d, which was drawn in CorelDRAW. After importing the template into Photoshop via the clipboard and scaling it to the required size, a copy of the image in Figure 8.17b was dragged on top of the right-hand side of the template; while the image was still selected, Image/Effects/Distortion was selected and the four corner handles of the image were dragged into alignment with the corresponding corners of the template. A second copy of the image was then dragged on top of the left-hand side of the template and the process repeated. The template was then deleted, producing the result in Figure 8.17e.

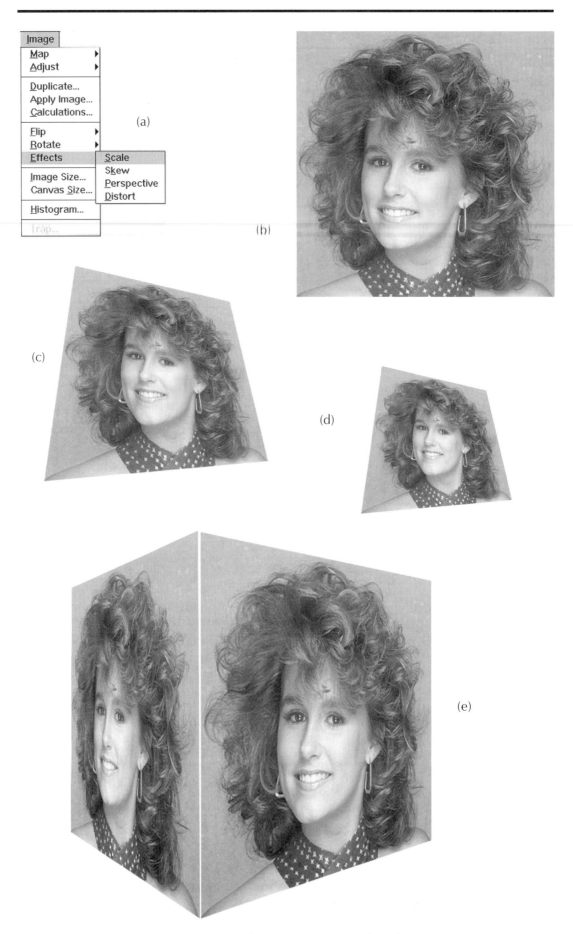

Figure 8.17 *Applying Perspective in Photoshop*

Fractal Painter and Corel PHOTO-PAINT also provide image perspective controls (via Effects/Orientation/Distort in the case of Painter—Figure 8.18a—and via Effects/Transformations/Perspective or 3D Rotate in the case of PHOTO-PAINT—Figure 8.18b). PHOTO-PAINT also provides particularly useful preview windows in which successive changes can be made before the effect is applied to the original image (Figure 8.19).

These perspective features can be very useful in photomontage work (about which more later), when it becomes necessary to place an image captured

Figure 8.18 *Perspective controls in Painter (a) and PHOTO-PAINT (b)*

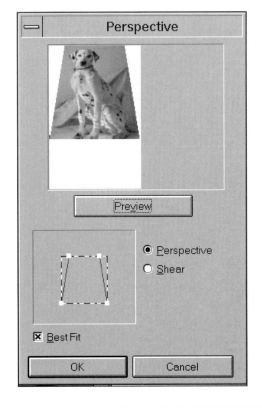

Figure 8.19 *PHOTO-PAINT's Preview facilities*

with one perspective into a setting with a different perspective. An example is shown in Figure 8.20. The original beach image was shot with a direct frontal elevation (Figure 8.20a), while the monitor screen on which the image is to appear, is turned at an angle of approximately 45° and viewed slightly from above (Figure 8.20b).

To produce the final result in Figure 8.20c, a copy of the clipart monitor was first imported from CorelDRAW into Photoshop, followed by a photolibrary image of the beach scene, which was first scaled to match the size of the screen. The *Distort* feature was then used, as described earlier, to align the four positioning handles to the corners of the screen bezel. A second copy of the screen bezel was then imported from an Ungrouped copy of the monitor and overlayed on to the adjusted beach image to conceal the square corners.

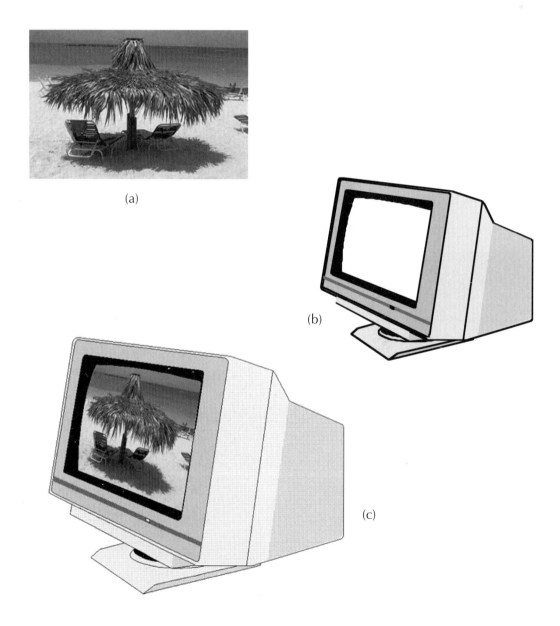

(a)

(b)

(c)

Figure 8.20 *Perspective editing and composition*

Three-dimensional applications can also be used to create powerful perspective illusions of both individual objects and combinations of objects. Figure 8.21 shows a simple isometric scene created in Ray Dream Designer, consisting of a floor-standing lamp, a table and a chair. During its creation, the scene is viewed through the lens of a virtual 'camera' placed in a default position. Once the scene has been created, the position of the camera can be adjusted via the Camera Settings dialog box (Figure 8.22a) which provides panning and tracking controls. Alternatively, the camera placement can be adjusted by entering coordinates in a second Numerical Settings dialog box (Figure 8.22b).

Examples of the different perspective views of the original scene in Figure 8.21 resulting from successive changes in the camera position are shown in Figure 8.22 c, d and e. Care in choosing suitable coordinates is necessary to avoid distortion of the image, which can occur, as seen in Figure 8.22e.

Realism of the perspective illusion can be further enhanced in three-dimensional programs by careful setting of both ambient and local lighting to illuminate the scene before final rendering of the image takes place.

Figure 8.21 A simple isometric scene constructed in Ray Dream Designer

Tracking and zooming controls

Rotation and panning controls

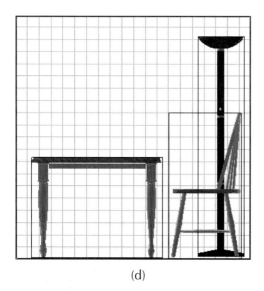

(d)

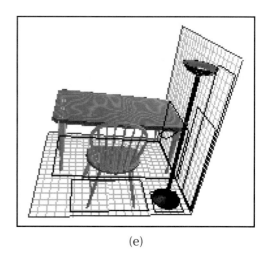

(e)

Figure 8.22 *Using camera controls to adjust perspective views*

Enveloping

We have seen how it is possible to manipulate the boundaries of images to give the impression that they are being viewed from different perspectives. Enveloping is a more general technique which involves manipulating image boundaries in order to constrain the image to conform to a particular shape or 'envelope'. Enveloping function can be found in specific plug-ins like Letraset's Envelopes, which works with Illustrator or Freelance, or as a built-in feature of CorelDRAW. Figure 8.23a shows the CorelDRAW Envelope dialog box; the object to be 'enveloped' is first selected and then one of three options is chosen from the dialog box:

Figure 8.23 Using CoreDRAW's Envelope feature

Add New places a dotted outline around the selected object, with manipulation handles at the corners which can be dragged to create the required envelope shape. Clicking Apply then causes the selected object to reflow to conform to the shape of the envelope

Add Preset provides a menu of simple geometric shapes, such as circles, rectangles and stars which can be used as ready made envelopes

Before using Create From, the user first draws or imports the shape to be used as an envelope. Choosing Create From then turns the mouse cursor into a black selection arrow. Positioning this arrow anywhere on the envelope and clicking then causes the original selection to reflow to the shape of the envelope

In graphic composition, probably the most common use of the envelope feature is in the reflowing of text to conform to an object's shape. This shape can vary from a simple single closed curve in the form of a circle to a more complex shape like a piece of clipart (Figure 8.23b, c, d and e). When the outline becomes too complex—e.g. the tail and horns of the bull in Figure 8.23b—then distortion of the text can occur; this can be rectified by point editing the envelope outline using the Bezier tool to confine the reflow to the principal shape of the envelope.

Another common application is to reflow the individual characters of a single word or text string into a series of repeated envelope shapes, e.g. the footballs in Figure 8.24.

As well as its use for creating interesting text effects, enveloping can also be applied to more complex, grouped graphic objects, producing results at times interesting, at times bizarre and at times just plain unpredictable! Figure 8.25 shows an example in which a circular envelope was applied to a simple XY grid using two different Envelope settings. With the Putty setting, conformance of the grid with the circular envelope was very close; with the Horizontal setting, not only were the horizontal lines maintained—the purpose of the Horizontal setting—but the final shape was more like the section of a spinning top than a circle.

Figure 8.26 shows the effect of applying the same circular envelope to a symmetrical array of black spots, using the Putty setting. The result creates the illusion that the spots have been applied to the surface of a sphere, the effect being further enhanced when a higher density array of spots is used.

Enveloping can be extended to still more complex objects, like grouped and filled drawings. Figure 8.27 shows the effect of selecting the clipart Union Jack in (a) and applying to it the envelope shown in (b); the result—Figure 8.27c is a reasonable simulation of the flag blowing gently in the breeze. Close examination shows that compliance to the target shape, while reasonable, is not perfect. To improve conformance, the result can be ungrouped and individual elements can be node edited as mentioned earlier.

Figure 8.24 Multiple envelopes

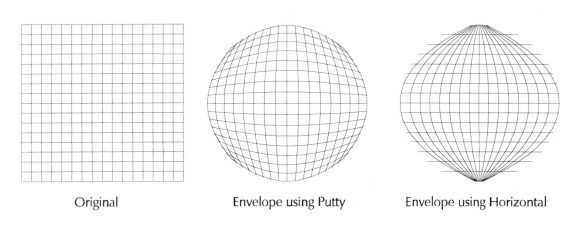

Original Envelope using Putty Envelope using Horizontal

Figure 8.25 **Enveloping a grid**

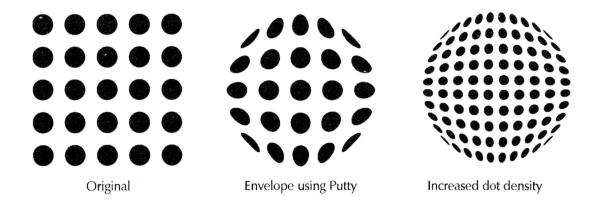

Original Envelope using Putty Increased dot density

Figure 8.26 **Enveloping an array**

Should the day arise when a well-known canned food manufacturer decides to use the image of a well-known Lady to promote a new product, then Figure 8.28 shows how a simple vector image can be 'enveloped' on to different sized labels to suit different sizes and shapes of can.

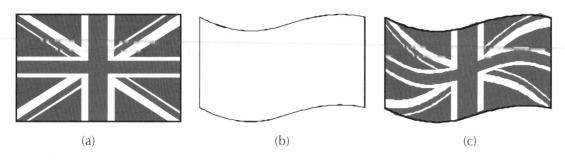

(a) (b) (c)

Figure 8.27 Waving the flag

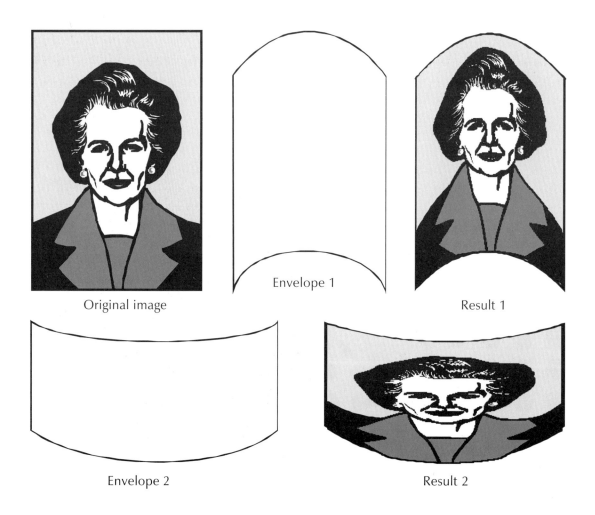

Original image Envelope 1 Result 1

Envelope 2 Result 2

Figure 8.28 The 58th variety?

Enveloping can also be used to create whole new views of our planet. The British view, for example—and probably the only one holding out some hope of the World Cup returning to these shores—is shown in Figure 8.29. The clipart map of the British Isles was first selected and a simple circular envelope was applied to it. A copy of the result was made, filled with black and placed behind the original to create a sense of depth. The two copies were then grouped and placed on top of a circle which was first given a radial fill.

Neither painting nor three-dimensional applications provide a function directly equivalent to that of Enveloping in vector applications. The nearest equivalent, though much more limited, function is to be found among the painting application's Distortion settings. Figure 8.30 shows an example from Photoshop. The function employed—Spherise—was first selected from Photoshop's Filter/Distort menu (Figure 8.30a) and applied to the image of the gentleman on the right (Figure 8.30b).

Clicking on Spherise opened the dialog box in Figure 8.30c which showed a preview of the effect on the image as the slider was moved between settings −100% and +100%, with positive values having the effect of wrapping the image around a sphere. The image resulting from the settings in Figure 8.30c was placed on top of a radial fountain-filled circle to create the result in Figure 8.30d. As well as spherical distortion, the same dialog box can be used to create either vertical or horizontal cylindrical distortion. The settings in Figure 8.30e created such an image which was placed on the cylinder in Figure 8.30f.

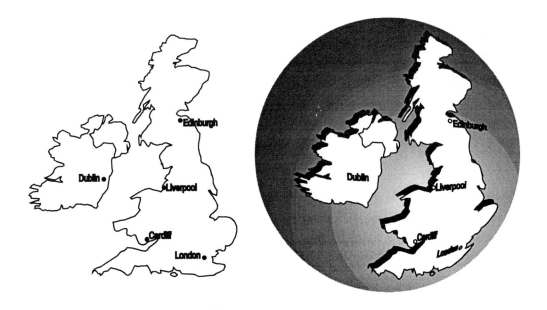

Figure 8.29 The new world order!

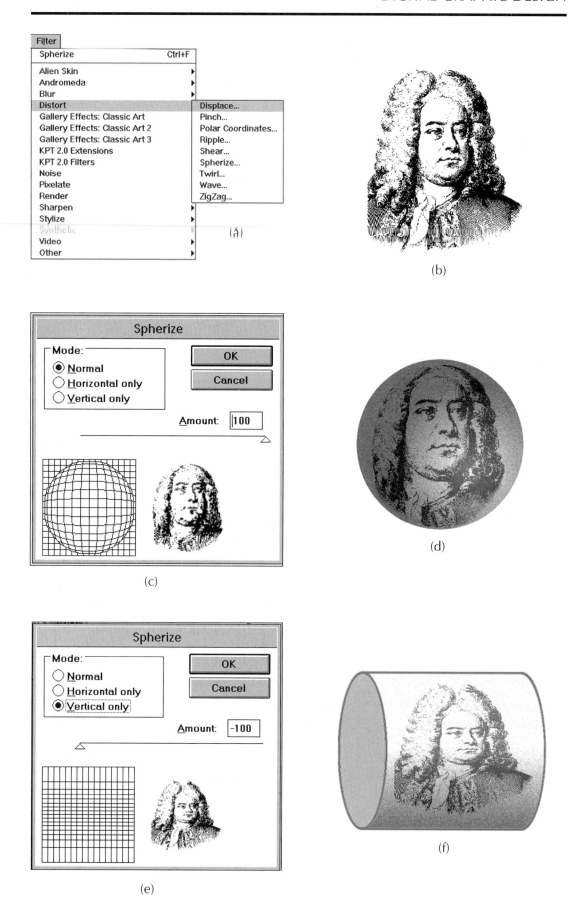

Figure 8.30 *Enveloping an image in Photoshop*

Painter's Image Warping feature can also be used to create spherical envelopes, although the method is less controllable than that of Photoshop. After the target image has been selected, Surface Control/Image Warp is chosen from Painter's Effects menu (Figure 8.31a), causing a thumbnail of the selected image to appear in the preview window of the Image Warp dialog box (Figure 8.31a). Using the Spherise option, the mouse pointer is then positioned in the preview window and dragged to create a circle; on releasing the mouse button, the part of the image which was contained by the circle preview image then reflows, as if mapped on to a spherical surface (Figure 8.31c). The effect produced can be altered by positioning the slider in the dialog box; the result is also quite sensitive to the exact positioning of the circle drawn with the mouse, so some trial and error is necessary to produce an acceptable result. Once the result is satisfactory, clicking on OK applies the effect to the image (Figure 8.31d).

To obtain the final result in Figure 8.31e, a circular mask was used to encircle the spherised part of the image which was then copied and pasted into a new window. The white ellipses help to reinforce the impression that they and the image lie on the surface of a sphere.

Another example is shown in Figure 8.32. First the image of the girl's head was separated from its original background, using the lasso selection tool (Figure 8.32a), pasted into a new window and selected. Then Image Warp was selected from the Effects/Surface Control menu (Figure 8.32b). With the Spherise option selected and the slider set to 100%, the mouse pointer was positioned to the right of the girl's head and dragged horizontally until it reached the left side; when it was released, the image reflowed as shown in Figure 8.32c. The process was then repeated, but this time the mouse cursor was dragged from left to right, producing the image shown in Figure 8.32d.

In this case, the method used to reinforce the spherical illusion was first to create a wirenet sphere in Micrografx Designer, using its three-dimensional tools. The sphere was exported from Designer in Adobe Illustrator format, so that it could then be placed on the Background Layer within a new Photoshop file. The two images of the girl, which had been saved from Painter in Tiff format, were then imported to Layers 1 and 2 of the same Photoshop file, using a transparent background setting, so that the grid lines would show through between and around the two images. Layer 1 was then selected and the opacity of the image was reduced to 80% to allow some 'show through' of the underlying grid. Layer 2 was then selected and the opacity of the second image was also reduced to 80%, creating the result shown in Figure 8.32e.

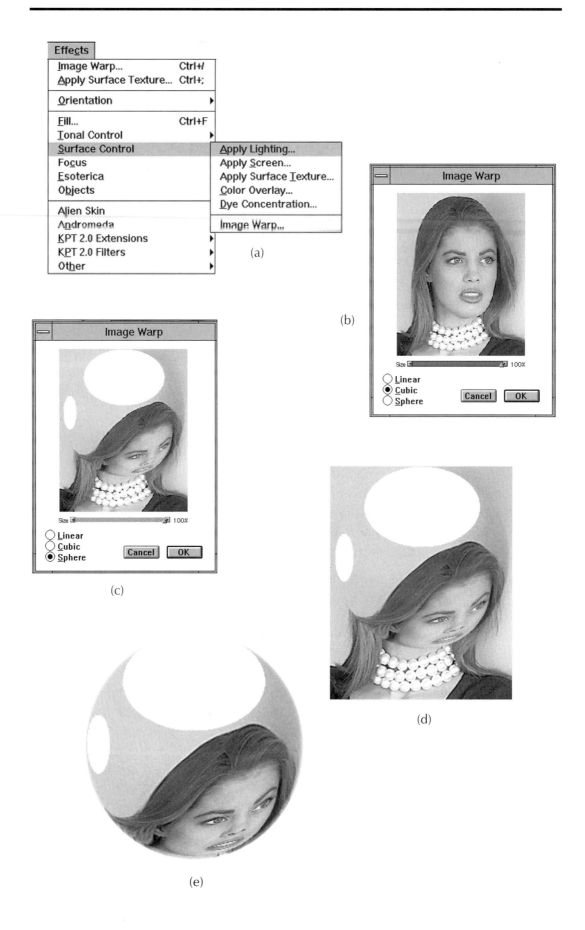

Figure 8.31 Spherical image distortion in Painter

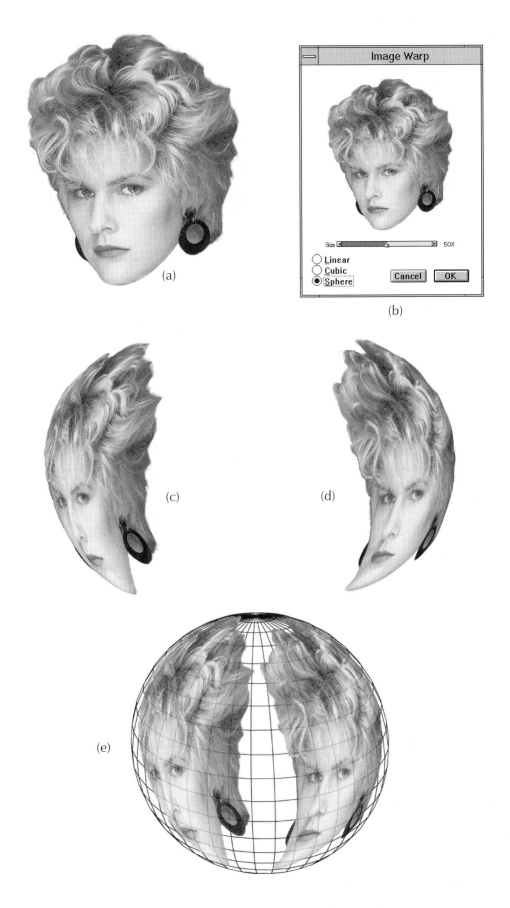

Figure 8.32 *Creating a composite image*

9

Three-Dimensional Effects

Already in previous chapters—and particularly in the Perspective section of the last chapter—we have seen some examples of methods which can be used to create the illusion of three-dimensional objects or scenes on a two-dimensional surface. The purpose of this chapter is to investigate more fully how such effects can be produced, using not only drawing and painting applications, but also by exploring the more sophisticated features of a custom designed three-dimensional application.

Many drawing applications offer the capability of creating simple three-dimensional effects by the extrusion of two-dimensional vector shapes. Figure 9.1 shows the principal extrusion dialog boxes provided by CorelDRAW. Extrusion type, vanishing point attributes and depth are set in box (a); once created, dialog box (b) allows an extrusion to be rotated in pseudo three-dimensional space either by clicking on the arrows shown or, alternatively, by typing in precise angular rotations for each of the three axes; dialog box (c) allows independent positioning of three different light sources and colours.

Figure 9.2 shows the result of extruding a series of simple geometric outlines. After an outline has been drawn, and before it is extruded, its vanishing point can be set to correspond with that of another extruded object. In Figure 9.2, this feature was used to specify a common vanishing point for all outlines. The fill of the extruded shape can be specified as either a solid colour or a gradient, independent of the fill, if any, of the original shape. In Figure 9.3 a series of circles were extruded to form cylinders with the same vanishing point (the intersection of the dotted lines). The three-dimensional effect of the composition was enhanced by varying the size of the cylinders to give an impression of depth, by giving them a graduated fill and by causing some of the 'nearer' cylinders to overlap more 'distant' ones. A particularly helpful feature of CorelDRAW when manipulating an extrusion—e.g. altering its position or size—is that it redraws such that its original vanishing point is maintained.

More complex compound objects can also be extruded successfully; Figure 9.4 shows a simple 'rotor blade' section after extrusion (a), then rotation (b) and finally with a gradient fill applied to enhance the result (c).

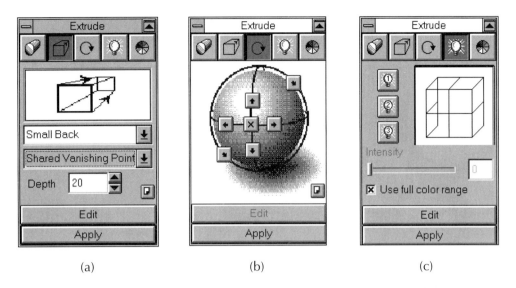

Figure 9.1 *CorelDRAW's extrusion dialog boxes*

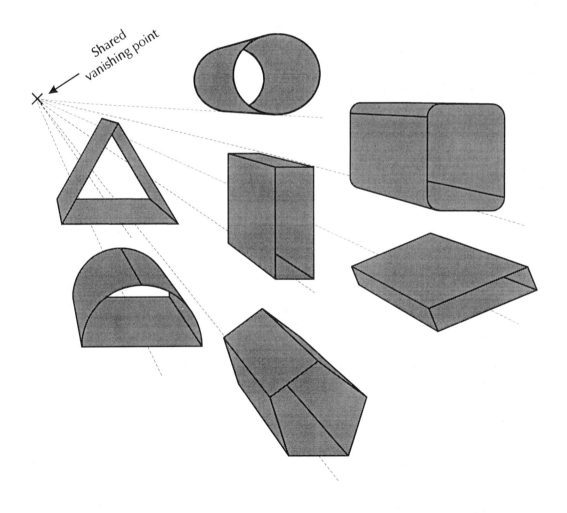

Figure 9.2 *Creating a composite image*

Figure 9.3 *Applying a graduated fill*

(a) (b) (c)

Figure 9.4 *Extruding and rotating a compound object*

When the two-dimensional object to be extruded is compound—made by combining two or more separate objects—then parts of the extrusion appear to have been cut out from the solid; Figure 9.5 shows the result of extruding such a compound starting object, consisting, in this case, of two small circles and a rectangle place within the perimeter of a larger circle (a) and then rotated to two different positions (b) and (c). The cutouts act as masks, allowing objects placed behind to show through.

The show through feature was used in creating the composition in Figure 9.6. First, a compound group was created from an outline of the front view of the Mini superimposed on a square representing a wall. After applying the brick fill, extruding punched the shape of the Mini through the wall. Finally, the policeman was placed behind the cutout and rotated into the position shown.

(a) (b) (c)

Figure 9.5 Creating cutouts

Figure 9.6 Using a cutout in a simple composition

It is not necessary for combined objects to overlap or be in contact for extrusion to be successful. Figure 9.7 shows the result (a, b) of extruding a series of small trapezoids set in an annular ring, while (c, d) shows the effect of extruding a series of filled squares.

As mentioned earlier, after extrusion an object can be rotated to a precise angle by typing in the angles of rotation around the X, Y and Z axes. Figure 9.8 shows a series of seven views of a gear wheel obtained in this way. The original two-dimensional view on the left was extruded and then rotated 30° about the vertical (Y) axis to create the second view; the second view was then duplicated, using Edit/Duplicate and rotated by a further 30°; this sequence was repeated five more times until the wheel had been rotated by a full 180°. To obtain the effect of positioning the copies along a path, the Preferences dialog box was used to set the required offset coordinates before the duplicates were made.

Figure 9.7 *Extruding unconnected objects*

Figure 9.8 *Rotating an extrusion along a curve*

The rotational feature was used again in producing the three-dimensional effect in Figure 9.9. The outline map of Ireland was first given a solid 30% grey fill and its outline was given a colour of None; it was then extruded to a depth of 2, with the vanishing point set to the bottom right corner of its selection rectangle. After reselection it was rotated 5°about its horizontal (X) axis, tilting it away from the viewer. Finally, the extrusion was given a graduated fill, once again with the outline colour set to None.

More complex structures can be created by building assemblies of separate extruded objects. For example, each of the guns in Figure 9.10 was built from three different components—two solid cylinders of different diameters and one hollow cylinder, all sharing the same vanishing point. Placing a simple armoured personnel carrier behind the guns, using Arrange/Order/ To Back commands produced a formidable looking hybrid!

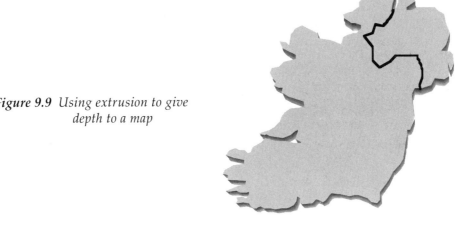

Figure 9.9 *Using extrusion to give depth to a map*

Figure 9.10 *Building extrusions into assemblies*

As well as providing the tools for creating the kind of extrusion types described above, CorelDRAW provides a library of Preset extrusions—templates for use by the busy users—which can be used to apply quite complex effects to two-dimensional objects like text. These templates are, in fact, recorded macros which store a sequence of object manipulation commands; when used on a new object, the selected preset template implements these sequential commands, applying to the new object the same effect as that demonstrated by the sample in the Preset dialog box.

The Preset dialog box is shown in Figure 9.11, which also shows a number of examples created by applying different presets to the text object 'Digital DESIGN'. While some interesting results can be obtained, it should be mentioned that some macros are quite complex, resulting in long screen redraw times. Printing can also be slow in some cases because of the large number of drawing objects created.

An application which specialises in producing extruded three-dimensional objects is Ray Dream's addDepth. Figure 9.12 shows its toolbox and Colour Style dialog box. two-dimensional objects can either be drawn in addDepth or imported from other drawing programs like Illustrator, Freehand or CorelDRAW. As in the case of Ray Dream's more fully featured program Designer, templates—called Wizards—provide a shortcut to achieving a quick result, offering a range of choices covering extrusion depth, angle and surface treatment.

As can be seen from the menu at the top left of the Colour Style dialog box in Figure 9.12, addDepth offers the ability to apply bevelled edges to extruded objects and also offers colour control of not only the front face and sides of the extrusion, as in CorelDRAW, but also independent control of the bevelled surfaces and the back face; each of the five surfaces can be assigned either a colour Fill and Stroke or a Shaded Fill (which responds to changes in the Light position) or a Graduated Fill or can be made Invisible. In addition, either the front or back faces can be filled with a Decal—a vector image imported from another drawing program; Figure 9.13 shows a .WMF clipart file of a crowd scene being applied as a Decal fill.

After an extrusion has been created and its surface attributes assigned, further dialog boxes—Figure 9.14—can be used to make fine adjustments to the depth of the extrusion or to the degree of bevelling, and to vary the position of a light source in relation to the extruded object. A Rotation tool—second from the left in the toolbox—can also be used to manipulate the extruded object, or copies of the object, in three-dimensional space after it has been created.

Figure 9.15 shows examples of the kind of results which can be obtained.

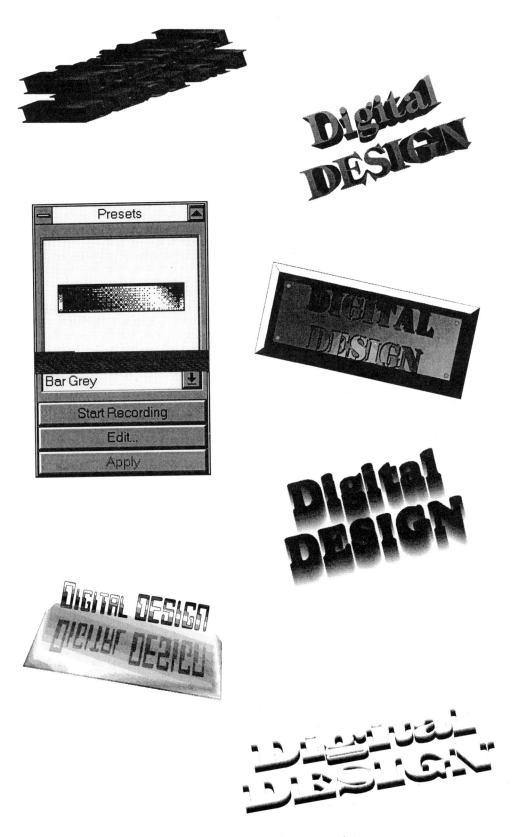

Figure 9.11 *Applying Preset templates*

Figure 9.12 addDepth's Toolbox (top) and Style dialog box (bottom)

Figure 9.13 Applying a Decal fill

Figure 9.14 The addDepth Geometry and Light Source dialog boxes

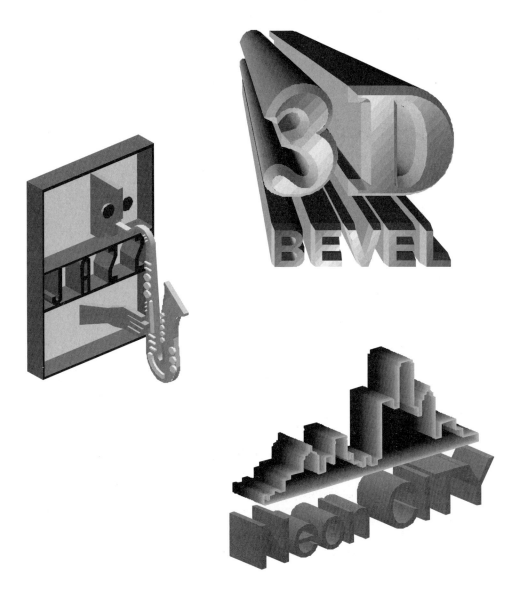

Figure 9.15 Some addDepth examples

Micrografx Designer Release 4.0 is another application which provides a fast and easy to use feature for employing either ready-made three-dimensional objects or for creating your own. The three-dimensional toolbox is shown in Figure 9.16; clicking the icon on the left of the top row opens the library of five basic three-dimensional objects shown as thumbnails in the second row. The toolbar also has a button which opens a menu offering a choice from three levels of precision when the object is drawn. Figure 9.17 shows a sphere, for example, drawn using the three different levels; the higher the precision selected, of course, the longer is the screen redraw and printing time.

Clicking on another button—the Shading control—opens another menu listing three choices for the smoothness of the surface shading. Figure 9.18 shows these three options applied to a cone; again, the smoother the shading, the longer the redraw and printing times.

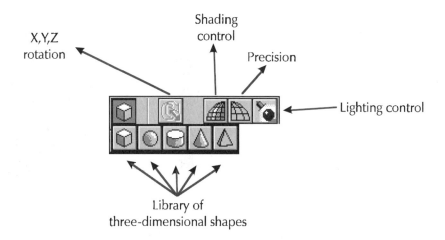

Figure 9.16 Designer's three-dimensional tools

Figure 9.17 Wireframe options

After an object has been created and scaled, with the required precision and shading attributes applied, clicking the X, Y, Z Rotation button causes three small squares to appear on the object, indicating three axes around which the object can be rotated. Four rotation handles also appear around the perimeter of the object. Rotation is accomplished by first clicking the square corresponding to the required axis of rotation, to select it, and then positioning the mouse cursor over one of the rotation handles and dragging until the required angle is reached. Figure 9.19 shows the result of rotating copies of a cylinder (a) around its X axis by 45°, 90°, 135° and 180° to positions (b), (c), (d) and (e) respectively.

Unshaded Shaded Smooth

Figure 9.18 *Shading options*

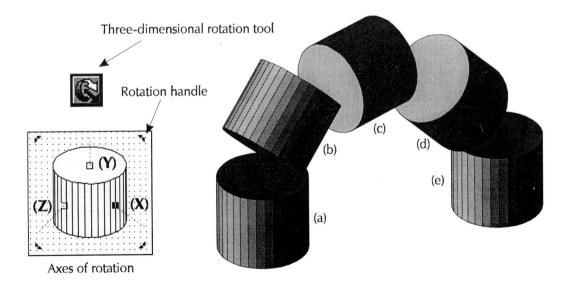

Figure 9.19 *Using the Rotation tool*

The last button on the toolbar gives access to the Lighting dialog box. Four sliders in the dialog box—see Figure 9.20—control the following variables:

The position of the light source relative to the front or back of the selected object

The intensity or brightness of the light falling on the object and the colour of the light

The highlighting or 'spread' of the light falling on the object

The ambience, or level of ambient light, illuminating the object and its colour

The actual position of the light source relative to a selected object is adjusted by dragging the small button at the top left of the preview window in the dialog box to the desired position; as the button is dragged, the effects are shown on the object thumbnail in the window.

To create the result shown in Figure 9.20, seven spheres were first drawn, scaled and positioned as shown. With X as the notional position of a light source, each sphere was then selected in turn and the Lighting button was dragged to the appropriate position in the preview window to correspond to the position of the light source relative to that sphere.

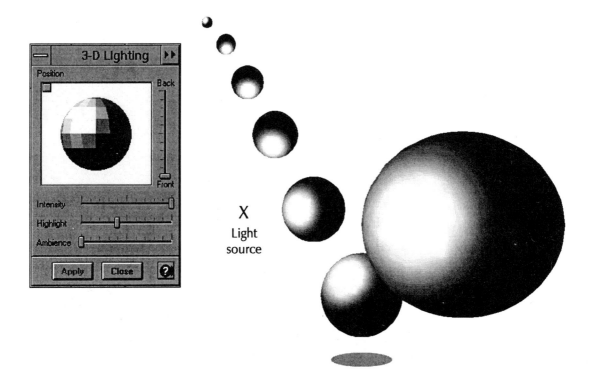

Figure 9.20 *Applying Lighting effects*

As well as using Designer's three-dimensional library components as they are, it is possible, using the Rotation tool, to assemble components to produce more complex objects, like the Heath Robinson-ish aeroplanes in Figure 9.21. These were built entirely from cylinders, cones and a single sphere as follows:

The wings, tail and fin were made from 'flattened' cylinders. (Note: any of the three square handles which appear when the Rotation tool is selected can be clicked and dragged to expand or contract the object along the selected axis)

Designer's Perspective slider was used to taper the fuselage

To make the cockpit canopy, a sphere was ungrouped and the unwanted lower elements were deleted

The various elements were scaled and rotated into position to make the final assembly, which was then grouped

Two copies were made, reduced in size, positioned behind the original and the black outline of the original was replaced with 40% grey

The process need not end with final assembly, as the grouped three-dimensional objects can be transferred to CorelDRAW via the clipboard and subjected to further contortions there! Figure 9.22, for example, shows two copies of the original, one converted into a Mk II supersonic version by means of applying the Perspective tool and the second showing definite signs of metal fatigue after an encounter with the Envelope tool. The Blend tool can also be applied; to produce the result in Figure 9.23, a copy of the original was scaled and placed in the upper right position; the original and copy were then selected and a two-copy blend was made between them, with angle of rotation set to −30°.

Figure 9.21 *Assembling three-dimensional components*

Figure 9.24 shows the result of a second assembly project. The head of the family, i.e. Mum, was first produced using a combination of spheres, cylinders and cuboids, suitably scaled, rotated, flattened and positioned as in the previous example. Three copies were then made and scaled to produce Dad and the kids, with Dad placed behind Mum and the two kids placed in the foreground to create a happy family group.

To create the swinging group in Figure 9.25, four copies of the original robot were made and pasted into CorelDRAW, where each was subjected to severe enveloping, using the freeform Add New option.

Perspective changes were also applied to three copies of the robot on the left of Figure 9.26, producing the results shown to the right.

Perspective Envelope

Figure 9.22 *Design modifications*

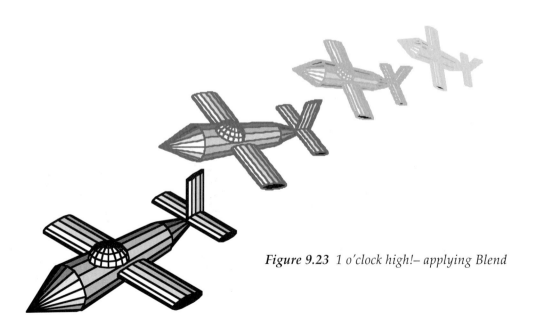

Figure 9.23 *1 o'clock high!– applying Blend*

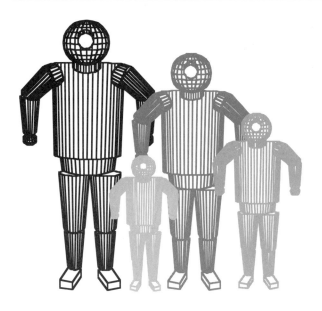

Figure 9.24 Family snapshot

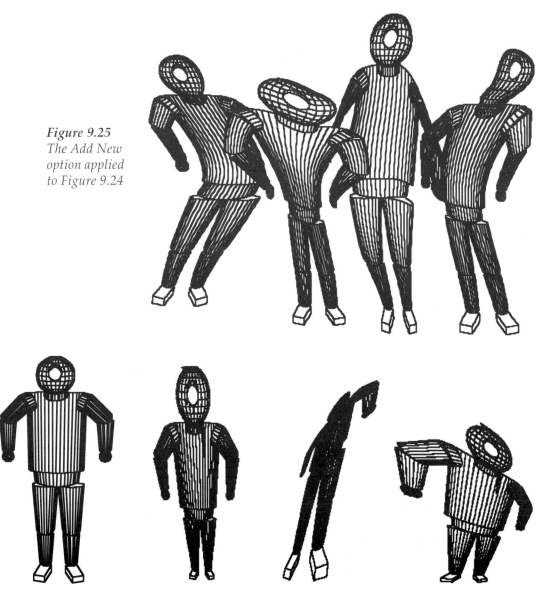

Figure 9.25
The Add New
option applied
to Figure 9.24

Figure 9.26 A sense of perspective

Of Designer's library of five basic three-dimensional objects (cuboid, sphere, cylinder, cone and pyramid), three (the sphere, cylinder and cone) can be produced by the process called 'lathing'—rotating a two-dimensional outline about a fixed axis. For example, a sphere can be produced by rotating a semicircle about its diameter. Next to extrusion, lathing can be considered as the second general technique for the production of three-dimensional objects.

As well as its library of basic components, Designer provides a tool for lathing both simple and complex objects. Figure 9.27 summarises the process. An outline (a) is first drawn using any combination of the drawing tools; the rotation tool (b) is then selected from the three-dimensional toolbox, causing a mirror image of the outline to appear (c) on the opposite side of an axis separating it from the original outline; clicking activates the lathing process producing, in this case, the 'wineglass' (d). Once created, a lathed object can be manipulated in three-dimensional space just like the objects from the library—see Figure 9.28—which reveals that the wineglass we have created does have a small design flaw; it is actually solid! To make our wineglass, or any other lathed object, hollow, we have to draw an outline which 'wraps back on itself'. Figure 9.29 shows such an example; the drawn outline is on the left, the resulting extrusion in the centre and the rotated copy on the right reveals the interior of the 'urn'.

Figure 9.30 shows how a toroid, or doughnut, can be created by lathing a circle; two copies were scaled and rotated into position for use in the assembly of a modern day penny farthing.

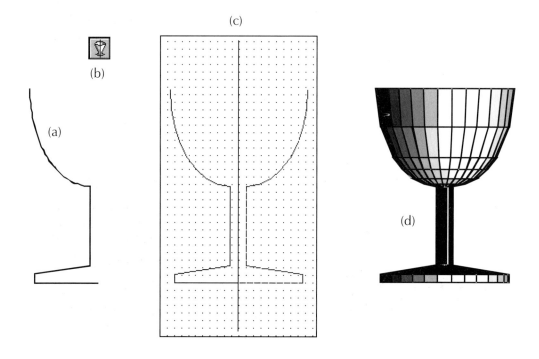

Figure 9.27 *Using the lathing tool*

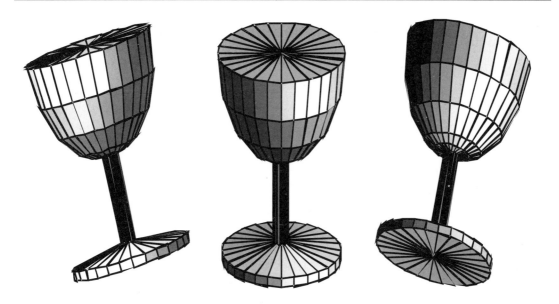

Figure 9.28 Manipulating a lathed object

Figure 9.29 Creating a 'hollow' lathe

Figure 9.30 A 'dune' penny-farthing

When used in building a graphic composition, a lathed object acts like any other drawing object when it comes to layering—i.e. setting the order of overlapping objects. For this reason, it would normally be impossible to place a component of the composition *inside* a three-dimensional object; Figure 9.31 illustrates a workaround method which can, however, achieve this effect.

The 'Ali Baba' urn (a) was first created in the usual way, using a wrapped outline as described earlier, and rotated forward to expose its open top. A clipart snake (b) was then scaled and positioned ready to be placed 'inside' the urn. Next, a copy of the urn, into which the snake was to be inserted, was placed in position on the right, converted to curves and ungrouped. These last two steps were necessary to allow manipulation of the part of the urn which was to appear to be behind the snake. The 12 elements of the urn making up the back of the top rim were selected by Shift Clicking and were then Grouped—see copy (c). By this method, we have separated this group of elements from the rest of the urn, although they still appear to be part of it. The snake was next placed on top of the urn in the required position and then selected and moved down one layer, using the Order command. The group making up the back of the urn was then selected and moved to the bottom layer, again using the Order command and producing the result shown in (d), making the snake appear to be rising from inside the urn. When using this technique, it has to be remembered that the process of converting the three-dimensional object to curves means that it can no longer be manipulated by the three-dimensional tools, so a copy should be made in case it comes necessary to backtrack.

Using the same process as described above, it is also possible to open windows in three-dimensional objects, as shown in Figure 9.32; to construct our alien spacecraft, a sphere was first created and then flattened to form the

Figure 9.31 *Placing one object 'inside' another*

Figure 9.32 *Illegal aliens*

base; a second sphere was created, sized and oriented appropriately in relation to the flattened sphere; it was then converted to curves and ungrouped, so that the unwanted lower half could be deleted. Four of the panels on the remaining hemisphere were then selected, grouped and 'hinged open' to allow the visiting Martians the means of engaging in Extra-Vehicular Activity, as our friends at NASA would say. As with the snake example, the whole of one Martian was placed on the layer below that of the spacecraft, so that he appeared to be looking out through the open window. To add further to the illusion, a spare Martian was dissected and his arm, complete with ray gun, and head were pasted on top of those of the Martian inside, so that the arm and head appeared to project through the open window.

The examples we have looked at so far are based mainly on very simple, lathed objects. With a little effort and imagination, a more comprehensive library of building blocks can be built up and stored for use in creating more complex compositions. Figure 9.33 shows just a few more examples of the kind of objects which can easily be created, including two—the pear and the bell—in which elements have been combined to produce the desired effect.

Figures 9.34 and 9.35 show how more complex lathed objects can be constructed and then used in building of higher assemblies. Figure 9.34 shows three different views of the same object, which we shall call a propulsion module. To construct a rather more aerodynamic craft than that seen earlier in the chapter, the wings were first created by flattening two cylinders and then shaping them using Designer's Distort function. A copy of the propulsion unit was then rotated, scaled and positioned between the wings and two smaller copies of the module were slung underneath the leading edges of the wings to complete the effect.

Figure 9.33 A medley of lathes

Figure 9.34 Three views of a 'propulsion unit'

Figure 9.35 *Roll your own executive jet*

So far, in this chapter, we have looked mainly at three-dimensional effects which can be created using extrusion and lathing tools provided by 'normal' drawing applications. Let's now investigate what additional features are offered by more dedicated three-dimensional applications like Ray Dream Designer, which we previewed in Chapter 5. In that chapter, we looked at Ray Dream's working environment and at the tools it provides for the creation and manipulation of three-dimensional objects. In Chapter 8, we also saw how different camera positions could be used to view a three-dimensional scene created in Ray Dream from different perspectives; so, what more has such an application to offer?

The *raison d'être* for three-dimensional applications is, of course, the design and rendering of complete photorealistic three-dimensional scenes using subtle lighting and atmospheric effects. It is important to understand that, while the design and manipulation of objects within a three-dimensional application employs vector drawing techniques, when rendering takes place—to reduce the three-dimensional scene to a high resolution, printable two-dimensional image—the result is a rasterised image. Rendering is a computationally intensive process, employing ray tracing techniques which calculate the effects of light rays interacting with objects within the three-dimensional scene. By simulating 'real world' effects like shadows, transparency and reflections, ray tracing provides the best means available to the digital designer of accurately representing reality. There is, however, a heavy price to pay in printing time for such results; depending on the complexity

of the scene, on the number of objects and lights used and on the power of the system processor, a rendered scene can take from minutes to many hours to print, so it's a job for the end of the working day, rather than the beginning! To help alleviate this problem, Ray Dream has provided a 'batch rendering' facility which allows a number of rendering jobs to be queued and then processed when system time is available.

In the hands of a skilled designer, such an application can produce quite stunning results, but for the more 'generalist' graphic designer, to whom this book is directed, a number of interesting features of such an application are accessible without the need to embark on the quite long learning curve required by three-dimensional programs.

We have already looked at examples of two of the main three-dimensional object categories—extrusion and lathing. As we shall see, Ray Dream offers additional features in both of these categories, as well as two additional categories called 'pipelining' and 'skinning'. The many permutations offered can be quite confusing, so a summary of the main selection options is shown in Figure 9.36. For example, choosing the Extrusion option opens a dialog box offering a choice between four different cross-section types (rectangle, ellipse, rounded rectangle or polygon—see Figure 9.37); clicking on one of these opens another dialog box offering a choice from four different path types (straight, curved, angular or wavy—see Figure 9.38); choosing one of these options opens a final dialog box into which the required dimensions of the extrusion are entered. Examples of extrusions created in this way are shown in Figure 9.39. Example (a) used a square cross-section and an angled path; example (b) used a rectangular section and a circular curved path; example (c) used a 12-sided polygonal cross-section and a wavy path.

Similar selection sequences are available for pipelining, skinning and lathing. Figures 9.40 and 9.41 show the lathing dialog boxes for choosing profile type and section shape respectively. Two examples of lathe shapes are shown in Figure 9.42; example (a) used the rounded ends profile with a circular cross-section; example (b) used a sloping line profile, with a polygonal cross-section. Figure 9.43 shows the dialog box used to specify the number of cross-sections in a skinned object and Figure 9.44 shows two examples of skinning (the term 'skinning' is believed to be derived from the process of stretching fabric or animal skins over formers of different cross-sections e.g. in the construction of early aircraft fuselages); example (a) uses three round cross-sections of different diameters, while example (b) uses three rectangular cross-sections of different shapes.

Finally, Figure 9.45 shows two examples of pipelining; example (a) uses a rectangular section and follows a curved path; example (b) uses an elliptical section and turns at right angles halfway along its path.

The examples shown are based on the standard defaults which can be selected from Ray Dream dialog boxes, but all of them remain as editable vector shapes when they are created on screen. They can be moved, scaled,

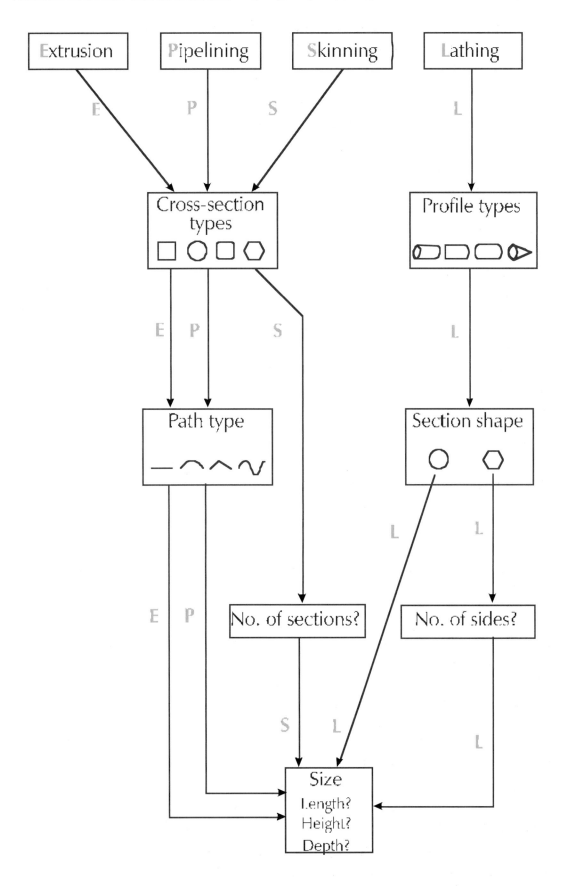

Figure 9.36 *Ray Dream Designer's three-dimensional options*

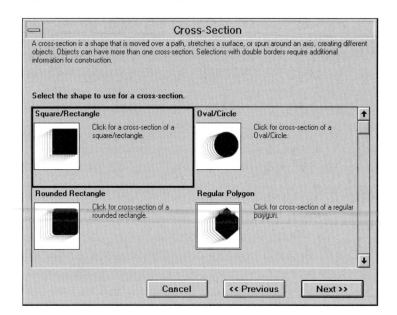

Figure 9.37 Cross-section dialog box

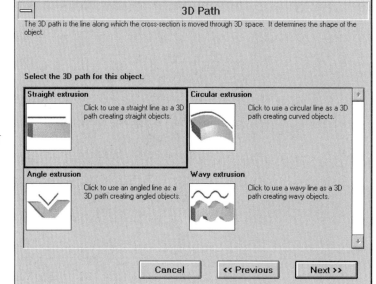

Figure 9.38 Path shape dialog box

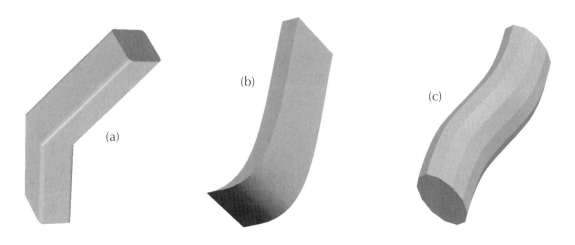

Figure 9.39 Ray Dream extrusion examples

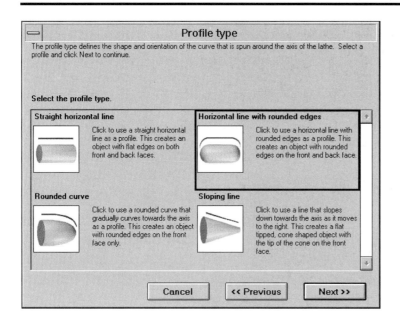

Figure 9.40 *Profile dialog box*

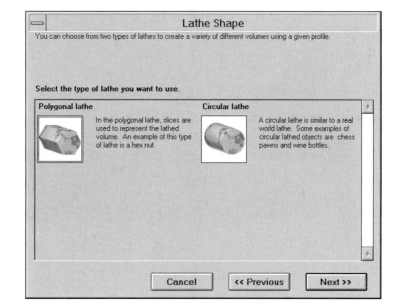

Figure 9.41 *Lathe shape dialog box*

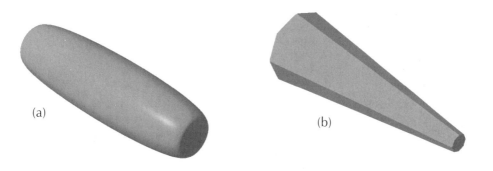

(a)

(b)

Figure 9.42 *Lathing examples*

Figure 9.43 Number of cross-sections dialog box

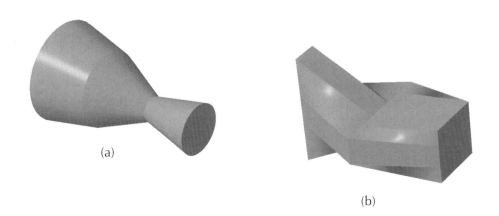

(a)

(b)

Figure 9.44 Skinning examples

(a)

(b)

Figure 9.45 Pipeline examples

rotated or even have their paths point-edited to achieve a particular result. It is at this point that the results can be saved for later rendering.

Other specialised forms—which are very difficult to create by other means—can also be generated in three-dimensional programs. Figure 9.46a, for example, shows the dialog box used to specify the parameters of a three-dimensional spiral—number of turns, length, radius and variation in cross-section of both extrusion and spiral. Figure 9.46b shows an example of such a spiral. Unusual effects can also be obtained by applying a 'twist' to an extrusion (see Figure 9.47); in Ray Dream, this is achieved simply by selecting one cross-section of an extrusion and holding down the Alt key while applying the rotation tool to the cross-section as it is being rotated.

After creating an extrusion by following the route shown in Figure 9.36, additional cross-sections can be added to the extruded object and manipulated individually in shape and size to produce the required final object shape. For such objects with multiple cross-sections, it is also possible to 'disconnect' a selected cross-section from the one preceding or following it, causing the fill of the disconnected section to disappear. This causes the object to appear to consist of intermittent sections, although the apparently separate sections remain part of the same object. Figure 9.48 shows an example.

Compound extrusions, in which objects appear to be fused together, can be constructed by first grouping separate extrusions; a method called 'corre-

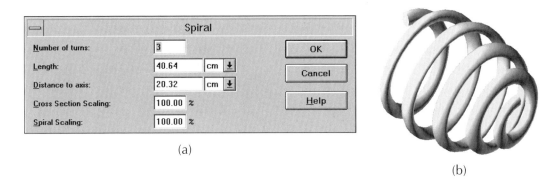

(a)

(b)

Figure 9.46 *Creating spirals*

Figure 9.47 A twisted extrusion

spondence numbering' is then used to switch the end cross-sections of the objects, so that one object intersects the other, the two appearing to become fused together at the intersection. Figure 9.49 shows an example.

Up to this point, the surfaces of the examples shown have been rendered in simple shades of grey. One of Ray Dream's most versatile features, however, is its ability to apply Shaders to objects. Shader is Ray Dream's name for an object's surface characteristics, which can be specified by up to seven different parameters ranging from colour to refraction (see Figure 9.50). Information related to each parameter is stored in a separate channel, making seven channels in all, although, for a given shader, there need not be information in every channel. The grey shade objects we have looked at so far, for example, have information only in the Colour channel.

The nature of the seven parameters is probably self-explanatory except, perhaps, for the Bump channel which is used to store information used to simulate localised variations in surface topography, e.g. the variations across the surface of an orange skin.

Ray Dream provides a ready-made set of Shaders, but any of these can be edited by altering the information stored in any of its channels or, alternatively, new Shaders can be built from basic Shader building blocks called Components which are used to modify information in Shader channels (see Figure 9.51). For example, the Basic Value component can be used to adjust Transparency from 0% to 100%, the Add operator adds together the effects

Figure 9.48 *Intermittent extrusion*

Figure 9.49 *Compound extrusion*

of two basic components, while the Marble function produces a Shader with a marble appearance. While initially complicated to use, Ray Dream's Shader Editor (Figure 9.52) can produce some quite unique effects. A few examples are shown in Figure 9.53.

Among the more interesting Shaders are those created with the use of Texture Maps—bitmapped images. Applied to the surfaces of an object, the

Figure 9.50 The seven shader parameters

Figure 9.51 The three component categories

Figure 9.52
Shader Editor dialog box

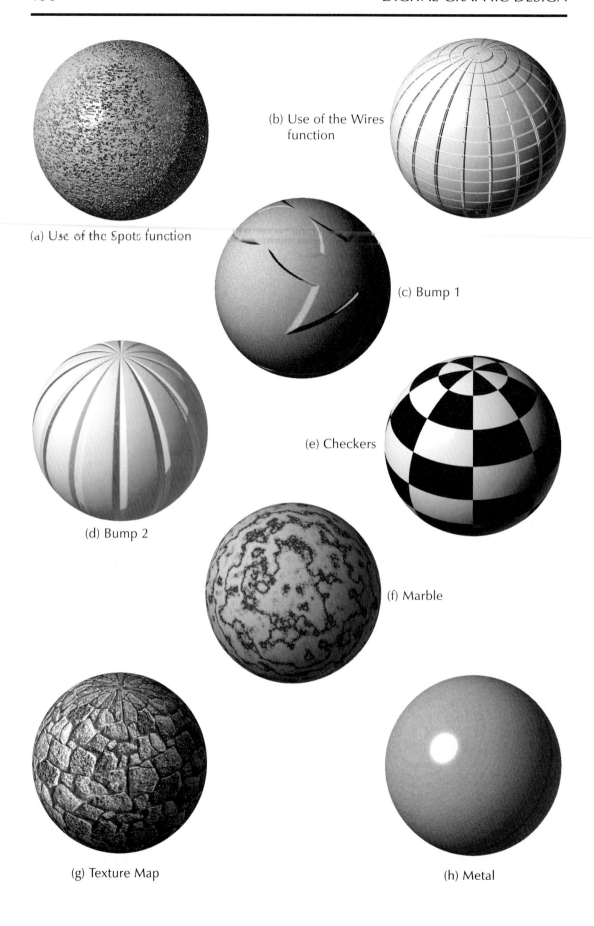

(b) Use of the Wires function

(a) Use of the Spots function

(c) Bump 1

(e) Checkers

(d) Bump 2

(f) Marble

(g) Texture Map

(h) Metal

Figure 9.53 *Shaders applied to spheres*

When setting up the images for Figure 9.56, two light sources were used, instead of the usual single default source. Figure 9.57a shows the positions of the two sources, the first one illuminating the front of the image and the second positioned to the east. Lights can be positioned either by dragging or by specifying coordinates in a numerical dialog box. Independent of the settings for fixed light sources, colour and brightness of ambient light illuminating a scene can be set by means of the dialog box shown in Figure 9.57b.

Interesting effects can also be obtained by using text as an image. The result in Figure 9.58 was achieved by first saving a page of text as a bitmap and then creating a Shader using the text bitmap as a Texture Map in the Colour Channel. The new Shader was then simply applied to the surface of a sphere as shown. Before an object or scene in Ray Dream is rendered, an image file can be selected for use as a background; in Figure 9.58, the same text bitmap which was used to shade the sphere was also used as a background.

Remarkable surface effects can also be created with the use of gels, a gel being an image placed in front of a light source; the darker areas of the gel block the light passing through it, while the lighter areas allow the light to pass, causing a projection of the gel to fall on any object lying in the path of

Figure 9.57 Positioning light sources (a) and setting ambient light (b)

```
Imsep pretu tempu revol bileg rokam ɪrevoc tep
u diams bipos itopu 175ta Isant oscuʻl bifid m
ore ibere perqu umh         ʻqu antra errorp netra
turqu breut ell              tamia ɪqueso uta
n nsomn anoct                anofɾe ventm h
ra intui urc                 rolⱡym oecfu
025u Anetn                   e iⱡngen umqu
udulc vireʂ                  f ɾnapat nti
r tiuve ta                   reʂs humus f
cit quqar                    ueⱡtfu orets
otoqu caga                   a ɪtarac eca
n carmi avi                  unerr veris a
sev 2050i Ec                 i eseeli sipse
spiri usore i                225a ɪImsep pre
u quevi escit b              qu aliqqu diams b
tat rinar uacae ie          ɡus ubesc rpoore ibere
revoc tephe rosve etepe tenou sindu ɪturqu bre
1 bifid mquec cumen berra etmii pyreⱙn nsomn a
```

Figure 9.58 Using text as a background and as an image Shader

the light beam. The gel's parameters are first set up in the lower part of the Lighting dialog box as shown in Figure 9.59a. In this example, a simple 1-bit image of a bird was imported and then tiled, with a frequency of 10 ∞ 10. A spotlight was selected from the Lights menu and projected through the gel on to the surface of a sphere, producing the result shown in Figure 9.59b

We have seen how Shaders can be used to specify the characteristics of a whole object's surface, but what about a situation where only part of the surface needs to be shaded, or where the desired effect requires different Shaders to be applied to different parts of a surface? To do this, the Ray Dream toolbox includes a set of tools to paint either geometric areas (rectangular, elliptical or polygonal), or simply to brush paint directly on to a

(a)

(b)

Figure 9.59 Setting up a gel (a) and applying it (b)

surface (Figure 9.60a). Once created, a paint shape can be repositioned, if necessary, using the manipulator tool. The paintbrush can be loaded with a simple colour, or even, if the fancy takes you, with marble, wood or concrete! Selecting the freehand brush from the toolbar opens the dialog box (b) for presetting the brush's parameters. An eraser is provided for correcting mistakes and a bitmap brush is provided for painting imported images directly on to the target object. Figure 9.60c shows the effect of painting bitmapped shapes on to the surface of a vase, while the lettering on the surface of the sphere in (d) was painted directly on to the surface, using the freeform brush.

The effect of combining three-dimensional objects can be seen in Figure 9.61, in which the same Shader has been applied to the base plane, sphere, cone, rotated cube and cylinder. When positioned partly below the base plane, objects like the cube and sphere appear to be embedded in the plane, merging into its surface; similarly, the cylinder appears to project from inside the

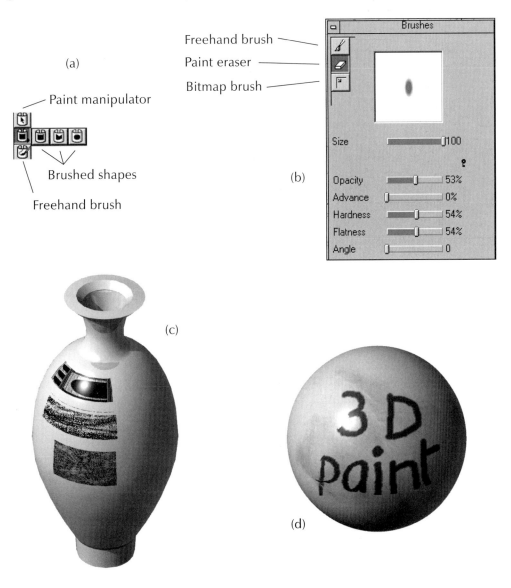

Figure 9.60 Painting on three-dimensional surfaces

sphere. This behaviour is extremely valuable when building more complex objects. Figure 9.61 also shows how the ray tracing process creates realistic shadows in a scene consisting of multiple objects.

As well as providing its library of basic three-dimensional shapes, Ray Dream also provides the facility to introduce text to the workspace, where it can be manipulated like any other three-dimensional object. In the text dialog box— Figure 9.62a—the required text is first entered and then the usual attributes like choice of typeface, type size, spacing and justification are chosen; additionally, depth and style of edge bevel can be specified for front and/or back face. The example in Figure 9.62b was given a marble Shader and positioned above a surface which was given a woodgrain Shader. Note the shadow cast by the overhead light.

Figure 9.61 *The effect of overlapping objects*

(a)

(b)

Figure 9.62 *Three-dimensional text dialog box (a) and example (b)*

As well as shadow effects, the ray tracing process can create object reflections which depend on the percentage reflectance specified in the appropriate Shader's Reflection channel. Figure 9.63 shows an example. A brick Shader was applied to the text object which was then positioned above a flat surface to which another woodgrain Shader was applied. In the wood Shader dialog box, the reflectance of the surface was set to a high value—70%—to give the wood surface a highly polished appearance. When the scene was rendered, the shadow cast by a spotlight positioned forward of, and above, the object, appeared on the floor behind the text object, while a mirror image reflection appeared on the floor immediately beneath it.

An accurate simulation of refracted light can also created, as shown in Figure 9.64. In this example, a rod was placed at an angle behind a rectangular extrusion. The extrusion was selected and, in its Shader dialog box, Transparency was set to 80%, Reflectance to 80% and Refraction to 50%. When the scene was rendered, the part of the rod which was above the 'glass' plate reflected on the top face of the plate, while light from the part of the rod which was behind the plate was refracted as it passed through the plate.

Figure 9.63 *Text object with shadow cast behind and reflection below*

Figure 9.64 *Image refracted through a glass plate*

As mentioned earlier, it is possible to select a background image to be included in a Ray Dream rendering. Figure 9.65 shows such a rendering, with the words Before Fog in the foreground and a simple fractal forest bitmap used as the background. It is also possible to introduce atmospheric effects to three-dimensional scenes by creating 'fog' which causes objects more distant from the camera to appear to fade into the distance. The dialog box for doing this, which is shown in Figure 9.66, requires specification of the colour of the fog, the distance from camera to object and the distance behind the object at which visibility falls to zero. When the effect was applied to Figure 9.67, it can be seen that the copies of the words After Fog appear to disappear into the fog, the further they are from the camera.

Figure 9.65 A forest scene before the fog

Figure 9.66 Fog dialog box

Figure 9.67 The same scene after the fog

As for two-dimensional vector applications, a growing range of clipart is now becoming available for three-dimensional applications. Just a few examples from the library provided with Ray Dream Designer are shown in Figure 9.68.

Figure 9.68 *Examples of three-dimensional clipart*

Currently, the features provided by vector applications, such as those we have looked at in this chapter, far exceed those provided by painting or photoediting applications. It is important, however, to remember that rendering of a vector object designed in Ray Dream, for example, produces a rasterised image which is easily imported into a painting application for further editing and/or merging with other two-dimensional images.

Apart from the ability to apply perspective to an image, as we saw in Chapter 8, the most obvious, and widely used, three-dimensional feature provided by painting applications is the drop shadow. Placing a drop shadow behind an object creates a powerful optical illusion, deceiving the eye into seeing a two-dimensional object in three dimensions. Creating drop shadows in painting applications used to be a fairly complex and time-consuming process involving the use of masks; however, the development of specific filters to do this job has made the task much simpler. Alien Skin, for example, provides a Photoshop plug-in specifically designed to create drop shadows in a variety of styles. As Figure 9.69 shows, this plug-in provides a set of controls for adjusting parameters like shadow offset, blur and opacity and even a set of preset effects (selected from the Preferences menu) for the really lazy user!

Examples of typical effects are shown in Figure 9.70; to create each of the examples (a), (b) and (c), the watch was first selected and different settings were applied using the dialog box sliders to vary the position, blur and opacity of the drop shadow applied. To create the examples (d), (e) and (f), the area outside the watch was first selected and the first shadow was applied to the watch itself, the resulting shading helping to give the watch more depth, and then the watch itself was selected and a drop shadow was added.

Figure 9.69 *Alien Skin's drop shadow dialog box*

(a) (b) (c)

(d) (e) (f)

Figure 9.70 Variations on a drop shadow theme

10

Type

A brief history

At the most simplistic graphical level, each character within a typeface family can be thought of as no more than a simple shape, to which all the techniques we have studied in preceding chapters can be readily applied. Natural as this may seem, in the fast emerging and frenetic world of digital publishing, to think in such a way would be to overlook the rich history of typeface evolution and design which has spanned many centuries. The story of this evolution was included in a previous book by the author entitled *Creative PC Graphics* and the following short summary is taken from that book:

> *The earliest form of graphic communication—the 'picture writing' technique of our ancestors, the cave dwellers—was still being used by the ancient civilisations of Babylon, China and Egypt 6000 years ago, but it was the Egyptians who finally imposed order and structure on the use of pictures. Although still a form of picture writing, Egyptian hieroglyphics included 24 signs which represented 'letters' as we would describe them today.*

> *As recognition then slowly dawned that spoken language was made up of a relatively small number of sounds, the key association between specific sounds and specific letters slowly began to emerge. From these early beginnings, the ancient Greek alphabet became established and was later adopted by the Romans about 2500 years ago. 'Capital' letters were used for formal purposes, while the use of smaller and more easily formed letters evolved for letter writing.*

> *The alphabet used today for the writing of English is based on the Roman alphabet. It differs markedly from other alphabets like those used in the Soviet Republics, the Arab states, China and Japan, which have followed different evolutionary routes.*

> *In the fifteenth century, the first typefaces were imitations of the early Gothic handwriting, but printers soon came to realise that the classical Roman letter styles were both easier to cast and easier to read.*

As printing technology spread and its range of uses grew ever wider, so did the demand for different, distinguishable typefaces. The names of the early typeface designers, like William Caslon and John Baskerville are immortalised in the names of their typefaces which are still in popular use today, even although the number of typefaces available to today's publisher runs into thousands. The major categories of typeface available to the designer can be summarised as follows.

1. Serif

Serif typeface designs were created by stonecutters and calligraphers who ended character strokes with serifs—short tapered lines. Aside from the design enhancements this offered, it is presumed that early stonecutters used the serif as a means of preventing the stone from chipping.

2. Sans serif

From the French 'sans', meaning 'without'. Sans serif type dates back to ancient Greece, where inscribed Greek capital letters were austere, geometric designs. The present revival began in the mid-nineteenth century with the emphasis on clean lines and simplicity.

3. Script

As the name suggests, script faces attempt to emulate handwritten letterforms.

4. Decorative

As the volume and scope of published media grew, demand arose for typefaces aimed at capturing attention and/or embellishing the appearance of documents, rather than simply communicating. Typical use is for headlines, titles, and banners. Decorative faces are also often referred to as 'display' faces.

5. Machine

Typeface characters with a precise, engineered appearance. Uses include computer-generated tables, charts and reports; they are also used in situations where a 'high tech' image is desired.

Family concept

The standard family group includes normal, bold, italic and bold-italic. The italic form was adopted from an early form of Italian handwriting. Some typeface families, because of their special nature, possess fewer than four members, e.g. a flowing type of simulated scripted face would not normally include an italic form. Other families have extra members, offering still further variations on the same basic style e.g. Helvetica Condensed or Bodoni Black.

Typeface design and manufacture

Until very recently, the manufacture of a new typeface involved casting each character and each punctuation mark in metal. This process imposed important constraints on the type designer, as the shapes making up each character had to be capable of being cut on a steel punch and then cast in molten lead. Thus the successful designer was one who combined the sensitivity and flair of the artist with practical awareness of the manufacturing process

Many early designs in metal derived from classical faces, like Times Roman, which are based on the original Roman characters and remain popular to this day. However many new designs have appeared since the fifteenth century, some surviving, while others have fallen by the wayside. Design of a new typeface, like other art forms, can often reflect both the culture and the mood of the period, from classical to grotesque, from formal to frivolous.

The design of a character which is pleasing to the eye involves a complex balancing act between the character's various components (Figure 10.1). One can imagine William Caslon labouring by candle-light for many hours over subtle nuances of curve and proportion and then waiting impatiently while his engraver prepared a new punch so that the latest variation could be tested—and then starting all over again to produce the italic version.

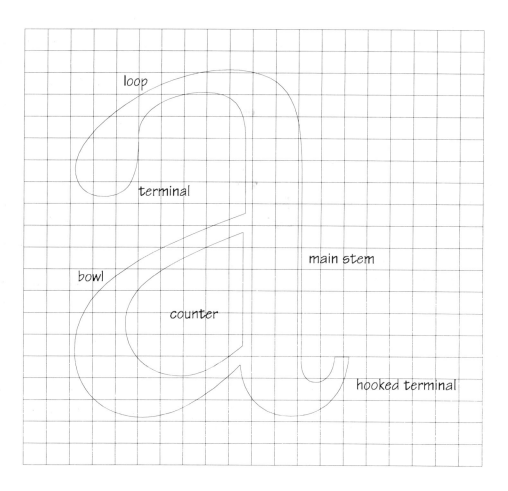

Figure 10.1 *The components of a type character*

Creating individual characters with the right properties was, of course, just the first challenge. The real long-term test of the success of a design lay in the balance and harmony between the different characters of which it was composed and, here again, there were many variables to be optimised. Figure 10.2 shows just some of these.

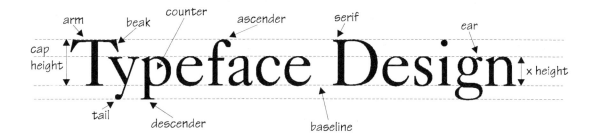

Figure 10.2 *The anatomy of type design*

Unlike his predecessor, the digital typeface designer is unfettered by the limitations of the hot metal printing process and has at his disposal the means of creating virtually infinite variations on a theme quickly and efficiently. This has led to an explosion in the numbers of digital typefaces now available. Figure 10.3 shows just a handful of examples. Many of these are simply digital equivalents of their classical counterparts, but many more are new designs spanning all of the five categories summarised above. Created by skilled designers, the majority of the new faces work well; however, so simple does the design process appear, that many less gifted for the job have tried their hand, producing results which are at best mediocre and at worst downright bizarre!

Amid the headlong flight from traditional to digital type, one casualty appears to have been terminology. The words *typeface* and *font* are often used interchangeably, with a tendency for the latter to be more common. The more traditional view would seem to reserve the term typeface to describe a particular type family, e.g. Helvetica, while font (originally fount, derived from the Latin for casting or melting) is more correctly used to describe the complete set of characters making up a member of the family—e.g. Helvetica Extra Bold.

Type manipulation

Today's digital outline fonts offer the graphic designer an enormous range of flexibility. For each of the many different typefaces available, the following possibilities can be exploited to produce a dazzling array of effects:

Scaling, without loss of definition

Adjustment of character stroke weight, style and colour

Figure 10.3 *Type galore*

Character fill, with colour, texture, bitmap pattern or image, vector pattern, PostScript pattern or screen

Rotating, skewing or mirroring of characters or text strings

Blending or contouring

Character shape editing

Fitting text characters or strings to a curve

Constraining text to fit within a shape

Extruding and/or applying perspective

Creating raytraced text with lighting effects

Creating bumpmapped text

Applying shadows, drop shadows or reflections

Using text characters or strings to mask a bitmap image

Creating decorative leading capitals

Many examples of the simpler application of these effects are included in *Creative PC Graphics* and we have also seen a few examples in earlier chapters of this book. In the remainder of this chapter, we shall concentrate on just a few more demonstrations of the many creative possibilities.

Word pictures

While the evolution from early forms of picture writing to the use of simple alphabetic characters was an essential catalyst to the spread of knowledge and, eventually, to the Industrial Revolution, few would argue that picture writing had an aesthetic appeal which Helvetica will never match. In today's fast moving world of information technology, we are required to absorb increasingly large amounts of diverse information at school, at work and even at play, and the written word remains the principal medium for delivering this information.

The graphic designer is not excluded from this world of words, however, as there are many situations where the way in which the words are presented, either alone or blended with graphics, can add significant weight to their impact. One of the oldest (and simplest) examples of this is the association of a particular typeface with, for example, a place or a period in history. In Figure 10.4, examples of several such typefaces are shown, with the name of

the typeface in brackets to the right of each sample. For example, the typeface Lithograph echoes the style of a typeface used for inscriptions found on ancient Greek monuments and, as such, has developed strong visual associations with Greece. Similarly, the typeface characters of Mandarin seek to emulate the flowing, painted characters of the oriental scribe. In the same way, Viking, Carleton and Fette Fraktur conjure up images of Scandinavia, England and Germany. Rather than a whole country, the typeface Posse is strongly reminiscent of the era of the Wild West in the United States, where such a face was used in the production of posters and broadsheets.

Associations of a different kind exist also for a number of other typefaces, as shown in Figure 10.5. One of the oldest and most commonly used typefaces, Times, will always have a close association with the banner heading of the London *Times* newspaper. In the world of entertainment, the typeface Broadway enjoyed a long period of popularity for the production of posters and

ANCIENT GREECE (LITHOGRAPH)

CHINA (MANDARIN)

SCANDINAVIA (VIKING)

KASBAH (ALGERIAN)

KENSINGTON PALACE (CARLETON)

Deutschland (Fette Fraktur)

THE HIGH CHAPARRAL [POSSE]

Figure 10.4 Geographical typeface associations

theatre programmes, while the typeface P T Barnum brings back childhood memories of circus posters. By way of contrast, Bible Script, Cloister Black and Mariage project a strong image of the Church, the Scriptures and the important events, such as weddings, which we associate with the Church. For many people, the face Bauhaus is synonymous with the style and flair of the design school of the same name, while, on a more general level, the informal, and yet clear and precise, lines of the typeface Tekton have an immediate visual association with the carefully handwritten annotations of a draftsman on a technical or architectural drawing.

Reflecting more modern styles, the typeface Bard (Figure 10.6) succeeds in capturing the spidery character formation often found in the writings of poets, while Kids makes a good attempt at simulating the formation and spacing found in the formative writing of young children. By using characters like those used for the lettering on magnetic cards, Keypunch almost shouts technology, while, by contrast, Bernhard Fashion evokes the style, and elegance of the world of fashion.

THE TIMES (Times)

SHOW BUSINESS! (Broadway)

Come to the Circus ! (P T Barnum)

The Holy Bible (Bible Script)

The Monastery (Cloister Black)

Wedding Invitation (Mariage)

School of Design (Bauhaus)

Technical Drawing (Tekton)

Figure 10.5 Other typeface associations

When a suitable typeface is not available to convey a particular message on a stand-alone basis, then an effective technique can be to manipulate the shape of the text to reinforce its message. Adobe's TypeAlign application is particularly adept at producing such results; the user interface, shown in Figure 10.7, provides tools for creating text within an envelope, the shape of which can then be edited by dragging the nodes on the envelope with the use of the mouse button. As the envelope deforms, the shape of the text inside reflows to conform to the shape envelope. The level of detail of the shaping can be increased by adding additional nodes to the envelope by Control-Clicking on its boundary. Figure 10.8 shows four examples. After shaping, the text can be combined with other graphics—the painted rain with the text for April and the basket graphic with the text for Balloon—to produce the final effect.

Word pictures can also be created with some of the special functions provided by painting applications. Figure 10.9, for example shows three different effects created in Photoshop. To produce the earthquake effect, the word was first typed using the Text tool, scaled and filled and then deselected. The Lasso tool was used to make an irregular selection of the lower half of the text which was then offset upwards and to the right, relative to the upper half of the text, simulating movement along an earthquake fault line.

The Blur and Wavy examples in Figure 10.9 were produced with the help of two of Photoshop's standard filters. In each case, the word was first typed using the Text tool , scaled, filled and then deselected. The Marquee Selection tool was then used to select a rectangular area which enclosed the text and then Filters/Blur/Motion Blur and Filters/Distort/Wave, respectively, were selected to produce the two different effects.

Figures 10.10 and 10.11 show the kind of results which can be obtained using PHOTO-PAINT's filters. The dialog boxes provide a wide range of control over the effects which can be obtained.

Poetry in Motion (Bard)

The cat sat on the mat (Kids)

Information Technology [Keypunch]

The catwalk (Bernhard Fashion)

Figure 10.6 *More recent typeface associations*

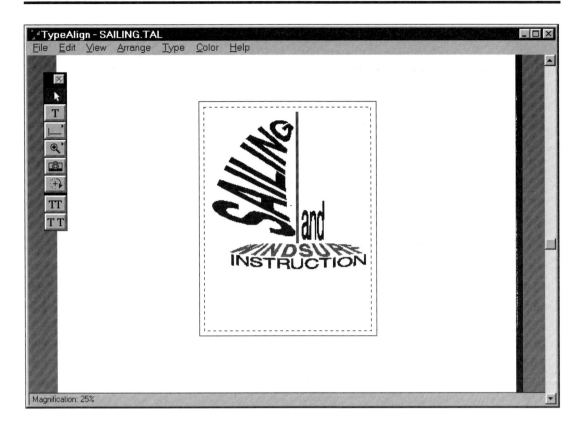

Figure 10.7 *Adobe's TypeAlign workspace*

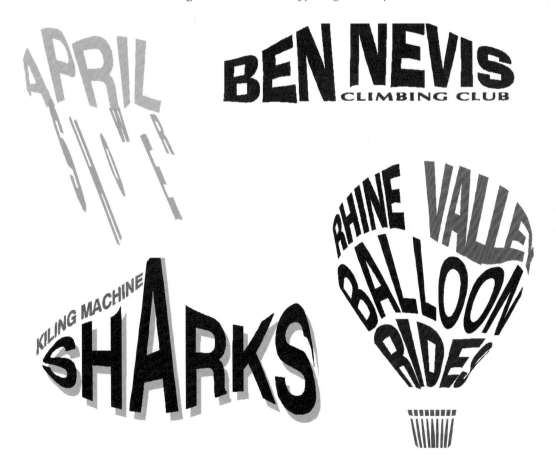

Figure 10.8 *Some TypeAlign examples*

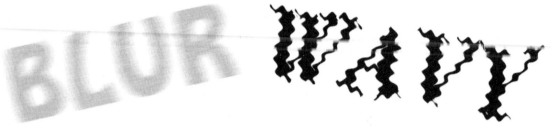

Figure 10.9 Photoshop effects

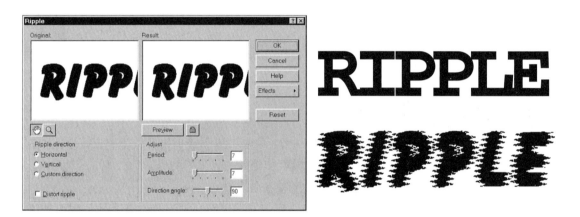

Figure 10.10 Using the PHOTO-PAINT Ripple filter

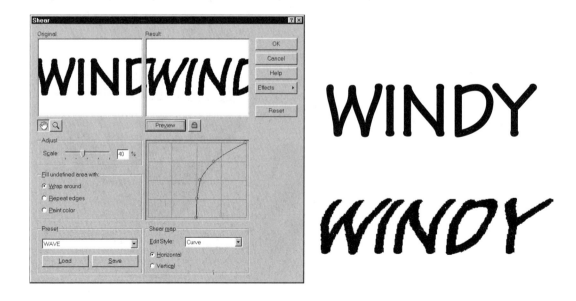

Figure 10.11 Using the PHOTO-PAINT Wind filter

Another form of word picture can be created using a substitution technique
—a technique in which a graphic object or an image is substituted for one or
more of the characters in a word. Figure 10.12 shows some examples in which
clipart pictures are substituted for one or more letters within words. To pro-
duce (a), an example of single character substitution, the host text R_SE was
first created and a clipart rose was then scaled and placed in position. Kerning
of the text was adjusted to make the position of the rose more natural. In this
example, the object substituted, as well as having the approximate shape of
the "O" which it replaced, was the object described by the word in which it
was placed. In example (b), two characters were substituted, using the same
process as described for (a), but, in this case the objects substituted were
chosen both because their shapes resembled those of the characters they re-
placed and because they were synonymous with Halloween. In example (c),
three characters can be successfully replaced because the object substituted
has the same sound as the characters replaced and because the object 'ear' is
closely associated with the word 'hearing'. In the final example, (d), the
wheels of the clipart bicycle was used to substitute the "O" characters of two
words. In this case the clipart bicycle was ungrouped and the wheels ad-
justed to match more closely the style of the text.

Figure 10.12 *Vector substitution*

The last, and probably the simplest, form of word picture we shall examine uses the Fill of the text characters to reinforce the meaning of the text by the use of visual association. Two simple examples of this are shown in Figure 10.13, with a greyscale image of a stone wall as a fill for *The Stonemason's Arms* and a wood texture greyscale image fill for the word *Forest* in *The Disappearing Forest*.

Masking

The two examples in Figure 10.13 were easy to create within CorelDRAW, as suitable Fill patterns were available from the Fill menu. When this is not the case, a masking technique can be used to create a fill using any suitable bitmap image. To produce the result in Figure 10.14c, for example, the word ZOO was first typed and scaled and then Combined with a surrounding rectangle, to produce the mask shown in (a). After Filling the mask with white and changing its Outline to None, the mask was placed on top of the imported greyscale image of elephants in (b), allowing parts of the image to show through the mask. To add interest, the ends of the tusks were drawn in so that they extended outside the limits of the mask.

A mask can also be used as an 'overlay' on top of an image, as in Figure 10.15. To create this effect, the curved box was first created as a vector object, using the Bezier tool. A copy of the top edge of the box was then made to provide the path to which the text was aligned using Text/Fit to Path. The text was then positioned within the curved box, the two were combined and

(a)

(b)

Figure 10.13 Using selective fills to reinforce a message

(a)

(b)

(c)

Jardins Zoologique

Figure 10.14 Simple text masking

a white Fill was applied, producing an opaque mask. The mask was saved in Adobe Illustrator format (.AI) so that it could be imported into Photoshop as a Path. Next, an image of a stone surface was opened in Photoshop and cropped to the required size and the mask was imported, using the File/ Place command and positioned on a Layer above the stone surface. The white areas of the mask were now selected, using the Magic Wand tool, not forgetting to include the centres of the letters R, O and B and a drop shadow was applied, using the Alien Skin filter mentioned earlier, so that the mask appeared to float above the stone surface. Using a different typeface (Bellevue), the remaining text was added using Photoshop's Text tool and given a white Fill. Finally, the canvas area was enlarged around the edge of the stone surface, leaving a white border, which was selected using the Magic Wand tool. Using Select/Inverse, to select the stone surface, a drop shadow was applied to the surface.

Figure 10.16 shows yet another masking technique, in which the mask—in this case the word PROVENCE—was made transparent, allowing the underlying image to show through. The imported PhotoCD image of the

Figure 10.15 Using a mask in a composition

Figure 10.16 Making a mask transparent

melons was first imported into Photoshop's Base Layer, where it was cropped to size. Using the Type tool, the words Melons de were typed, scaled and positioned on Layer 2. The word PROVENCE was then typed, scaled, given a Fill of white and positioned on a transparent layer—Layer 3. Reducing the opacity of the layer to 60% allowed the image of the melons to show through the text. Using the same method as for the rockclimbing example, the composition was given a drop shadow.

Engraving and embossing

As the art of the stonemason, the woodworker and metalworker and their knowledge of material properties evolved over the centuries, the art of engraving and embossing lettering on solid surfaces emerged in parallel and grew in popularity. Emulating these attractive effects, a number of typefaces have been designed which appear to set the printed text in relief on the paper surface. Some examples are shown in Figure 10.17.

Figure 10.17 Examples of relief typefaces

While these faces have their uses when a 'quick and dirty' solution is acceptable, a much more impressive result can be obtained by using the 'bumpmapping' feature provided by Photoshop. A new RGB file is first opened and then a new channel is added, in which the object to be bumped—in the example below, the word EMBOSS—is created. A Gaussian Blur of 10 was applied to soften the edges of the text and then, using the Noise filter, a Gaussian Noise setting of 10 was applied to the text itself and a value of 20 was applied to the surrounding area (the noise creates a textured effect when the object is bumped). After these modifications to the text (Figure 10.18a), switching to the RGB channel and selecting Render/Lighting Effects from the Filters menu, opens the dialog box shown in Figure 10.18b. When the Bump Channel (#4 in this example) is selected from the Texture Channel drop down menu at the bottom of the dialog box, the bump effect is displayed in the Preview window to the left. Various controls are provided in the dialog box for selecting from a range of different types of light source and for changing the colour, intensity, position and range of the selected source. Using the Properties controls, surface parameters can be altered to create subtle variations in the way light appears to reflect from the object surface.

After setting the various controls, switching back to the RGB channel causes the result of the bumpmapping to be displayed, saved or printed. Figure

(a) Text with blur and noise applied

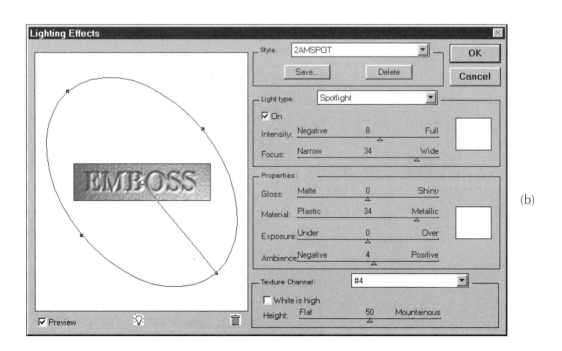

(b)

Figure 10.18 *Bumpmapping a text object*

10.19 shows the kind of variations which can be obtained using, in this case, a constant white spotlight source and varying the bump height by means of the slider at the bottom of the dialog box. The settings used are shown alongside each of the examples. When white is set to High in the dialog box, as in examples (a) and (b), then the black areas appear sunken i.e. the word appears to be stamped or engraved into the surface (although there appears to be an optical illusion at work here, as I personally found that I could see these two examples as either raised or lowered depending on the angle and distance from which I viewed them! It helps to keep reminding yourself that the light is coming from the bottom right). When white is not set to High, as in examples (c) and (d), then the black areas appear to be raised, i.e. the word appears to be elevated as if embossed. The effect of increasing the Height setting in stages from 5 in example (a) to 50 in example (d) can be seen clearly. The noise which was introduced in Figure 10.18a converts to a fine texture in (a) with the setting of 5, becoming more pronounced with settings 10 and 25, until, with a setting of 50, it starts to cause the surfaces and edges of the lettering to start to break up.

As well as the simple spotlight used to illuminate the examples in Figure 10.19, Photoshop's Lighting Effects dialog box offers, via its drop-down Style menu, a whole range of other lighting types. Quite dramatic effects can be obtained by experimenting with the settings of these lights. Figure 10.20 shows just a few examples.

(a) White high, Height setting 5

(b) White high, Height setting 10

(c) White low, Height setting 25

(d) White low, Height setting 50

Figure 10.19 Result of varying bump map settings

The settings used to obtain the results are shown alongside each example. (a) used a wide beam 'Omnilight' positioned directly above the centre of the object. (b) used a 'Flashlight' to simulate the effect of a camera photographing a dark scene. (c) used a group of five small 'Spotlights' to illuminate the object at an angle; three were positioned to the north of the object and the other two to the north-west and the north-east. Object (d) was illuminated with a beam of 'Parallel' light from a northerly direction. Although the same levels of blur and noise were applied to all four base objects, it can be seen that the perceived surface topography varies with the type of illumination used.

(a) White low, Height 50,
Omnilight centred,
Intensity 8

(b) White high, Height 50,
Flash offset left,
Intensity 23

(c) White high, Height 50,
Five spotlights,
Intensity 100

(d) White high, Height 70,
Parallel from top,
Intensity 100

Figure 10.20 *Varying the lighting of a bumpmapped image*

In all the examples we have looked at so far, the object to be bumped has been created in an alpha channel, with nothing present in the RGB channel. Even more interesting results can be obtained when images are placed in this channel. To create the effects shown in Figure 10.21, for example, a bitmap file of a wood texture was first opened in Photoshop before the text was created in the alpha channel. The bump and lighting settings are shown next to the figures. In both cases, a 'Floodlight' was used to illuminate the surfaces from a northerly direction. In case (a), as in the examples in Figures 10.19 and 10.20, the text in the alpha channel was filled with black before blurring. In case (b), the effect of the outline of the letters being branded into the wood surface was obtained by giving the text a fill of white and then applying a two-pixel black stroke to the character outlines before blurring and then setting white High before bumping.

It should be mentioned that bumpmapping requires working in five channels—RGB composite, Red, Green, Blue and the alpha channel. The process will not work in monochrome or greyscale. When the bumping process is complete, however, the final image can be converted to greyscale, if required, to reduce the file size.

(a) White low, Height 50,
Floodlight from top,
Intensity 17

(b) White high, Height 50,
Floodlight from top,
Intensity 17

Figure 10.21 Applying texture

Still further effects of the bumpmapping technique reward a little experimentation. To create the effect in Figure 10.22a, an apple was first rendered in Ray Dream Designer, saved in Tiff format and imported to Photoshop. The word APFEL was typed into an alpha channel, filled with black and blurred. Next, from the Filters menu, Distort/Spherise was applied to the whole channel. The effect of the Spherise filter is to distort the shape of objects in the channel, as if wrapping them around the outside of a spherical surface, as in Figure 10.22b. After switching to the RGB composite channel, the bump dialog box was opened and an Omnilight was selected. The centre of the Omnilight was dragged to align with the highlight which had already existed on the rendered image of the apple and a wide angle was applied to the beam to apply an even illumination which would avoid conflict with rendered lighting effects. With white set Low, the resulting effect was as if the text was embossed on the curved surface of the apple.

Finally the outline of the apple was selected and a soft drop shadow was applied to enhance further the three-dimensional effect.

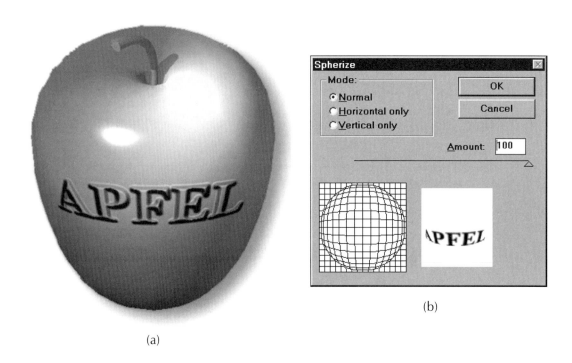

(b)

(a)

Figure 10.22 A bumpmapped apple

As pointed out at the beginning of the chapter, type occupies a very special place in the history of graphic design. While not essential to the digital design process, a brief study of the evolution of type is helpful in ensuring continuity of its traditions. The ease with which new typefaces can be designed and manipulated can easily lead to excesses which are out of harmony with these traditions.

The secret of successful use of type lies (a) in choosing the right typeface for each situation, always remembering that the purpose of the type is to communicate its message clearly, and (b), in setting the type in such a way that the setting enhances and reinforces the message, rather than competing with it. In this chapter we have concentrated on some of the more interesting effects which can be applied to text objects. Other effects can be found scattered through the book. When used thoughtfully, such effects can enhance and enrich the communication process, but the designer must be aware that what works well on a business card may not work at all on an advertising hoarding or on a slide projected on to a large screen in an auditorium. Readability must always be the first consideration, followed by matching the style of the type to the image and message being projected. Special effects should be used sparingly and with consistency. When in doubt, understatement is preferable to over-indulgence!

11

Image Manipulation

In Chapters 3 and 4, parallels were drawn between the environment in which today's graphic designer works and those in which the traditional artist and photographer have worked for many years. In the development of the first desktop painting and photoediting applications, emphasis was very much on mimicking these traditional environments and on providing the digital artist and photo retoucher with tools and techniques which simulated those evolved by his predecessors. While today's applications still offer this user-friendly similarity, it is astonishing to observe how, after few short years of evolution, software developers have not only refined these traditional methods to a high degree of precision and sophistication, but they have also added features which take the applications' capabilities, in some respects, far beyond what is possible using only traditional methods.

In Chapters 5 to 10, as we investigated ways of creating and editing graphic objects, emphasis has been on the use of vector applications—object-oriented programs—which excel at manipulating lines and shapes. In this and the following chapter, emphasis will shift more to bitmap applications as we examine the ways in which they now closely emulate their traditional counterparts and as we explore some of the amazing features which they now provide.

The approach throughout this book has been on how different types of graphic effect can be produced by making collective use of state of the art desktop applications—not on what a particular application can or cannot do. Often, to achieve a particular result, use of two or more applications in combination is needed. Also, the distinction between painting and photoediting applications has become blurred as, increasingly, they share many common features. Fractal Design's Painter has, indisputably, the lead in offering the widest range of simulated natural media tools and canvases, but it also possesses a range of sophisticated image editing tools. Photoshop, conversely, has been the long-standing choice of graphic professionals for photoediting, but also includes a range of powerful painting tools. Other applications, like Corel PHOTO-PAINT, with each successive upgrade, seems to offer many of the features of the other two and more besides!

In what follows, therefore, emphasis will continue to be on what results can be produced using the collective features of these applications, however, particular reference will be made to the application being used when an effect is unique to that application.

For the purpose of this chapter, we shall define an image to be any bitmapped (as opposed to vector) object which can be displayed on the screen, originating from any of the following sources:

Created using digital painting tools

Scanned and imported as a bitmap file

Imported from an electronic photographic library

Downloaded from a network

Rasterised from a vector format

Rendered from a three-dimensional application

Captured from videotape

Downloaded from a digital still camera

Such images can range from low to high resolution—typically from 72 dpi to 300 dpi—and vary in colour depth from single bit (black and white) to 32 bit (photorealistic colour).

Tools and techniques

The tools and techniques available for manipulating such images were reviewed in Chapters 3 and 4 and can be briefly summarised as follows:

Tools

Brushes to create freehand brushstrokes

A Line tool to produce straight lines

Selection/Masking tools to select geometric areas, such as rectangles and ellipses

A Text tool for placing text directly into the painting area

A Fill tool to flood a designated area with colour, a gradient fill or a texture

An Eraser tool to remove colour from selected pixels

A Cropping tool to cut out a selected area from a larger image

A tool for adjusting image brightness and contrast, and Dodge and Burn tools to make local brightness adjustments

Local Smudge and Sharpen tools

A Clone tool to copy areas of an image for placement elsewhere in the same image or in another image

A tool for adjusting highlights, shadows and midtones using levels

A tool for adjusting tonal values using levels

Tools for adjusting hue, saturation, colour value and colour balance

Techniques

Adjusting stroke weight, style and colour via a dialog box and colour palette

Applying process or spot colours or tints, gradients, textures or pattern fills

Painting with patterns

Path editing—adjusting path shape by moving nodes/handles

Scaling a selection—proportionally or non-proportionally

Rotation—in fixed increments or freeform

Skewing or shearing—about a fixed point

Flipping—vertically or horizontally

Distorting—giving an object a three-dimensional appearance

Adjusting a selection's perspective

Feathering—reducing hardness of selection edges

Adjusting transparency of selections

Layer masking—used to adjust transparency of layer

Lighting—creating directional flood or spot lighting effects

Applying drop shadows

Creating mattes

Compositing images

Applying filters

Morphing—transforming one image into another

Basic operations

Examples showing how many of the above tools operate and how a number of the techniques can be applied to images were included in *Creative PC Graphics*. Examples of some of the basic operations will be included here for completeness, before we investigate more complex effects.

Figure 11.1, for example, shows two methods for correcting image brightness. To correct the PhotoCD image (a) which is too dark, we can simply

select the whole image and adjust the Brightness slider in the Brightness/Contrast dialog box in (b). An increase of 30% produced the improvement shown in (c). While this method can produce an acceptable result, use of the Brightness control tends to wash out the highlights in an image. Using instead the Levels dialog box to redistribute the grey levels of the image usually produces a better result. The levels in the original image are shown in (d). Adjustment—by dragging the sliders to the positions in (e)—produced the more balanced result in (f).

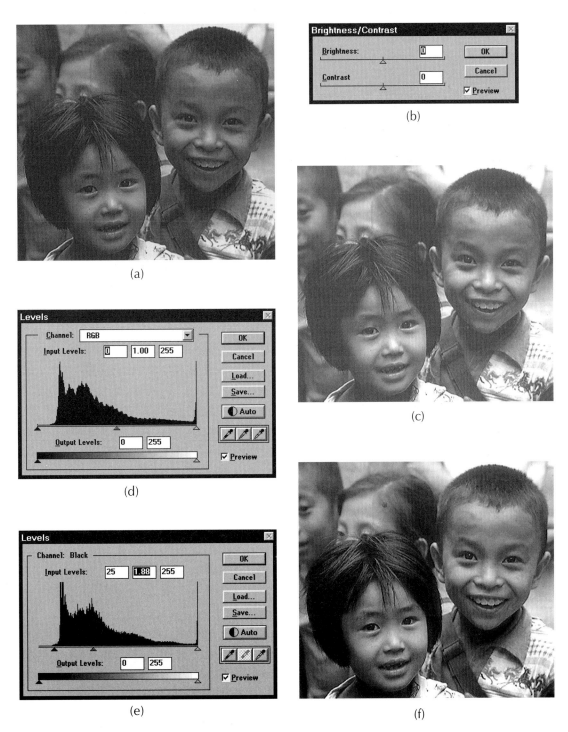

Figure 11.1 Adjusting Brightness

Local adjustments to brightness and contrast can also be made either by using Dodge or Burn tools or by masking the area to be edited and applying changes just to that area.

The distribution of grey levels in an image can also be adjusted using the Curves dialog box. When the image in Figure 11.2a is first selected, the grey level curve forms a straight line, as in (b), indicating that, if no editing takes place and OK is clicked, then the output value of each pixel remains the same as its input value. However, if the shape of the curve is altered by dragging the ends of the line or intermediate points on the line, then the grey values of the corresponding pixels will be altered. (c) shows an extreme

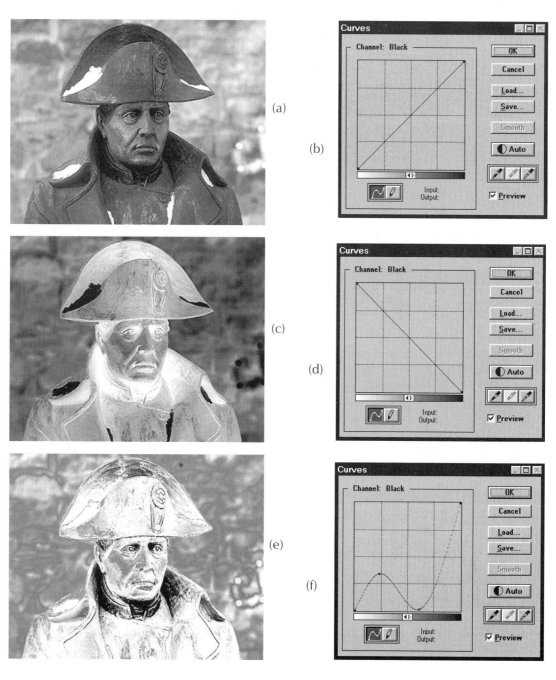

Figure 11.2 Adjusting Curves

example of this. If the ends of the original line in (b) are dragged into the positions shown in (d)—i.e. the slope of the line is reversed—then black pixels in the original image become white, white pixels become black and the intermediate grey pixels adjust proportionally, producing a negative of the original image.

More subtle effects can be obtained by changing not only the slope of the curve, but also its shape. The example in (e) was the result of altering the shape as shown in (f), keeping some pixel values close to their original level, while causing others to change sig-

nificantly (notice how this effect brings a gleam to Napoleon's eyes!). Incidentally, other Photoshop tools and techniques used in preparing Figures 11.1 and 11.2 were the Crop tool to select parts of larger PhotoCD images, the Mode menu to alter the images from RGB to greyscale and the Image Size dialog box (Figure 11.3) to set the final image sizes and resolution.

Figure 11.3 *Specifying image size and resolution*

Figure 11.4 demonstrates some other basic features offered by paint/photoediting applications. A PhotoCD image of a dog set against a background was opened and the Lasso tool was used to select the dog. The selection was copied, feathered to two pixels, and pasted into a new document, with a background colour of white—see image (a). The image was duplicated and scaled to 50% to provide (a) with a younger brother (b). Another duplicate of (a) was then made and this time the Lasso tool was used

Figure 11.4 *Scaling, flipping and rotating*

to select just the dog's head. This selection was also feathered to two pixels and then rotated using the Free Rotation option from the Image/Rotate menu. The Eraser and Clone tools were used to tidy up the areas disturbed by the rotation of the head.

Another common technique used for manipulating greyscale images is posterisation. As stated previously, posterisation creates an effect reminiscent of that produced when silkscreen posters are produced using a small number of colours or grey tones. Figure 11.5 shows an example. The original image (a)—a 256 greyscale image—was first selected and then the posterisation dialog box (b) was opened via the Image/Map menu in Photoshop. Setting the posterisation level to 8 causes the original 256 grey shades to average down to just eight shades, producing the result shown in (c), which still manages to retain much of the detail of the original. With the level further reduced to just 4 shades (black, white and two shades of grey, as in example (d), much of the detail is lost and the 'poster-like' effect appears.

The smoothness of a posterised image can be enhanced by filtering. To illustrate this, a copy of the child on the right of Figure 11.5 was first selected, copied to the pasteboard and then pasted into a new document—see Figure

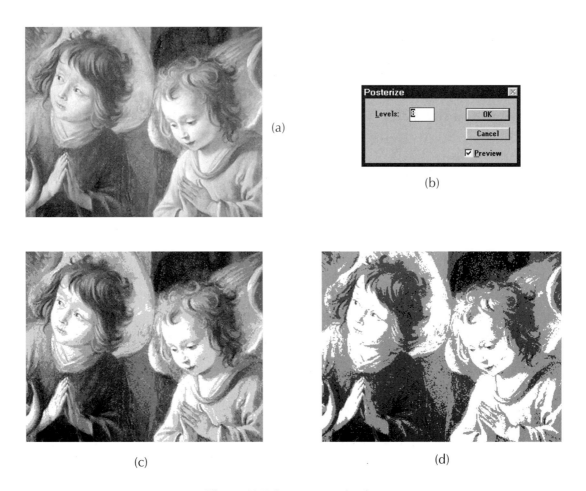

Figure 11.5 *Image posterisation*

11.6a. Filter/Noise/Despeckle was first used to remove stray pixels from the image and then the Filter/Noise/Dust and Scratches dialog box was opened (Figure 11.6b). Although the common use of this filter, as the name suggests, is the removal of blemishes from scanned photographs, it can also be used to suppress 'noisy' areas of an image. Setting the radius to 3 pixels produced the much smoother, but consequently less detailed version of the image shown in (c), while backing off the pixel radius to 1 produced the less smooth, but more detailed compromise in (d).

As we saw in Chapter 8, skewing or shearing of a vector object can be used to adjust its perspective when using the object as a component within a packaging composition. As shearing is a feature also common to painting applications, the same treatment can be applied to bitmapped images. Figure 11.7a shows a bitmapped image of a painting, to which the name VINCENT has been added using the Text tool. To produce the result shown in (c), the painting was first selected and, by means of the Image/Canvas dialog box, white space was first added around the perimeter of the image; clicking on Filter/Distort then opened the Shear dialog box shown in (b). The image was sheared to the required angle by dragging the top and bottom of the guideline in the dialog grid box; it was then reduced in height to 86.6% (with Keep Proportions switched off in the scaling dialog box), saved and imported to CorelDRAW, where it was used as the front cover component in the construction of a book.

After rotating the image into position, the straight line and Bezier tools were used to draw the other elements of the book structure. To obtain the appearance of pages inside the book, the Blend tool was used; a black line was first drawn midway between the top and bottom covers and then Blended, using eight steps, with a 20% grey copy of the line positioned immediately above the edge of the bottom cover; the black line was then separated from this blend and a second 20% grey copy was this time positioned immediately below the edge of the top cover; once again, the black and grey lines were blended using eight steps. Finally the text for the spine was typed, sheared to the left and then rotated into position along the spine of the book cover.

(a) (b) (c) (d)

Figure 11.6 Smoothing a posterised image

(a) Original bitmap

(b) Shearing dialog box

(c) After shearing and rotation

Figure 11.7 Shearing an image

As we saw in Chapter 4, other basic photoediting operations allow the adjustment of hue, saturation and value in colour images, or selected areas of such images. The same tools can be used to 'colourise' greyscale images. Colour casts can also be removed from images by means of iterative use of the Variations feature.

For obvious reasons, such operations sadly cannot be effectively illustrated in a black and white publication such as this.

Selections, masks, paths and layers

Using selections

Less well understood and consequently less frequently used than the basic operations discussed so far, Selections, Masks, Paths and Layers are the features of painting and photoediting applications which offer the greatest creative potential to the designer.

A selection can be drawn on top of an image in the form of a simple rectangle or ellipse or, using the Lasso tool or Magic Wand tool, can take on a highly complex and detailed contiguous or non-contiguous shape. Once created, if necessary a selection can be edited both in shape and in size and, once the boundary has been finalised, the contents of the selection can be moved, by dragging, or can be copied or cut from its original position and then pasted into, or behind, other selections within the same or different images. For example, the Lasso tool was used to select just the head and the hands of the woman in Figure 11.8a. The selection was feathered to 2 pixels and copied to

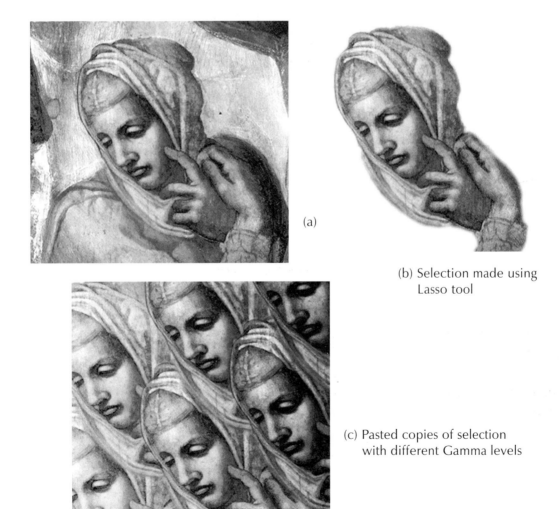

(a)

(b) Selection made using
Lasso tool

(c) Pasted copies of selection
with different Gamma levels

Figure 11.8 *Working with selections*

the clipboard. A single copy from the pasteboard is shown in (b). A new document was created and another copy of the selection was pasted into it from the clipboard. The copy was dragged to the bottom left-hand corner of the new document and, while still selected, Image/Adjust/Levels was chosen and the Gamma level was increased to 2.00. A second copy was pasted, automatically deselecting the first, dragged into position above the first copy, overlapping it partially and its Gamma level was set to 1.5. In turn, four further copies were pasted, each one being positioned in turn to build up the result shown in Figure 11.8c. Gamma levels of these copies were set at 1.0, 0.75, 0.5 and 0.3 respectively providing a progressive variation from light to dark moving from bottom left to top right.

Using masks

A mask is essentially a selection which can be used, like a traditional stencil, simply to protect one area of an image while paint, or a special effect, is being applied to the non-masked area. Masks may be used 'on the fly' and then discarded or, if subsequent use is anticipated, saved to a channel. Any one or more of the whole range of editing options available for the complete image can equally be applied locally to areas not protected by the mask.

To create the result shown in Figure 11.10, a copy of the image of the 'Laughing Cavalier' (Figure 11.9a) was imported into Photoshop and his hat was selected using the Magic Wand tool. After using Select/Inverse to invert the selection, clicking on Quick Mask caused the area of the hat to be filled with pink, to show that it was protected. While working in Quick Mask mode, the

(a) (b)

Figure 11.9 *Working with masks*

Brush tool, loaded with black paint, can be used to extend the limits of a masked area; this method was used to expand the mask from just the hat to include the head and neck down to the collar. Cancelling Quick Mask now showed a selection consisting of the hat and the head. The selection was cut to the clipboard, leaving a black background where the head and hat had been. The Clone tool was used to fill this area by cloning from the neighbouring textured areas. Next, the Lasso tool was used to draw a selection which enclosed the arm and everything to the bottom right of the image and the selection was saved in a channel—see Figure 11.9b. This selection was then inverted, so that the area coloured white in (b) became the selection, and the head was pasted back from the clipboard, using the Paste Inside option. Finally, the head was dragged into position 'underneath' the arm—and all the while, he continued to smile!

Figure 11.10 *With his head tucked underneath his arm*

As the above example shows, alterations to the effect of a mask can be achieved by 'painting' within its boundaries (painting with black adds to the mask, painting with white erases the mask and reveals the image below, while painting with grey partially removes the mask, selectively exposing the image beneath. A greyscale mask can have fills, edits and other special effects applied to it to control how much detail passes through to affect the image below. Alternatively, an existing bitmap can be used to edit a transparency mask.

Figure 11.11 shows an example of an image (a) being edited by the application of a radial gradient to its mask. After selecting the whole image, Quick Mask was switched on and a radial gradient was applied, shading from black through to white. With Quick Mask switched off, the image was now covered by an invisible mask which was ready to act as a filter to any effect applied to the image. To produce the result shown in (b), a black fill was applied to the whole area, passing through the filter and affecting the image where the mask was thin and vice versa.

Figure 11.12 shows how a bitmap can be used to edit an image to create an ephemeral, dream-like image. First, a picture of a girl (a) and a picture of clouds (b) were imported into Photoshop. Image parameters—dimensions and dpi—were adjusted until the two matched. Image (a) was selected and Quick Mask was switched on; then image (b) was selected and dragged across to overlay image (a), becoming its mask; (a) was reselected and Quick Mask was switched off, leaving the clouds as an invisible filter overlaying the

(a) (b)

Figure 11.11 *Editing an image with a gradient*

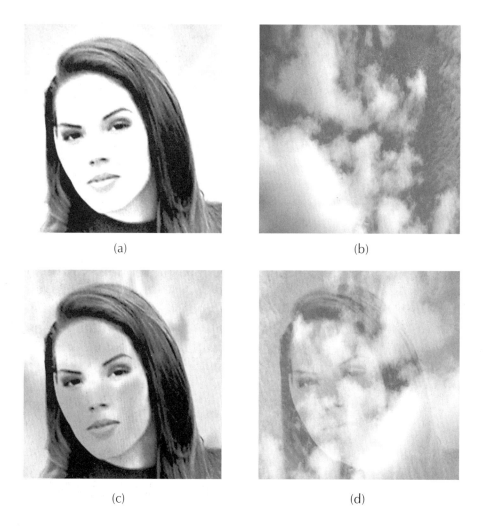

(a) (b)

(c) (d)

Figure 11.12 *Editing an image with a greyscale bitmap*

image of the girl. Finally a black fill was applied to the whole image and its opacity adjusted until the effect in (c) was obtained. To produce the result in (d), the process described above was reversed, i.e. the clouds (this time flipped horizontally) were used as the base image and the girl was used as the filter, once again using black at a reduced opacity to fill the final image.

Another way to create composite images in Photoshop is to use the Channel Merge command from the Channels palette to combine images into a single Multichannel document and then to use the Apply Image feature from the Image menu to combine the contents of the channels using one of the Blending options. The effect can produce a powerful visual association between two images as shown in the example in Figure 11.13. Images of India (a) and the Bengal tiger (b) were first merged into a single multichannel document using the Channel Merge command. Selecting Image/Apply Image then opened the dialog box shown in (c) which offers a dropdown list of Blending options. To produce the result in (d), the Darker option—which com-

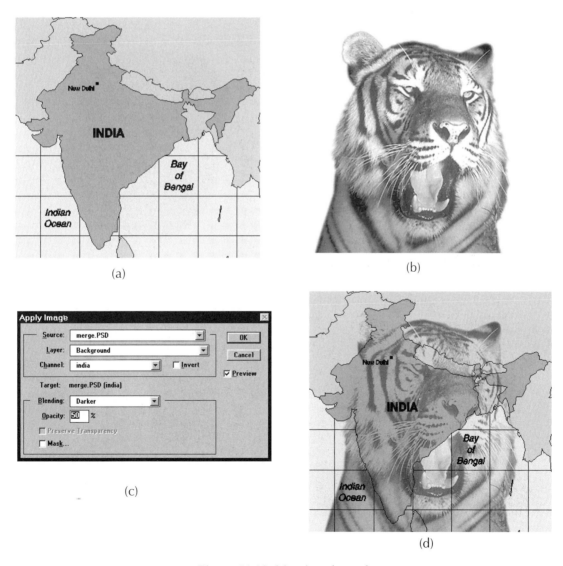

Figure 11.13 *Merging channels*

pares the brightness values of the corresponding pixels in the two image channels and displays the darker of the two—was selected, with Opacity, which controls the strength of the effect, set to 50%.

Yet another compositing method, which uses Photoshop's Calculations feature is shown in Figure 11.14. Suppose we want to create an image which associates China's repressed 'bicycle economy' with the ideology of Chairman Mao. First we select the two images (a) and (b) which we want to composite, having first selected the head of Mao from its original background and pasted it into a new document with a feathering of two pixels. Next, the head is scaled down to a size which will fit into the bottom right-hand area of (a) and then the canvas size of (b) is increased, using the Image/Canvas command to set the image dimensions and resolution of (b) equal to those of (a). Clicking Image/Calculations opens the dialog box shown in (c), within which the channels to be merged can be selected, composited using any of the Blending options and saved into a new document. To create the effect in (d), the Multiply option—which multiplies the pixel values in the two chan-

(a) (b)

(c) (d)

Figure 11.14 *Using Calculations*

nels and divides the result by 255, rather like superimposing two positive transparencies on a light table—was applied with an Opacity of 60%.

Paths

Instead of using the Lasso tool to select an irregularly shaped object, a smoothly curved Bezier path can be drawn to outline it. Such a path can be open or closed and remains editable, by means of its nodes and handles after it is drawn. Closed paths can be converted to selections and manipulated like any other selections. Paths can also be saved and opened in vector applications, for example, to provide a curved path which vector text can be fitted to. The text, and path if desired, can then be reimported to the photoediting application. An example is shown in Figure 11.15. The Pen tool was selected from the Paths tools palette and used to draw a smooth curve following the curve of the seal pup's back (a). The path was saved to the Paths palette by clicking on the right pointing arrow in the Paths dialog box (b) and selecting Save Path, while the path was still selected. The path was next exported using the File/Export/Paths to Illustrator command, which creates a file in .AI format. This file was then imported to CorelDRAW and the text was created

(a) Path drawn in Photoshop

(b) Path saved in Paths palette

(c) Text fitted to path

Figure 11.15 *Using Paths*

and fitted to the path. The path was deleted and the text was saved in .AI format and then reintroduced to Photoshop, using the Place command, which imports an .AI file as a floating, editable selection. A drop shadow was added to the text to produce the final result in (c).

A special type of path, called a 'clipping path', can also be used to define an area within an image, which can then be exported to a vector drawing program. When imported to such a program, only the area inside the clipping path will display, the area outside being transparent and revealing any underlying vector drawing. (A selected area of an image which is exported without the use of a clipping path will appear in the drawing program within an opaque white rectangle which obscures the vector image beneath it.) An example is shown in Figure 11.16. The objective was to clip the chimpanzee (a) from its greyscale background and place it 'inside' the vector drawing of a stall (b). A path was first drawn around the outline of the chimpanzee and saved to the Paths palette (c). The path was converted to a clipping path by selecting it and choosing Clipping Path from the menu opened by clicking the right facing arrow in the Paths palette. The image was saved in .EPS format and then imported to Corel DRAW, where it was scaled to the required size and positioned within the open frame of the stall (d).

Figure 11.16 Clipping paths

Other means can also be used to achieve such a result. Traditionally, drawing applications have provided the means of cropping imported bitmaps, but only by reducing the size of the bitmap in the X or Y direction. In applications such as CorelDRAW, however, it is now possible to crop or 'clip' a bitmat to a precise shape with the use of the node editing tool. In Figure 11.17, selecting bitmap (a) causes four nodes to appear at its four corners. Selecting nodes (i) and (ii) and dragging to the right and then selecting nodes (iii) and (iv) and dragging to the left clips the image to the size shown in (b). Three more (curve) nodes—(v), (vi) and (vii)—are next added at the points on the perimeter as shown, by means of the Node Editing palette (c). Dragging these inwards trims the bitmap back to the final required shape in (d).

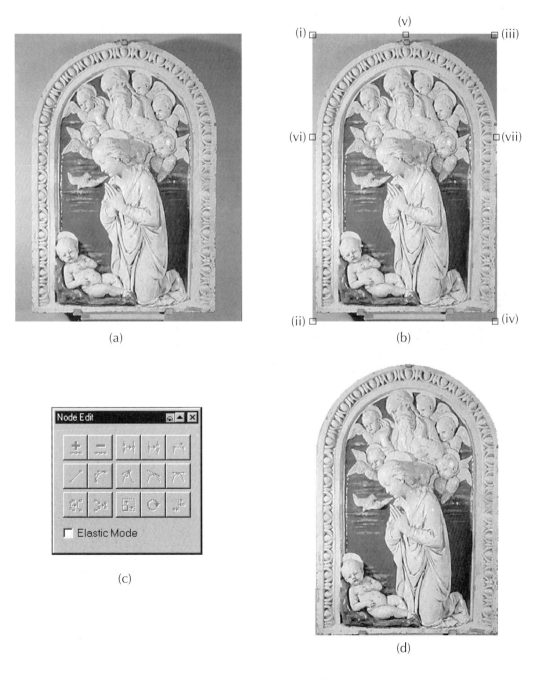

Figure 11.17 *Node editing a bitmap*

CorelDRAW's Power Clip feature can also be used to clip a bitmap, as shown in Figure 11.18—especially useful for those needing to feature a giant Galapagos tortoise in a vector composition! To produce the final result in (d), the image (a) was first imported into CorelDRAW. Using the Freehand drawing tool, a closed outline was drawn around the shape of the tortoise (b). This outline was to become the Container for the bitmap. Image (a) was next selected and Place Inside Container was chosen from the Effects/Power Clip menu (c). Choosing this option turns the mouse cursor into an arrow; clicking the arrow on the outline of Container (b) caused the bitmap to be clipped inside it, as in (d).

Layers

The introduction of the use of Layers in applications like Photoshop and PHOTO-PAINT has vastly increased the possibilities for the designer. In use, layers act rather like a set of transparent overlays. Items on one layer can be edited independently of items on another and each layer has its own 'layer mask' which can be edited to control the way in which layer contents interact with one another. As with most good things in life, however, there is unfortunately a price to pay—each layer added increases the file size by 100%

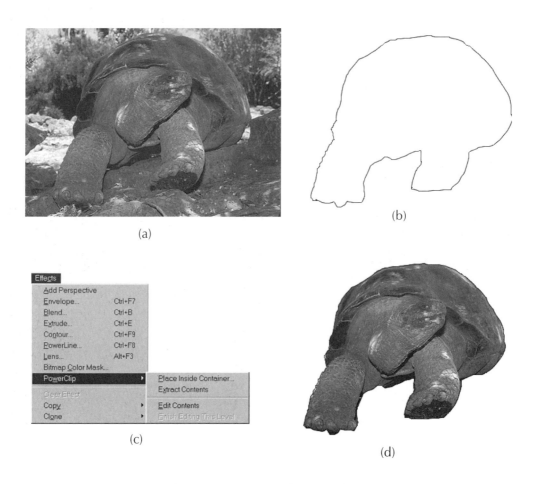

Figure 11.18 Power Clipping a bitmap

of its original value, so working on large, high resolution colour images will make high demands on your system. A way of avoiding this can be to save a new copy of the working file (including the layer information), as the work on each new layer is completed and then to 'flatten' the completed layer into the base image before a new layer is created; while keeping the file size manageable, this approach does forfeit the flexibility of being able to experiment with different edits on individual layers while observing the composite effect on the final image in real time.

Figure 11.19 shows two simple examples. In the first example, an image of a rose is loaded to the background layer and text is placed immediately above it on Layer 1, as can be seen in the Layers dialog box in (a), producing the result shown in (b). Even after it is deselected, the text remains editable; it

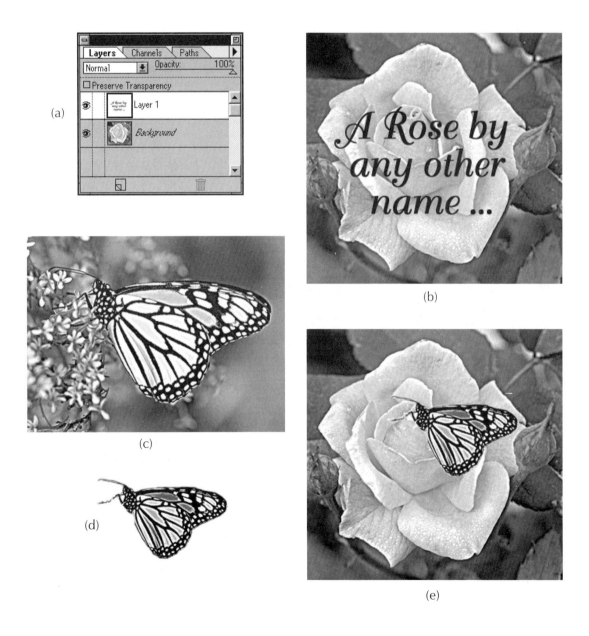

Figure 11.19 *Simple use of layers*

can be moved, scaled, rotated, have its fill or stroke attributes altered or its opacity changed by means of the opacity slider in the dialog box.

Figures 11.19c–e show an example of layer use for simple photomontage. From the image in (c), the butterfly was selected using a combination of the Magic Wand tool and Quick Mask. The resulting cutout (d) was then scaled, its grey tones were adjusted using Levels and it was then dragged and placed in position on the rose (e). As did the text, the butterfly remains fully editable after deselection.

The example in Figure 11.20 shows a more complex layering effect. Starting with image (a) as the background layer, a flower (b) was cut out of a second

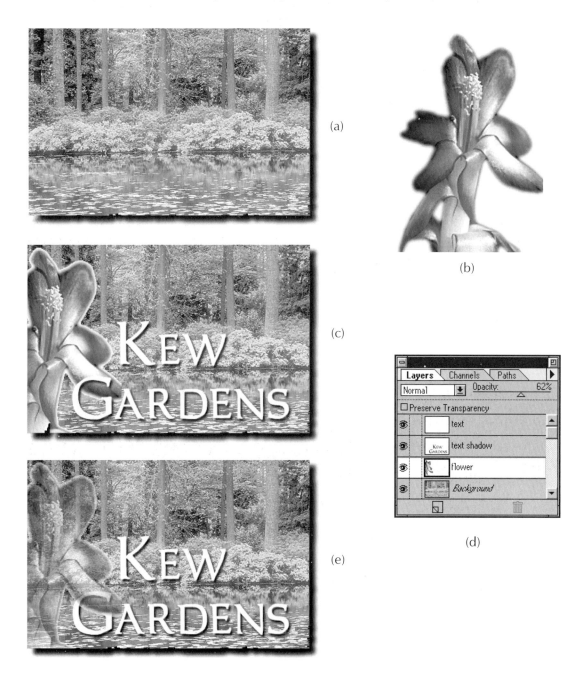

Figure 11.20 *More complex layer assembly*

image and pasted on to a second layer, above the background. A third and then fourth layer were added to carry text shadow and text respectively, making four layers in all; text was first added to the top layer using Photoshop's text tool and filled with white and then the text was copied , pasted to the empty layer below, filled with black, offset 3 pixels to the right and 3 pixels down and then given a Gaussian Blur to create a soft drop shadow for the text above it (b). Layer contents appear in the Layers palette (c). Text on the top layer is not visible as it is filled with white.

Figure 11.20d shows how easily layers can be edited, once set up. In this case, the opacity of the second (flower) layer was reduced to 60%, making it partially transparent, and it was then dragged above the text layer in the *Layers* palette to make it overlay the text beneath.

The use of layer masks introduces yet another dimension of possibilities. Each layer can have its own layer mask which, as suggested earlier, can be thought of as a filter which suppresses the image where the mask is black, makes visible the contents where the mask is white and partially visible where the mask is grey. Figure 11.21 shows an example. A new file was created with image (a) as the background layer and then a second layer was created for placing text as shown in the Layers palette (b). With the second layer still selected, Add Transparency Mask was chosen from the dropdown menu accessed by means of the right facing arrow at the top right of the palette, causing a 'mask' window to appear on the text layer to the right of the original window. Clicking the mask window to select it, the two words of text were typed on to the mask and filled with white; as explained above, the white text effectively punched holes in the mask, ready to reveal anything which was placed in the layer window to its left. The latter window was selected and, in turn, the areas corresponding to the positions of the two

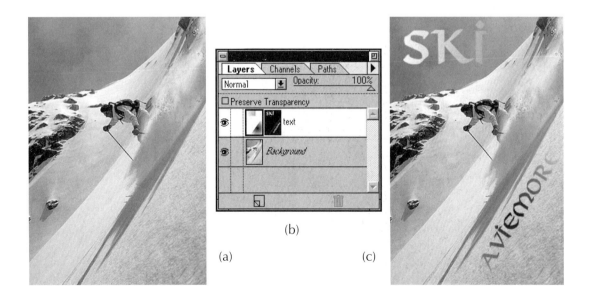

Figure 11.21 Using a layer mask

words were selected and filled with gradient fills, which now showed through the mask to produce the result in (c).

Another powerful technique offered by the Layers function is the ability to place one image above another and then to select a combination of pixels from the two images to produce a third, composite image. This effect is demonstrated in Figure 11.22. After cutting the image of the girl's head (a) from its background, three copies were pasted on to three separate layers above the image of a cloudlike texture which formed the background layer. The layer carrying the first head was selected and Layer Options was chosen from the Layers palette drop down menu (b). The sliders in the Layer Options dialog box are used to control which pixels, on which layer, appear in the final, blended image. If the colour values of the pixels in the upper layer are inside the range specified on the This Layer slider, they are blended into the final image, while if the pixels in the underlying visible layer are outside the colour range specified by the Underlying Layer slider, they are retained in the final image. Figure 11.22c shows the different results obtained by varying the settings of the sliders.

Figure 11.23 shows the power of Layers in creating a complex photomontage which combines two photographic images, (a) and (b), three clipart

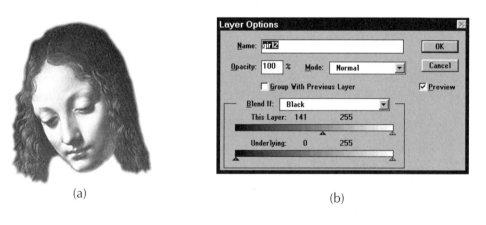

(a) (b)

(c)

Figure 11.22 *Blending layers*

(a)

(b)

(c) Three clipart images

(d)

(e)

Figure 11.23 *Photomontage*

images (c) and text, on six different layers (d). A number of different layer treatments were used to achieve the final result shown in (e). The photographic image of La Grande Arche at La Défense in Paris was used as the background layer, the view through the arch to the sky providing a centre point around which the other components could be placed. The image of the violin was placed in position on the second layer and its opacity was reduced to 70%, allowing partial show-through of the background. The clipart image of Sacre Coeur was then pasted on the third layer, scaled, rotated and positioned to the bottom right of the composition; to create a feathery outline, a layer mask was added—see (d)—and a rectangle enclosing the area of the church was filled with white; next the airbrush paint tool, using a large soft-edged setting, was used to paint with black into the mask around the perimeter of the church to suppress those parts of the image. The Eiffel Tower was added, its image inverted, using Image/Map/Invert, and placed in position, followed by the Arc de Triomphe on the fifth layer which was rotated and placed, using the Difference option in the Layers menu (the Difference option subtracts the brightness value of the pixels of the active layer and the background layer and displays the result); the opacity of this layer was reduced to 40%. Finally the text was added using the Text tool and rotated to align with the inner frame of the arch.

The method used above to create a feathery edge to the Sacre Coeur image by painting out the edges of the image is used in a different way in Figure 11.24. In this case, only two layers are involved, with the image of the skull (a) pasted on to the upper layer and the image of the man's head (b), used as the background layer. Using a reduced opacity for layer two, so that both images were visible, the skull was scaled, and positioned so that the principal facial features—the eye sockets, nose and mouth—were aligned with the same features of the image on the lower layer. A layer mask was then applied to the upper layer and filled with black, the effect of which, as explained earlier, is to suppress totally the image on this layer, i.e. at this point in the process all that is visible is the face on the background layer. To re-introduce part or all of the skull into the composite image, white paint has to be applied to the mask. Therefore, with the upper layer and its layer mask still selected, a soft-edged brush was chosen, loaded with white paint and carefully applied to the areas of the image to the left side of the man's face. The effect on the layer mask can be seen in (c) and the effect on the composite image is shown in (d). Painting out part of the mask has caused that part of the skull image to reappear, overlaying the corresponding features of the lower image.

Earlier in the chapter, we looked at several techniques—clipping paths, node edit cropping and Powerclip—which can be used to 'clip' a selected part of a bitmap image from its background. Using layers, we can also create 'clipping groups' which allow a selection on one layer to be defined as a mask for one or more layers above it. For example, if there is a shape on one layer, an image on the next layer, and some text on a third layer, then all three layers can be defined as a clipping group so that the image and the text appear only through the shape. In a clipping group, the bottom layer in the group

(called the base layer) controls the mode and transparency of all other layers in the group. The Layers palette indicates a clipping group by dotted lines separating the layers within the group. The name of the base layer is underlined in the Layers palette. Examples are shown in Figures 11.25 and 11.26. To produce the result shown Figure 11.25, a vector image of a rose (a) was imported to Photoshop and placed above a white base layer to form the clipping shape. After pasting the image of the girl (b) on to the layer above the

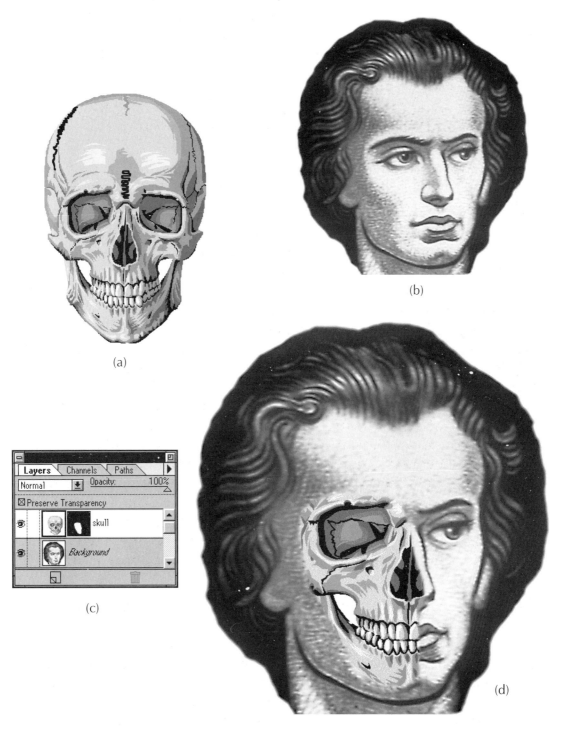

Figure 11.24 *Painting in a layer mask*

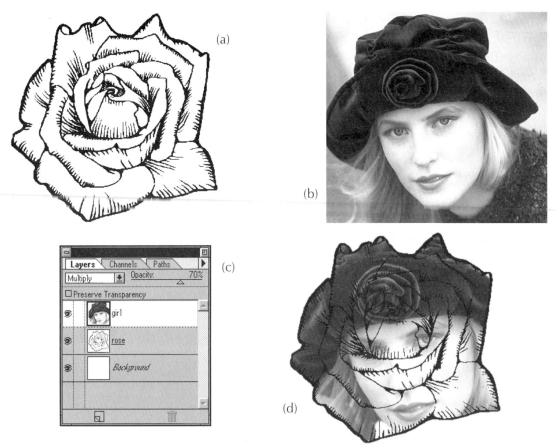

Figure 11.25 *A simple clipping group*

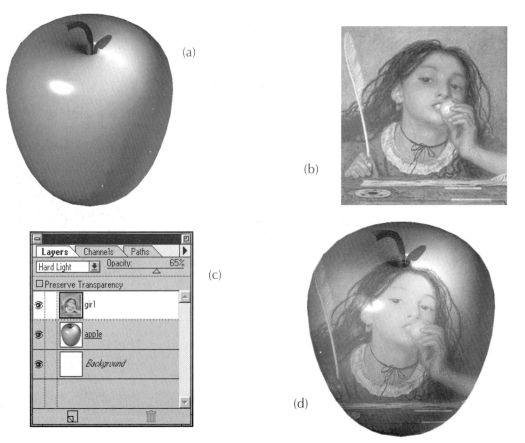

Figure 11.26 *Using a clipping group to create a painted look*

rose, Alt-clicking on the boundary in the Layers palette (c) between the two layers created a clipping group in which the girl was now seen through the shape of the rose. To produce the result shown in (d), the opacity of the upper layer was set to 70% to allow show-through of the rose outlines and the effect was enhanced by using the Multiply mode for the top layer (Multiply mode multiplies the shade of each pixel in the base layer by the shade of the corresponding pixel in the upper layer).

A more interesting result is shown in Figure 11.26, in which a rendered three-dimensional image of an apple (a) was used as the clipping shape. The image of the young girl eating an apple was placed on the upper layer and Hard Light was selected as the blending mode as shown in the Layers palette (c), with opacity set at 65%. Hard Light mode creates an effect similar to shining a spotlight on to the image. Where the upper layer is lighter than 50% grey, the image is lightened, creating highlights; where the upper shade is darker than 50% grey, the image is darkened, creating shadows. The result (d) has the appearance that the picture of the girl has been painted on the shiny surface of the apple. To enhance the effect, the Airbrush tool was used on the upper layer to darken further the shadow areas.

Before leaving the subject of bitmap clipping, CorelDRAW's bitmap colour masking feature is worth mentioning. Normally, when a bitmap is imported into a vector drawing application, it is 100% opaque, completely obscuring any objects on top of which it is placed. Using the *Bitmap Colour Mask*, however, it is possible to select colours within a bitmap and suppress or hide them, so that an underlying vector or bitmapped object can show through in these areas. The colour mask dialog box is found under the *Effects* menu and is shown in Figure 11.27. To pick a colour to hide—or a shade of grey in a greyscale image—the bitmap is first selected and then the eyedropper tool in the dialog box is activated by clicking with the mouse. Clicking with the eyedropper tool on the chosen colour or shade to be hidden in the bitmapped image then causes that colour to display in the first horizontal stripe in the dialog box; the colour *Tolerance* with which the chosen colour or shade is hidden can be varied by adjusting the slider at the bottom of the dialog box between 0 and 100%. Figure 11.28 shows the mask at work. To demonstrate the effect, a greyscale bitmap of a dog (a) was placed on top of a bitmap image of a wolf (d) and then the colour mask eyedropper was used to select four of the shades of grey in the image of the dog. To produce (b), tolerance was set at 12% for each of the four shades selected, allowing the image of the wolf to start to show through the image of the dog. To produce (c), the tolerance was increased to 24%.

Figure 11.27
Colour mask dialog box

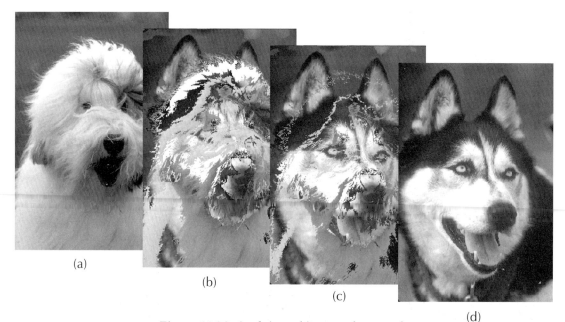

(a)

(b)

(c)

(d)

Figure 11.28 *Applying a bitmap colour mask*

Image distortion

In the work of many great artists—Salvador Dali, Pablo Picasso and Francis Bacon, to name but three—we can find striking examples of art in which reality has been distorted in order to achieve powerful, heightened, visual impact, while in the fields of caricature and cartoon, exaggeration and distortion have for centuries been the very stock in trade of their creators. Such effects can also produce startling results when applied appropriately within our digital environment. Earlier in the book, while exploring other effects, we have seen some examples of how both vector and bitmapped objects can be distorted by the processes of non-proportional scaling, shearing and applying perspective. In this section we shall investigate more fully the fascinating distortion options which are now at the disposal of the graphic designer.

The first four examples use CorelDRAW's Lens function. By applying a lens to an object or part of an object, we can change the appearance of the object, or part of the object, which lies beneath the lens. A lens does not change the object beneath, only the way the object appears through the lens, i.e. if we select and move the lens aside, the object reappears in its original form.

A lens is generated using any drawing tool to create its shape and size and then by clicking on Apply in the Lens palette. Figure 11.29 shows an example which uses the Magnify lens set to a magnification of 2x (a). This example demonstrates a practical use of this feature, which is to create lenses to magnify details of an object—in this case a guitar (b)—and then, by applying the Freeze button in the palette, to drag and position copies of the lens contents (c), (d) and (e) around the original object.

Figure 11.30 shows the distortion effect of the Fisheye lens at a Rate of 150% (a). A circular lens applied to the Chuck Berry sketch in (b) produced the

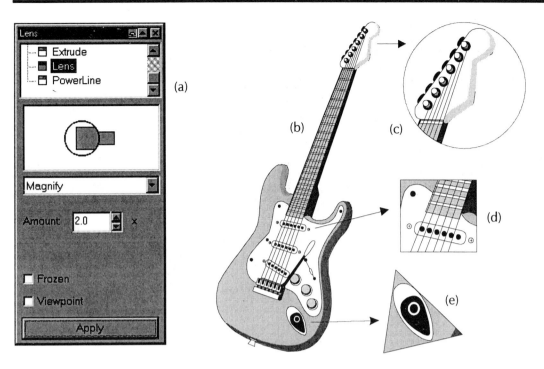

Figure 11.29 *Using the magnifying lens*

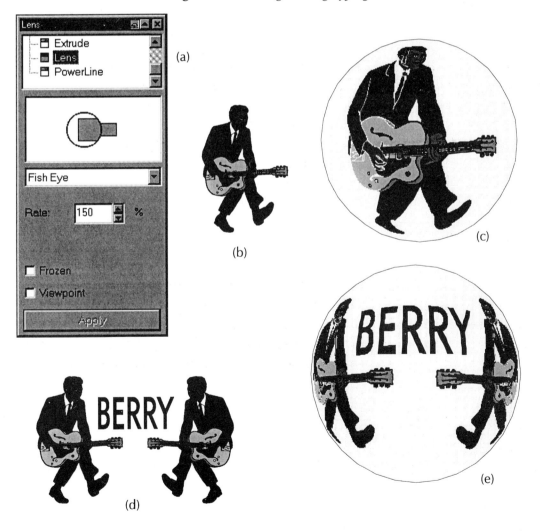

Figure 11.30 *Using the fisheye lens*

result in (c). Lenses can also be applied to groups of objects, as shown by applying a circular lens to the group (d) in order to produce the result in (e). In the above two examples, the lens outline is shown, but if required, it can be suppressed by selecting it and applying an outline of None.

As seen in Figure 11.30 and again in Figure 11.31, the distortion applied by the fisheye lens can simulate the effect of wrapping the object around a hemispherical surface. Both of these examples use the lens in a positive mode i.e. the object is distorted in a convex direction. Using the lens with a negative Rate setting distorts the object to which it is applied in a concave direction. Figure 11.32 shows a variety of positive and negative lenses applied to a regular XY grid. Using the Frozen option—see Figure 11.30a copies of the lenses and underlying parts of the distorted grid were made and positioned to the right of the grid.

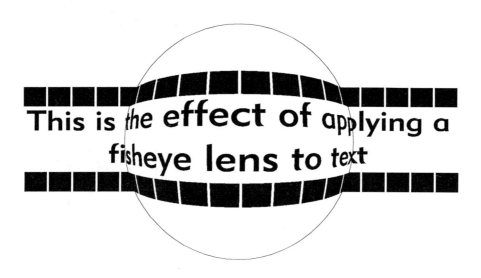

Figure 11.31 *The effect of the fisheye lens on text*

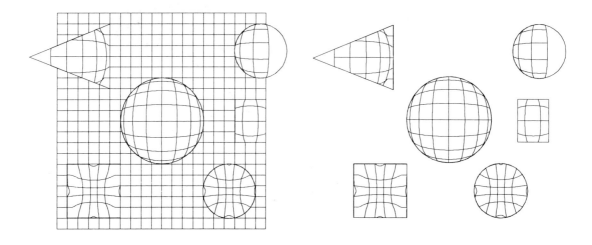

Figure 11.32 *Positive and negative fisheye effects*

In this section, Micrografx Designer's Warp tool also deserves a mention. When an object is selected for warping, Designer places a warp frame around it. As nodes on the grid are dragged, the object distorts in response. The Add Warp button (Figure 11.33a) replaces an edited warp frame with a new one. The Remove Warp button cancels the last warp grid and replaces it with the previous one. The Line Warp button uses straight edges to edit a warp grid, while the Curve Warp button uses curves and the Bezier Warp button uses curves and Bezier control points. The Add Horizontal and Add Vertical buttons double the number of editable horizontal and vertical nodes in the grid.

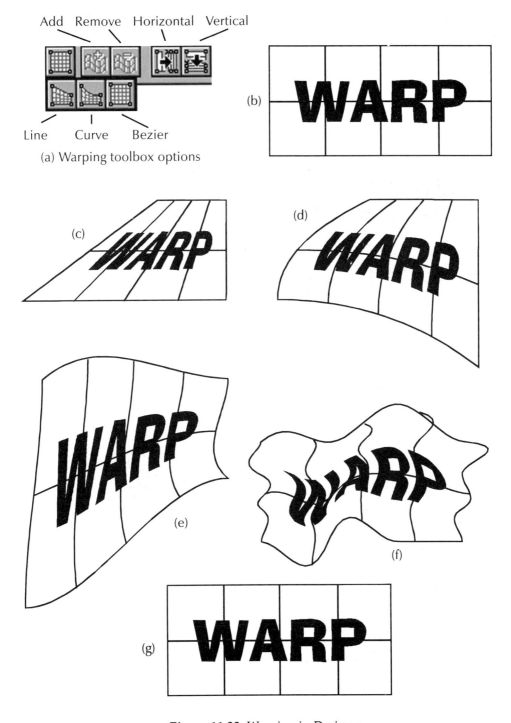

Figure 11.33 *Warping in Designer*

Figure 11.33b shows an object, consisting of text superimposed on a simple line grid, before warping. (c) shows the effect of applying the Line Warp tool and (d) shows the effect of the Curve Warp tool. (e) shows the more extreme effect of using the Bezier Warp tool using a 5 x 5 Bezier node array, while (f) shows the more detailed effect of using a 10 x 10 Bezier node array. The test object contained within the 10 x 10 array is shown in (g) prior to warping.

Photoshop, PHOTO-PAINT and Painter all provide the means of distorting an image using a 'pinching or punching' technique. Figure 11.34 shows a Photoshop example. After selecting image (a), clicking on Filters/Distort/Pinch opens the dialog box in (b). Moving the slider between 0 and +100% causes an imploding or pinching effect on an image, while varying it between 0 and −100% creates an exploding or punching effect. The dialog box grid and

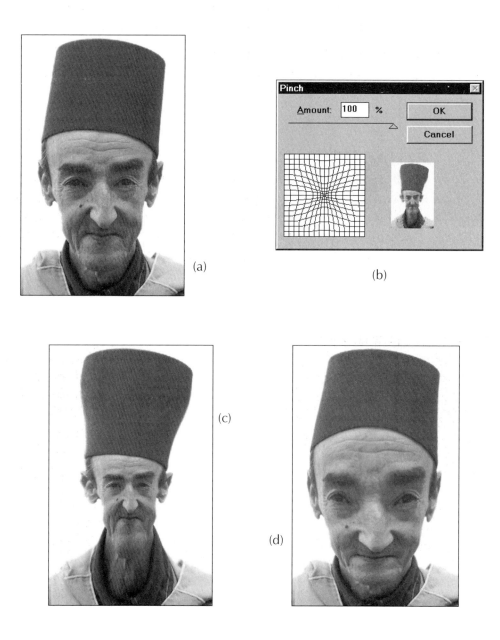

Figure 11.34 *Pinching and Punching in Photoshop*

thumbnail provide respectively a preview of the strength of the effect and the impact on the image, prior to updating it. The effect of applying the full +100% pinching effect is shown in (c), while (d) shows the result of applying the full –100% effect.

As well as offering a similar Pinch/Punch feature to that of Photoshop, PHOTO-PAINT provides a Mesh Warp facility, with user control over the mesh. Clicking on Effects/3D Effects/Mesh Warp opens a dialog box, as shown in Figure 11.35, which displays the image to be warped behind an XY grid of lines. Each line intersection displays a node which can be dragged by means of the mouse; as the node moves, the image beneath it distorts. Clicking the Preview button shows the effect on the image within the dialog box. For more detailed manipulation, the number of editable nodes can be increased by adjusting the slider at the bottom of the dialog box to increase the number of grid lines up to a maximum of ten. As Figure 11.35b shows, this method allows more detailed distortion than the simple Pinch/Punch feature.

While Photoshop and PHOTO-PAINT can produce interesting results, Painter has a clear lead in the area of image distortion. Where PHOTO-PAINT provides a grid for warping, Painter's Mesh Warp feature allows the user to manipulate an image as if it were made of elastic; instead of just fixed points being dragged, the whole of the image area selected distorts smoothly as if stretched, creating effects like those seen in funfair distorting mirrors.

Figure 11.36 shows some examples. Clicking Effects/Surface Control/Mesh Warp opens the dialog box in (a), displaying a thumbnail of the image to be warped. The reading on the slider determines the area of the effect, which can be applied after selecting one of three different methods indicated by the three radio buttons in the dialog box. The Linear button pulls the

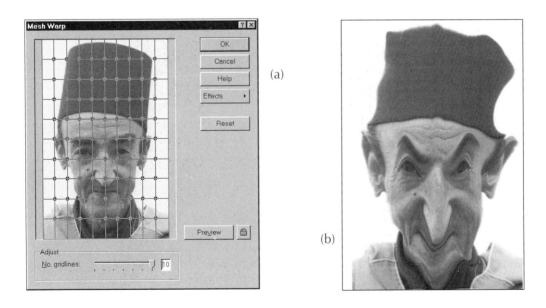

Figure 11.35 PHOTO-PAINT's Mesh Warp feature

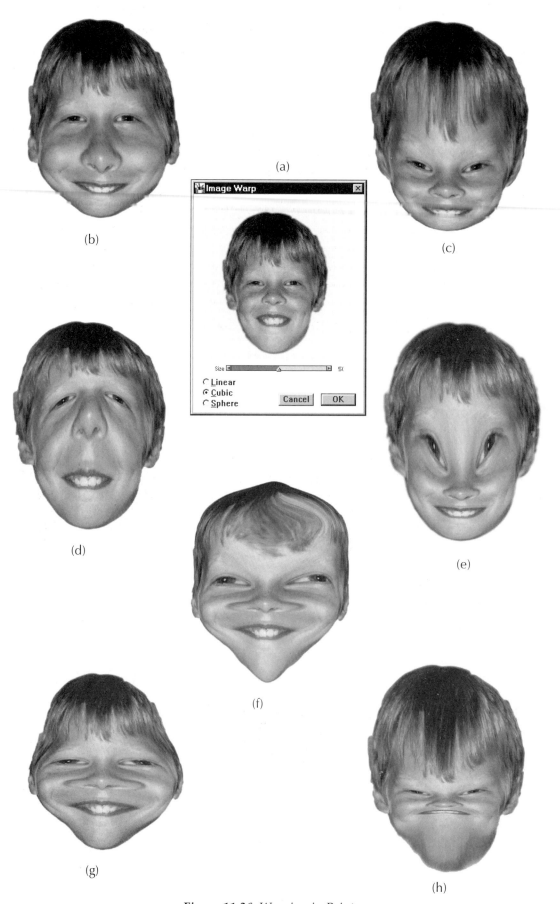

Figure 11.36 Warping in Painter

selected area as if pulling from the top of a cone. The Cubic button pulls as if dragging a flat surface. The Sphere button pulls a surface as if applying a lens to the surface to distort the image. As the mouse is dragged in the thumbnail displayed in the dialog box, a circle appears, denoting the area affected. Figure 11.36 b–h shows just a few examples of the wide range of effects which can be obtained with a little experimentation.

An even more intuitive distortion method provided by Painter is its Distortion paintbrush which, in use, has the same effect as moving wet paint around on a painting. The Distortion brush is found within the Liquid drawer in Painter's brushes palette—see Figure 11.37a. For the purpose of this example, the Coarse variant was selected, the brush size was set to 172 in the Brush Controls palette and our old friend the chimpanzee was selected as the guinea pig (c). Using the Distortion brush simply involves placing the brush cursor over a point in the image and then holding the mouse button down while dragging in the direction to be distorted. The size of the brush dictates the coarseness of the distortion. The three examples (d), (e) and (f) were produced by applying multiple strokes with the 172 size brush.

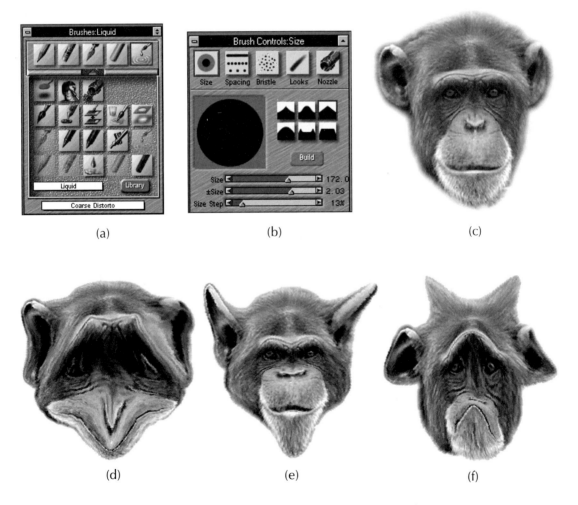

(a) (b) (c)

(d) (e) (f)

Figure 11.37 Using Painter's Distortion brush

12

Filters and Special Effects

The filter has long been a tool used by creative photographers to enhance their work. Placed directly in front of the camera lens, the photographic filter interacts with the light originating from the image, modifying it before it reaches the film in the camera. While the earliest filters did little more than apply a particular tint to the final image by selectively removing a range of wavelengths from the incident light, modern filters offer a wide range of effects from soft focus to starbursts.

In the sense that it provides a way of interacting with and modifying an original image, the digital filter is similar to the photographic filter, but the way in which the interaction takes place is, of course, quite different. The digital filter 'sees' an image simply as an array of pixel addresses, with each address describing the present state of the pixel—e.g. black, white, 20% grey, 40% red—and changes the state of the pixels, using a mathematical formula or algorithm, so altering the appearance of the image. As the thing that computers do best is to apply specified formulae consistently, rapidly and repetitively, the potential of the digital filter was recognised and investment in design of ever more complex digital filters has grown apace in the last few years.

Early development focused on designing filters to improve productivity by providing assistance with common design tasks like sharpening the focus of an image, but more recent developments have extended the scope to cover the whole gamut from the sublime to the ridiculous. As range and power have increased, so too has the sophistication of the controls provided, to the point that some filters, such as Kai's Power Tools, have assumed the proportions of mini-applications in their own right.

Analysis of the filter sets currently being provided with popular applications like Photoshop, PHOTO-PAINT and Painter shows that some common denominators have already been established both in terms of the 'standard' filters provided and in their categorisation. The same analysis also shows that creativity is very much alive and well in this area, with exciting new filter types appearing with almost every new application update, increasingly supplemented by plug-ins from third-party designers.

As filter design is still a very new science, few standards have yet emerged and therefore little consistency exists between applications, concerning naming conventions or categorisation of filters or special effects. Table 12.1 is an attempt to suggest some major categories and to place the major filters and special effects provided by three leading applications into these categories. Within this summary are examples of filters and effects directly descended from the traditional world of photography, e.g. Dust and Scratches (for the removal of blemishes from a scanned image), Motion Blur (simulating the effect of photographing a fast moving object), Diffuse (to give an image a soft, atmospheric mood) or Lens Flare, which simulates the effect of photographing an image with the sun or a bright light source behind it.

At first sight, many other examples in the table do not appear to have a practical purpose, but in practice they do. For example, the Blur filters are useful for softening drop shadows; the Noise filters can be used to give an object texture or to reduce the visibility of banding in a printed image; the Ripple and Wave filters can be used to give an object a ragged edge or to create the effect that an object is blowing in the wind. The 3D and Perspective filters are extremely useful to the designer working on three-dimensional compositions. Filters in the Artistic Attributes category provide the means of creating canvas textures and giving an object or a whole composition a painted appearance.

The number and variety of effects which can be produced with the help of filters is virtually unlimited, so unfortunately, comprehensive coverage is not possible in the space available in this chapter. What is included in the following pages is a series of examples which hopefully will at least indicate some of the fascinating possibilities which they offer.

Noise

As mentioned above, Noise filters have a number of practical, rather than artistic applications, particularly in relation to cleaning up scanned images. As well as the obvious use of the Dust and Scratches filter, the Remove Noise filter softens edges and can reduce the speckled effect created by the scanning process. In Chapter 10 we also saw how noise can be converted to three-dimensional texture via the process of bumpmapping. Noise can also be used to provide a range of simple random two-dimensional textures to otherwise bland and featureless image backgrounds. The upper half of Figure 12.1 shows such a range, created simply by making a series of five rectangular selections, clicking Filters/Noise/Add Noise in Photoshop (a), and applying to each rectangle in turn a Gaussian noise level varying from 50 to the maximum of 999 (b). The lower half of Figure 12.1 shows how the same five noise settings can be used as a very simple way of adding visual impact to text characters.

Focus

Like those in the Noise category, a number of the filters in the Focus category have mainly practical application, such as use of the Unsharp Mask to

Table 12.1 Summary of filter and effects

CATEGORY	APPLICATION			
	Photoshop	**PHOTO-PAINT**	**Painter**	**Plug-ins**
NOISE	Add noise Despeckle Dust & scratches Median	Add noise Remove noise Dust & scratches Median 3D stereo noise		
FOCUS	Sharpen Sharpen edges Unsharp mask Gaussian blur Motion blur Radial blur Diffuse	Edge enhance Directional sharpen Unsharp Gaussian blur Motion blur Diffuse Smooth Soften	Sharpen Soften Motion blur	
PIXELATION	Crystallise Facet Fragment Mosaic	Pixelate Puzzle Mosaic Glass block		
DISTORTION	Displace Pinch Polar Ripple Twirl Wave Zigzag	Displace Shear Pinch/Punch Ripple Swirl Glass Whirlpool	Image warp	
ARTISTIC ATTRIBUTES	Pointillism	Canvas Impressionism Wet paint Psychedelic	Auto Van Gogh Autoclone Glass distortion	GE Watercolour
VALUE/LEVEL ADJUSTMENT	Solarise Find edges Trace contour High pass	Solarise High pass Outline Edge detect Contour	Colour overlay Dye concentration High pass	
TEXTURE	Mezzotint Wind Texture fill	Wind	Texture Screen	KPT Texture Explorer
LIGHTING EFFECTS	Lighting Lens flare	Lighting Lens flare	Lighting	Lighting
3D & PERSPECTIVE	Spherise Shear Extrude Emboss	Map to object 3D rotate Mesh warp Perpective Emboss		
OTHER	Clouds Custom Tile	Vignette Tile/Terrazzo Page curl The Boss	Blobs Grid paper Marbling	KPT Glass lens KPT Vortex tiling GE Plastic wrap

sharpen up the focus of an image, but some, like the Diffuse or Motion Blur filters, can also produce interesting effects. As its name suggests, the Diffuse filter can be used to break up the hard edges of an object. Figure 12.2 shows an example in which the Normal mode has been selected in the Diffuse dialog box (a) and applied to text in order to give it an aged or weathered appearance (b).

Motion Blur is another filter which breaks down the hard lines of an image, giving the appearance of a photograph of a fast moving object taken with a slow shutter speed. Figure 12.3a shows the dialog box, in which both the angle of blurring and its distance, or intensity, can be set. Applying the effect to the sports car (b), with the angle set to Horizontal and the distance set to 22 pixels produced the result in (c). Setting the blurred object against a static background and adding speed 'streaks' behind the car helps to reinforce the illusion of motion.

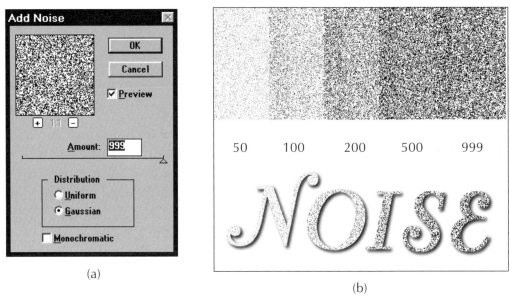

Figure 12.1 Using Noise to create texture

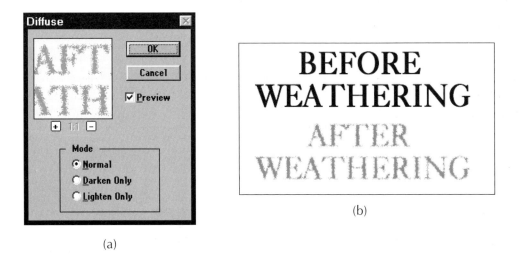

Figure 12.2 Using Diffuse to create a weathered look

Figure 12.3 Using Motion Blur

Pixelation

In the early years of desktop computing, users were obliged to suffer silently as they sat before grainy, pixelated screen images produced by low resolution graphics cards and then watched their output produced as equally grainy print-outs from low resolution matrix printers. While rapid advances in the design of graphics cards, monitors, printer engines and drivers and miraculous utilities like Adobe's Type Manager have largely put an end to this suffering, filter designers have now paradoxically rediscovered the potential of the pixel, offering filters which allow the user to create—yes, you've guessed it—grainy images on screen and grainy print-outs! These filters allow the user to control of the attributes of pixels of which an image is composed in order create some interesting special effects.

Figure 12.4 shows an example of the Crystallise filter at work. With this filter, the user can import or create an image in the normal way and can then, by choosing Filters/Pixelate/Crystallise, open the dialog box (a). The Crystallise filter groups pixels into a solid colour in a polygon shape, with a cell size as specified in the dialog box (the cell size is the width of a cell in pixels). An original image and three copies 'crystallised' using cell sizes of 4, 8 and 12 pixels are shown in Figure 12.4b. As can be seen from the examples, the effect of increasing cell size is progressively to reduce an image to its basic features.

The Mosaic filter, also found in the Pixelate submenu, groups pixels into square blocks. Once again, the cell size selected in the dialog box shown in Figure 12.5a specifies the width of each cell in pixels. The pixels in a given block are the same colour, and the colours of the blocks represent the col-

ours in the selection. As shown by the example in Figure 12.5b, increasing the cell size progressively from 4 to 6 to 8 pixels breaks down the smooth outlines of the original object, giving it an increasingly pixelated appearance.

Two of the pixelation filters included with PHOTO-PAINT are Puzzle and Glass Block. Applying the Puzzle filter breaks an image down into irregular square or rectangular blocks, of a size specified by the user. With Block Offset, space between blocks can also be specified, as can the fill of the space between the blocks. Figure 12.6a shows the dialog box with a thumbnail of the selected image displayed on the left and a preview of the effect using the current settings on the right. The effect shown in the dialog uses a Block Height of 10, a Block Width of 10, an Offset of 50% and a Fill colour of black. To produce the example shown in (b), Fill colour was changed to white, with the other settings remaining the same. Applying Noise and then Puzzle to a selection containing just a grey fill also provides a simple way of creating a textured background with a pleasing 'paved street' appearance.

Figure 12.4 Crystallising an object

Figure 12.5 Progressive pixelation

Applying the Glass Block filter to an image gives it the appearance of being viewed through a window glazed with a blocky textured glass. The horizontal and vertical dimensions of the glass blocks can be set independently. The lowest setting produces complete glass blocks in the viewing area, while larger settings produce a diamond-like pattern. The dialog box in Figure 12.7a shows a Preview using a Block Width of 12 and a Block Height of 12. The effect shown in (b) was created by first producing a window frame in CorelDRAW, using its Combine feature to render the 'glass' areas of the window transparent and then by importing the filtered image of the man shown in (a). The filtered image of the man was placed behind the window frame using Arrange/Order/To Back to create the illusion that the he was looking through the window.

(a)

(b)

Figure 12.6 Breaking an image into puzzle pieces

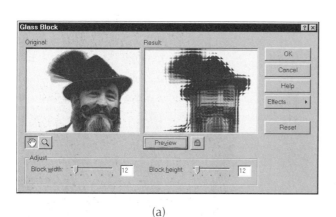

Figure 12.7 Through the looking glass!

Distortion

We already looked at the effects which can be produced using some of the distortion filters in Chapter 11. Here we shall only examine one additional variation—PHOTO-PAINT's Whirlpool filter which blurs an image by applying fluid streamlines to it. The Spacing slider controls the frequency of the fluid simulations, while the Smear Length slider controls the length of the fluid lines. The Twist slider makes the fluid flow in rings around the whirlpools or out of them like fountains, while the Streak Detail slider allows restoration of some of the image detail lost in the Whirlpool process. Clearing the Warp check box applies the fluid simulation on top of the image. Checking Warp applies the effect to the image itself by moving the actual image pixels to simulate the fluid streamlines. Figure 12.8a shows the Whirlpool dialog box, which includes a Style menu offering different effects. After selecting the image of the girl, a mask was created which protected the hair, the eyes and the mouth, limiting the filter application to the face. (a) shows the result of choosing and applying the Rings style, while (c) shows

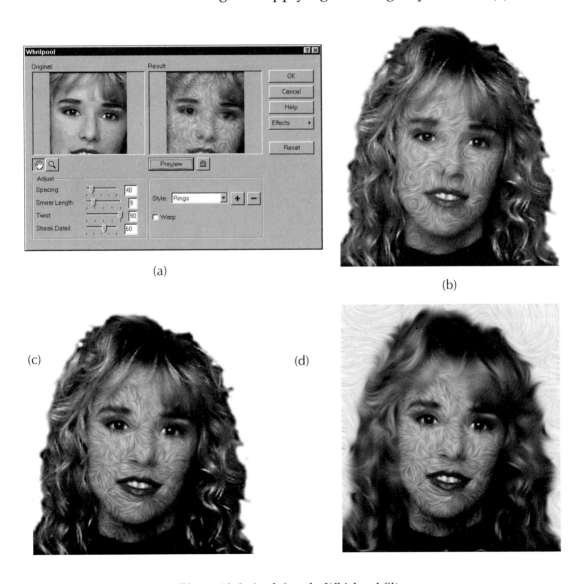

(a)

(b)

(c)　　　　　　　　　　(d)

Figure 12.8 *Applying the Whirlpool filter*

the effect created by the Fountains style. A copy of (c) was then made and the mask was inverted and modified to protect the face, eyes and mouth. The Brush Strokes style was then applied to the rest of the image to produce the result in (d).

Artistic attributes

As filter development became more sophisticated, designers began to discover effects which were reminiscent of the painting styles of some traditional schools of art. Further research into this artistic potential led to a number of filters which the designer can now use to give images, or selected parts of images, a painted appearance.

Pointillism, a late nineteenth century method of painting originated by the French painters Georges Seurat and Paul Signac, consisted of depositing small dots or strokes of pure colour on the canvas. To emulate this style, Photoshop's Pointillise filter breaks up the colour in an image into randomly placed dots, using the background colour as a canvas area between the dots. Dot or Cell size is specified in the filter's dialog bog—Figure 12.9a. The effects of applying the filter to image (b), using cell sizes of 3, 6 and 10 respectively, are shown in (c), (d) and (e).

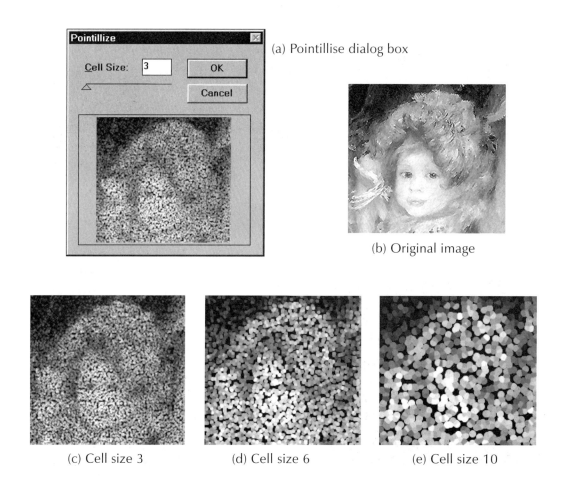

(a) Pointillise dialog box

(b) Original image

(c) Cell size 3 (d) Cell size 6 (e) Cell size 10

Figure 12.9 *Pointillising in Photoshop*

Impressionist painters like Edgar Degas, Claude Monet and Pierre Renoir were concerned more about the interaction of light with an object than with depicting the object itself, believing that light tends to diffuse the outlines of the form. Their primary objective was to achieve a spontaneous rendering of a scene through careful representation of the effect of the natural light illuminating it. They achieved this effect by placing short brushstrokes side by side, juxtaposing primary colours which would blend when viewed at a distance. PHOTO-PAINT's Impressionist filter seeks to emulate this effect. The degree of 'scattering' can be varied using independent horizontal and vertical sliders—see Figure 12.10a. The filter was applied to image (b), using a horizontal setting of 10 and a vertical setting of 5. If the settings are increased much beyond this level, then the objects begin to lose their identity—see subset of original image in (d) with horizontal and vertical settings of 15 and 5 respectively applied.

The work of Vincent Van Gogh, Dutch Post-Impressionist painter, is famous for an emotional spontaneity which represents the ultimate form of Expressionism. Painter's Van Gogh filter attempts to capture the spirit of the Van Gogh style. To demonstrate this filter, an image was opened in Painter and cloned using the File/Clone command. With the clone selected, the Artists brush group was selected and the Auto Van Gogh style was chosen from the submenu. When Esoterica/Auto Van Gogh was selected from the

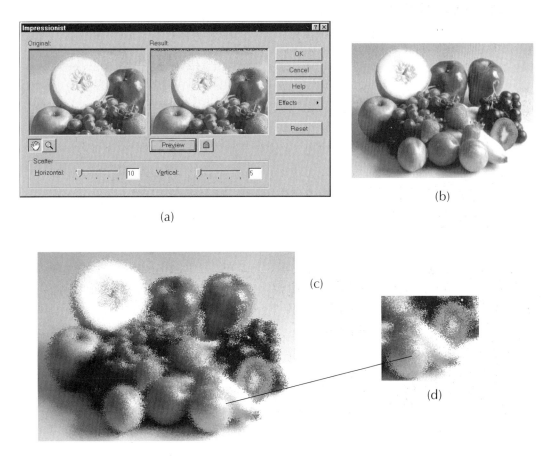

Figure 12.10 *A touch of Impressionism*

Effects menu, the clone was redrawn in a simulation of the Van Gogh style. Figure 12.11 shows an original image (a) and the result of applying the filter to a clone of the image (b).

Although it has the word 'distortion' in its description, Painter's Glass Distortion filter has been included in this section as it is capable of producing artistic effects when the Image Luminance option is selected in the filter dialog box—Figure 12.12a. Image Luminance creates texture based on the image's brightness. The dialog box provides control over Amount and Variance of distortion. The farther the Amount slider is moved to the right, the greater the distortion. The farther the Variance slider is moved to the right, the more the image will break up, as if composed of splintering glass. With the right combination of settings, an unusual, etched effect can be obtained—Figure 12.12b.

Gallery Effects' Watercolour filter can be used to alter the look of an image to make it appear as if painted in watercolours. The filter paints the image using a medium brush loaded with water and colour. The colour appears to have dried on smooth paper, leaving characteristic concentrations of pigment around the edges of the paint strokes. Figure 12.13 shows an example. The filter provides control over Brush Detail, Shadow Intensity and Texture. The transformation of (a) into (b) used settings of 12 for Brush Detail, 1 for Shadow Intensity and 2 for Texture.

If, out of all the filters which can produce artistic effects, only one could be chosen, then it would have to be Paint Alchemy for its sheer versatility. It provides 30 user-definable parameters arranged in five groups, as well as many preset styles. So numerous are the parameters that they are displayed on five tabbed pages within the dialog box; only one page is visible at any

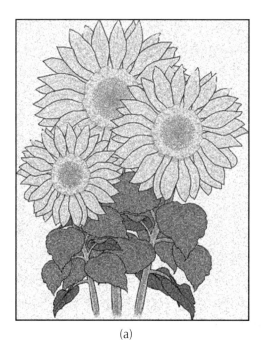 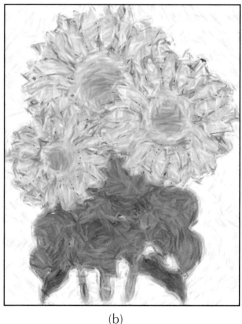

(a) (b)

Figure 12.11 *Van Gogh by Painter*

one time, but the parameter sets on all five pages are always active. The five pages provide controls for Brush, Colour, Size, Angle and Transparency. The range of possible effects is so great that it is only possible to include here a glimpse of what can be done with this versatile tool. Figure 12.14a shows the dialog box and 12.14b shows the test image to which various filter settings were applied to produce results (c) to (k).

(a) Glass Distortion
dialog box

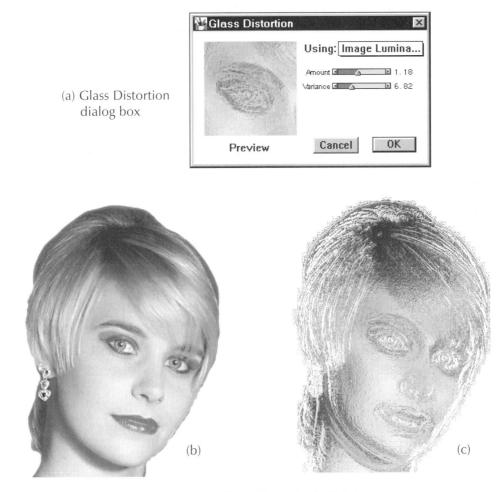

(b)

(c)

Figure 12.12 *Glass Distortion in Painter*

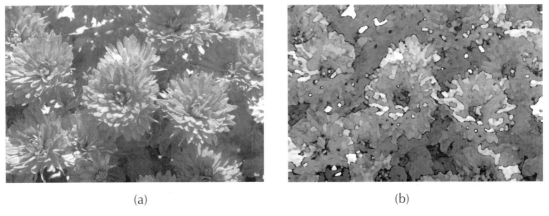

(a)

(b)

Figure 12.13 *Applying the GE Watercolour filter*

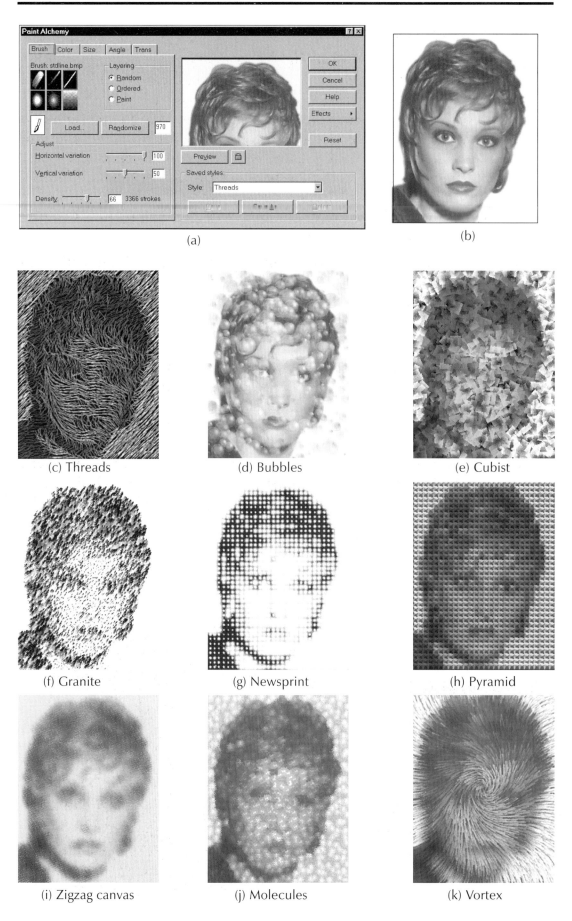

(a)

(b)

(c) Threads

(d) Bubbles

(e) Cubist

(f) Granite

(g) Newsprint

(h) Pyramid

(i) Zigzag canvas

(j) Molecules

(k) Vortex

Figure 12.14 A few examples using PHOTO-PAINT's Paint Alchemy filter

Value/level adjustment

Filters in this category can be used to adjust the levels of an image, e.g. to produce a solarised effect or to highlight just the outlines of the image. An interesting member of the category is the Highpass filter, which suppresses low-frequency areas containing gradual or smooth transitions of brightness levels, leaving just the high-frequency areas containing abrupt shifts between brightness levels. Setting a Radius slider determines the amount of low-frequency suppression, defining a radius in pixels around each pixel in the selected image area. Moving the slider to the left suppresses larger amounts of low-frequency information. Moving the slider to the right suppresses smaller amounts of low frequency information.

Figure 12.15a shows the Highpass dialog box. Applying the filter, with a radius setting of 11.73 to the same source image as that used in Figure 12.12 produced the result in (b).

Texture

Photoshop's Mezzotint filter converts an image to a random pattern of black and white areas reminiscent of a technique used in Intaglio printing. The traditional mezzotint pattern is produced by a tool called a 'rocker'—a heavy instrument with a semicircular serrated edge which leaves teethmarks when worked over a copper plate. After detailed finishing with a scraper tool, the burnished plate is inked and printed. The gradation of tone from solid black areas to pure white can create images of striking contrast. Figure 12.16a shows the Photoshop dialog box which includes a menu from which a style can be chosen before the filter is applied. Applying four different styles to the image in (b) produced the results shown in (c), (d), (e) and (f).

(a)

(b)

Figure 12.15 *Painter's Highpass filter*

In Chapter 6 we saw how KPT's Texture Explorer plug-in could be used to generate an enormous range of texture types. Using the Layer Options function described earlier, it is a simple matter to blend any of these texture types with another image. In Figure 12.17 a copy of the image in Figure 12.16b has been blended, using the Layer Option settings shown in (a), with a simple pattern created in KPT's Texture Explorer (b) to produce the result shown in (c).

Figure 12.16 *Mezzotint effects*

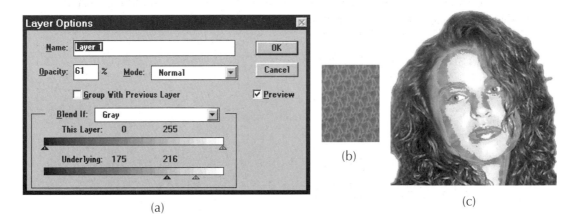

Figure 12.17 *Applying a KPT texture*

Lighting effects

Lighting effects filters are now included with most painting applications, allowing the addition of subtle lighting effects to enliven what might otherwise be flat compositions. In Chapter 8, for example, we saw how a combination of lighting and bumpmapping in Photoshop could be used to give depth and interest to text objects. Painter provides an excellent set of controls for applying lighting effects—see Figure 12.18a—as well as a range of preset effects, one of which (Splashy Colour) was applied to the gargoyle image (a) to produce the result in (b). Figure 12.19a shows PHOTO-PAINT's dialog box, which also provides a menu of presets and a good range of controls.

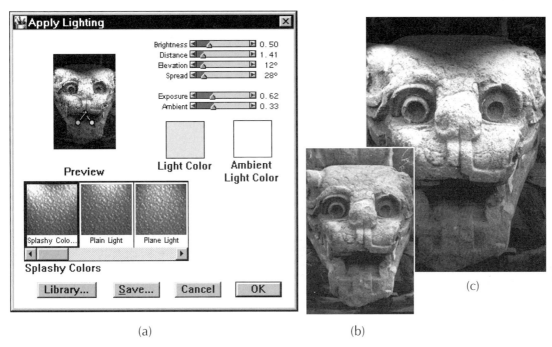

(a) (b)

Figure 12.18 Apply Lighting in Painter

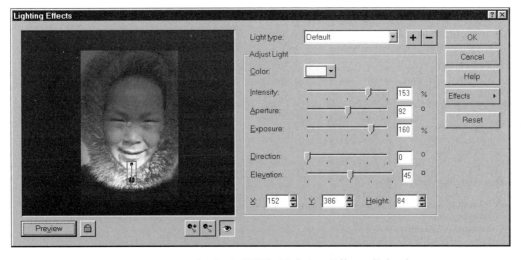

Figure 12.19 PHOTO-PAINT's Lighting Effects dialog box

A filter offering a more unusual form of lighting feature—simulating the effect of taking a photograph with a bright sun appearing in the background—is Lens Flare. When used appropriately, it can add atmosphere to a scene, as shown in Figure 12.20. The Photoshop dialog box is shown in (a), which includes three lens options and a Brightness slider. As can be seen in the dialog preview window, a cursor can be dragged to position the centre of the flare. As example (b) shows, as well as the flare, other internal reflection artefacts can also be seen in the bottom right quadrant of the image against the black silhouette of the buildings.

Thee dimensions and perspective

Several effects in this category were covered in Chapter 11, but a useful one which not included—the Emboss Filter—is shown Figure 12.21. The dialog

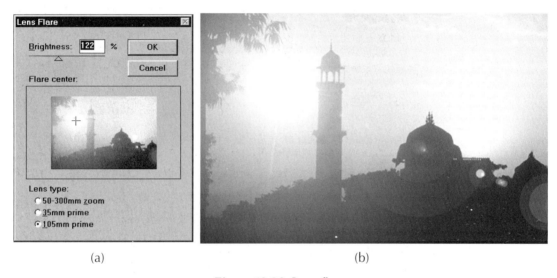

(a) (b)

Figure 12.20 Lens flare

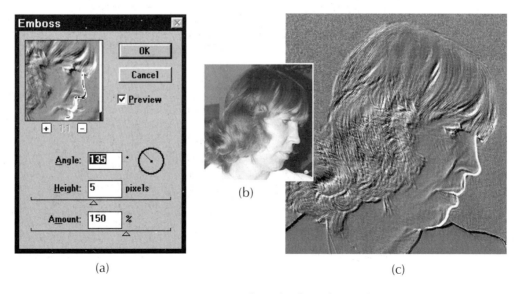

(a) (c)

Figure 12.21 Using Photoshop's Emboss Filter

box (a) includes controls to adjust the strength of the effect, the 'height' of the embossed effect and the direction in which light appears to fall on the surface.

Other

'Weird and wonderful' might be a better description for some of the filters which are included in this final category. While they can produce some amazing effects, it is not easy to imagine many real life projects in which they could be applied. An exception to this, perhaps, is the now ubiquitous Page Curl filter, which, as the name suggests, wraps the selected corner of an image back on itself. Figure 12.22a shows PHOTO-PAINT's dialog box which allows specification of the corner to be curled, whether it should be curled from the top or the side of the page and whether the curl should be opaque or transparent. Applying the filter to the image in (b), with settings Top right, Vertical and Transparent produced the result in (c). One possible practical use of the filter is shown in (d), in which the top 'page' has been curled back to reveal text on the next 'page'. To achieve this effect, the top image was first curled and then the Magic Wand tool was used to select the white area; the selection was inverted and this inverted selection—the image less the white area—was pasted to the clipboard, then pasted on top of the lower image.

The technique of creating vignettes—images which fade out at the edges—has, over time, enjoyed popularity with artists and painters alike; the

Figure 12.22 PHOTO-PAINT's Page Curl filter

technique is still commonly used today to produce soft-edged wedding portraits. The Vignette filter creates a similar effect. PHOTO-PAINT's dialog box—Figure 12.23a—provides user controls to specify whether the image fades to black, to white or to a paint colour; to determine the distance from the centre of the image at which it begins to fade and the rate at which fadeout occurs. Examples (b) and (c) show the contrasting effects of shading the same image to white and to black respectively.

KPT's Glass Lens filters use a ray tracer to 'spherise' a selection and then to illuminate the sphere with a spotlight. Three different effects—Bright, Normal and Soft—are obtained by varying the intensity of the ambient light and the spotlight. No dialog box is provided, so the chosen version is simply applied to the image, or selected part of the image. Applying the Glass Lens Bright option to the image in Figure 12.24a produced the result in (b).

The Gallery Effects Plastic Wrap filter alters an image so that it appears to be wrapped in shiny plastic film, accentuating the surface detail of the image and giving it a Surreal appearance. The parameters of the effect can also be set to create images similar to those made from Polaroids which have been

(a)

(b) (c)

Figure 12.23 *Creating vignettes*

scratched and textured by hand. The dialog box—Figure 12.25a—provides controls for adjusting the Strength of the effect, the level of Detail affected by the highlighting and the Smoothness of the effect.

Probably the most bizarre of all the filters presently on offer—Painter's Blobs filter—takes whatever has been placed on the Clipboard (or uses the current colour if the Clipboard is empty) and uses it to produce a swirling pattern of blob-shaped replicas, called a Stone pattern. The dialog box, shown in Figure 12.26a, allows specification of the number, size and variation in size of the blobs. Applying the effect to a simple circle with a radial fill, using the settings shown in the dialog box, produced the organic looking result shown in (b). To create the effect of a grid in the background, another Painter filter, Grid Paper, was applied the white area between the blobs.

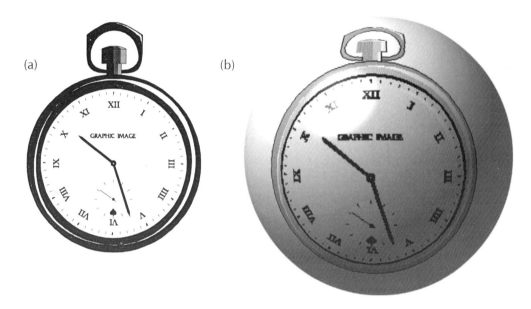

Figure 12.24 *Glass Lens Bright*

Figure 12.25 *Applying Plastic Wrap*

Closely related to the Blobs filter is Painter's Marbling Effects filter which creates marbled patterns based on the actual technique of dragging a rake across pigment floating on liquid in a container. The controls in the dialog box—Figure 12.27b—are similar to those used by real life marblers. As the effect of applying the filter to the ordered greyscale grid (a) shows, marbling does an excellent job of converting chaos out of order, as shown by the result (c).

KPT's Vortex Tiling filter distorts and rotates multiple copies of a source image, scaling and positioning the copies which appear to be sucked down into a spiralling vortex. Such was the fate of the hapless orang-utan in

Figure 12.26 Using Blobs and Grid Paper

Figure 12.27 Marbling a regular grid

Figure 12.28. The filter has no dialog box and is simply applied to an image—in this case our friend (a)—or selected part of the image, to produce the kaleidoscopic effect in (b).

PHOTO-PAINT's Terrazzo filter can produce spectacular patterns from simple images or parts of images. The tile pattern created may be applied (a) to the whole composition or selected part of it, (b) back to the image used to create it, so that it appears to be contained within its boundaries or, (c), to the area surrounding the original image. Terrazzo offers a choice from 17 different symmetries to create a tile—see Figure 12.29. Applying the filter

(a)

(b)

Figure 12.28 Down the plughole!

Figure 12.29 Terrazzo tile symmetry options

reproduces the selected area and performs various operations to change the relative position and orientation of each copy. Each symmetry produces a different result by applying various combinations of translation, rotation, mirror reflection and glide reflection to the original selection. Options in the Terrazzo dialog box—Figure 12.30a—allow choice of source image, setting of the level of feathering between tiles and setting the opacity level.

To create Figure 12.30b, the image of the girl was selected and inverted so that the tile pattern would fill the background area. Using the Pin Wheel symmetry, the girl's face was used as the original motif and the size and position of the selection box in the preview window was manipulated until an acceptable pattern was obtained. Clicking on OK then caused the selected background of the original image to fill with the tile pattern. To produce (c), instead of using the girl's face as the source image, a bitmap pattern was selected, the Sunflower symmetry was chosen and the background tiles were created from the bitmap pattern. Finally, to create (d), using the Gold Brick

(a)

(b)

(c)

(d)

Figure 12.30 Terrazzo tiling

symmetry, only the girl's face was selected and another bitmap pattern was used to create a tiled fill.

Not to be outdone by the bitmap application filter designers, vector software designers are now designing an increasing number of special effects which are either included in, or offered as plug-ins for, vector applications. During earlier chapters we have seen examples of vector shearing, extrusion, perspective, distortion, blending, contouring and enveloping and also how vector objects can be made to interact with one another using the Trim, Intersect, Weld and Powerclip operators. As we saw in the Image Distortion section of Chapter 11, Lens effects have added even more possibilities.

CorelDRAW's Lens roll-up provides 11 lenses which can be applied to objects in a composition. Application of a lens to an object changes its appearance as well as that of any objects located beneath it. The Transparency lens, for example, causes the colour of an object under the lens to mix with the lens object's colour, creating the illusion that the lens object is partially transparent. The lenses work both on vector objects and on imported bitmap objects.

Figure 12.31 shows the effect of the Invert lens which inverts the colours under the lens to their complementary colours. The lens dialog box is shown in (a). A rectangle was drawn slightly larger than the size of the vector drawing of the sailing ship (b) and placed so that it surrounded a copy of the drawing. With the rectangle still selected and Invert appearing in the Lens dropdown menu, clicking Apply converted the rectangle to an Invert lens, changing the copy of the sailing ship to a negative image of the original (c).

The Heatmap lens maps the colours of an object or image to colours in a predefined palette, giving the object an infra-red appearance. Bright, or hot, colours are mapped to hot colours (yellow, orange), while dark, or cool, colours are mapped to cooler colours (blue, cyan, red and purple). Figure 12.32

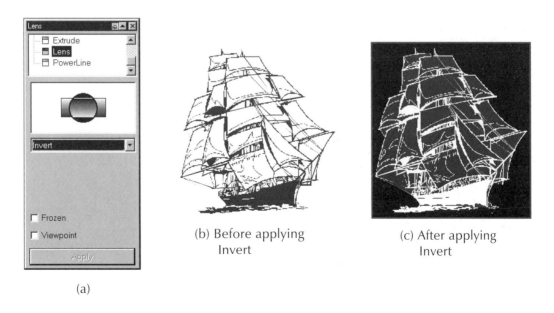

(b) Before applying
Invert

(c) After applying
Invert

(a)

Figure 12.31 Applying the Invert Lens

shows the effect of a rectangular shaped lens applied to the right half of a vector London bus (a) and to the right half of a bitmap image (b).

The Wireframe lens displays the lens object's outline only and changes the fill and outline colour of the objects under it to colours specified in the Lens roll-up. Figure 12.33a shows the effect of applying it to the lower half of an unsuspecting guardsman on sentry duty.

Finally, the Brighten lens adds brightness or darkness to objects underneath the lens. Figure 12.33b shows the effect of applying brightness values of 20%, 40% and 60% to the top right, bottom right and bottom left quadrants respectively of the image of the girl

(a) (b)

Figure 12.32 *The Heatmap lens*

(a)

(b)

Figure 12.33 *Wireframe (a) and Brighten (b) lenses*

13

Painting

Since its adoption as the earliest method for conveying ideas in a graphical form, painting has evolved over thousands of years into the multicultured, multifaceted artform which it is today. If we consider painting reduced to its basic elements, it involves (i) a canvas, or other surface on which the work is to be rendered, (ii) the substance or substances deposited on the surface to create the image, (iii) the implement or method used to deliver the material to the surface and, last but most important, (iv) the artist who wields the implement or applies the method. The following is a brief overview of the Western history of these four elements.

The surface

The cave walls of the Paleolithic cave painters in Southern Europe

The walls of the Pharaohs' tombs in Egypt

The walls of Minoan palaces and the surfaces of pottery in Crete

Greek and Roman mosaics

Byzantine icons on wooden panels

Stained glass of Gothic cathedrals

Murals and ceiling frescoes on wet or dry plaster

Wood panels covered with linen

Stretched canvas

Sides of subway trains in New York

Gable ends of buildings in Northern Ireland

Pavement surfaces used by street artists

The material

Pigments used by cave painters comprising various minerals ground into powder and mixed with binders such as plant juices or animal fats and blood

Enamels, gouache, grisaille, watercolours

Charcoal, oil paints and inks

Pastels—powdered pigments mixed with gum

Acrylics, chalks, wax crayons

The implement

The cave painter's sticks or reeds

Sharpened wooden stylus

Pen made from goose-wing feather, with angled cut for calligraphy

Horsehair brushes

Pencils, pens, crayons, airbrush, aerosol

Sponges, spatulas, paint dripped from tubes on to canvas

The artist

The cave painter

Egyptian and Minoan wall painters

Greek and Roman mosaic artists and painters of wall frescoes portraying rituals, myths, landscapes, still-lifes and scenes of daily activities

Early Christian and Byzantine painters of frescoes in catacombs and churches

Painters of icons—stylised paintings on wooden panels of Christ, the Virgin or the saints

Decoration of illuminated manuscripts by monks of the mediaeval monasteries

Production of stained glass to decorate windows of Gothic cathedrals

Early Renaissance painters employing the principles of linear perspective

Leonardo da Vinci, Raphael, Michelangelo and Titian, the masters
of the High Renaissance period, producing classic works such as
Michelangelo's ceiling frescoes in the Sistine Chapel in Rome, of
the 'Creation and the Fall' and his vast wall fresco of the 'Last
Judgment'

Albrecht Durer's engravings such as 'Knight, Death, and the Devil'
and the paintings the 'Four Apostles', showing superb mastery of
the human form

The work of the Baroque painters such as Rembrandt, producing a
style with a strong sense of movement and use of strong contrasts
of light and shadow

Succeeding Neoclassicism, the Romantic movement introduced a
taste for the mysterious and an exploration of the picturesque and
sublime in nature. Artists like Constable and Turner produced
remarkable works depicting the effects of light and atmosphere

During the nineteenth century, Francisco Goya created highly
individualistic works with a strong expressionistic and hallucinatory
content

Also around the mid-nineteenth century, Gustave Courbet devel-
oped the movement called Realism, painting pictures, for exam-
ple, of artisans at work or ordinary people attending a funeral

In the 1860s, Manet created a style which proved to be the pre-
cursor to Impressionism, with subjects from life around him in Paris

In the late nineteenth century, Degas painted subjects in move-
ment, as though captured by a camera lens, in a style influenced
by photography

Georges Seurat introduced the style Pointillism in which the loose
brushstrokes characteristic of the Impressionist style became pre-
cise dots of pure pigment

In the late nineteenth century, Post-Impressionist artists like Van
Gogh developed a style which used pure colour applied thickly in
bold strokes, as a means of conveying intense emotional expression

At the turn of the century, Gauguin was strongly influenced by
primitive work of the South Seas region, employing complex deco-
rative colour patterning

The emergence of Expressionism produced works more concerned
with recording subjective feelings and responses, via distortions of
line and colour, than with the faithful representation the subject,
tending to a semi-abstract form of painting

Cubism, developed by Picasso and Braque, used a harsh geometric approach to the depiction of landscape forms and still-life objects, marking a further move towards abstraction

Surrealist artists like the Spaniards Salvador Dali and Joan Miró brought the subconscious and the role of dreams into artistic creation

The Abstract Expressionism movement in New York in the 1940s and 1950s continued the exploration of the unconscious. Jackson Pollock used a technique involving dripping colours over large canvases to create dynamic, random patterns

Pop artists like Andy Warhol drew their imagery from advertising hoardings, films and common, everyday objects

The cynical images of Pop Art provoked a revival of a new form of realist painting—photorealism, which relied on photography to achieve a precisely detailed, impersonal kind of result

Abstract Expressionism evolved towards a more rigorous formal purity, culminating in Minimalism, in which painting was reduced to simple geometric forms

The 1980s saw a number of young artists like Baselitz, Chia, Clementer and Kiefer rebel against the austerity of much abstract art, with work employing rough brushwork and bold colour and avoiding any attempt at depicting realism

Set against such a rich and varied history of traditional artists and the methods and techniques which they have evolved over centuries, the digital art of today pales into insignificance. However, those who dismiss it as irrelevant fail to recognise the pace at which other forms of communication and expression are becoming digitised. In a way that has no parallel in the long history of art, digital technology is opening up possibilities for the artist which could never otherwise have been dreamed of. Already, such is the variety of sophisticated tools, techniques and types of canvas now available to the digital painter, that a whole book could easily be devoted to the subject. In Chapter 3, a brief introduction to the subject has already been provided. The objective of this chapter is to build on that introduction and to give a least a glimpse into some of the exciting new techniques available to today's digital artist.

The digital surface

The concept of the digital surface is more complex than that of its traditional counterpart. In fact, there are three surfaces to consider—the phosphor surface of the cathode ray tube on which the working image is displayed, the background (or digital canvas) on which the composition is created and, finally, the paper or transparency surface on which the output is printed.

With regard to the system monitor, regular calibration is important using one of a number of utilities which optimise the consistency of colour integrity between scanner, monitor and output device. It is also important to understand the differences between the RGB image displayed on the monitor and the CMYK image printed on the output device. There are several excellent books available which cover this topic.

Increasingly, in the future, the final output devices for much digital artwork may simply be monitors connected to the Internet. Such a paradigm change will not happen overnight, but the prospect of millions having access to artwork via the Net, as opposed to the handful who have access to works of art via the traditional art gallery, is intriguing. Meanwhile there is a wide range of paper and artboard stock on which final output can be printed using inkjet, laser, dye sublimation or thermal wax devices or via screen printing, offset litho, letterpress or gravure printing.

With regard to the digital canvas—the background on which the digital painting is created—back in Chapter 6 we examined the wide range of fill types (Figure 6.21) which are currently available. While any of these can be used to provide a background for painting on, the texture fills most closely resemble traditional surfaces (see Figures 6.56 to 6.66). Unlike his traditional counterpart, the digital painter can experiment with different canvas sizes and surface fills at any stage of composition, as the canvas exists an a separate electronic layer from the paint applied to it. While applications like Photoshop and PHOTO-PAINT offer a wide range of canvas textures, only Painter offers canvas textures which can appear to interact with paint, as they would do when using natural media. As Figure 13.1 shows, if a Painter surface texture is selected (a) and then applied to a canvas (b), brush strokes applied to the surface with a brush loaded with the same texture—in (c) through a mask in the shape of a letter A—appear to be affected by the surface topography of the canvas. Figure 13.2 shows three examples of the different kinds of effect which can be obtained when the same image is painted using, in each case, the same brush texture and canvas texture.

Figure 13.1 *Paint interaction with a textured surface in Painter*

Figure 13.2 Use of Painter textures

The digital material and implementation tools

Like their conventional counterparts, Photoshop and PHOTO-PAINT provide brushes which can be loaded with paint from a colour palette. Compared with the range of colours within the visible spectrum, the range which can be displayed on a CRT screen is limited by the photochemistry of the screen phosphor, while the range which can be printed by the conventional CMYK offset printing is limited to the colours which can be produced by mixing these four inks. That said, the colour range available is enormous and, of course, colours and tints can be selected, saved and reselected with digital precision. Once a brush is selected in Photoshop, paint Opacity and Mode (e.g. Diffuse, Multiply, Hard Light) can be defined and precise control can also be maintained over paintbrush size, roundness, hardness, spacing (between paint dots) and angle—see the dialog boxes in Figure 13.3. A combination of these controls with the brush/canvas metaphor provided by the latest stylus/tablet combinations provides our digital artists with capabilities which would have been the envy of their predecessors.

A powerful feature of digital painting, which has some parallel in the traditional technique of stencilling, is the ability to create 'custom brushes' using any part of a scanned image or an existing piece of artwork. All the leading applications provide preset brushes to illustrate the technique. Figure 13.4a shows some of Photoshop's presets; via the dropdown menu, additional libraries can be created, saved and accessed when required. Once selected, the spacing of a preset brush can be adjusted to control the distance between impressions or 'stencilled' copies. Figure 13.4b shows the effect of adjusting this spacing while using a preset consisting of a simple circle. Checking Pressure options in the brush dialog box (Figure 13.3) can cause the copies to vary in size and/or colour and/or opacity as the stylus is tracked across the tablet.

Figure 13.5 shows two more complex examples. In (a) a copy of the apple image created earlier in Ray Dream Designer was scaled, selected and made into a new preset brush, using the Define Brush command in the Brushes dropdown menu (Figure 13.4a). A full-size copy of the original apple was pasted into a new image and then, with the new preset selected and spacing

Figure 13.3 *Photoshop's brush controls*

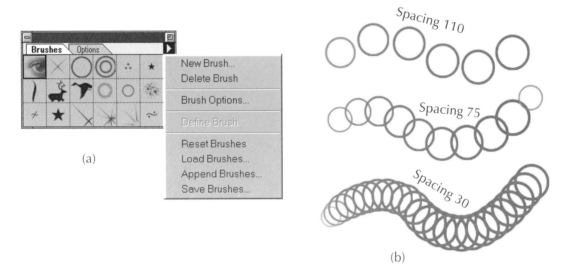

Figure 13.4 *Painting with presets*

Figure 13.5 *Applying custom brushes*

set to 110, a ring of smaller apples was painted around the perimeter. To create (b), a preset was created from a copy of the little clipart aeroplane and then, with spacing set to 60, the preset was used to paint the shape of the letters A, N and D.

As well as conventional and preset brushes, PHOTO-PAINT and Painter provide a range of 'natural media' brushes, which, in operation, simulate the application of oils, chalks, watercolours, wax crayons, charcoal, etc. Each of these is provided with a menu of variations, for example the Airbrush comes with five variants—Fat Stroke, Thin Stroke, Feather Tip, Spatter and Single Pixel. Any one of a wide range of textures can be applied to the brushstrokes of a number of these variants, providing an enormous range of possibilities. Figure 6.8 in Chapter 6 already showed a few examples of the many brush effects which can be created.

Painter's brush control palette, (a), and dialog boxes, (b) and (c), are shown in Figure 13.6. Figure 13.7 shows two of the tools at work; (a) is a simple line sketch of Albrecht Durer's famous portrait of his mother (*c* 1500) produced with the use of the Scratchboard version of the Brush tool. Via the Effects menu, Surface Effects/Apply Surface Texture was used to impart a canvas-like texture to a copy of the line sketch; next, the Grainy variation of the Charcoal tool was used to reproduce Durer's original charcoal-on-paper masterpiece. While the work proceeded, the Brush Controls: Size and Controls: Brush dialog boxes were used to make adjustments to the size and shape of the tools being used.

Painter's cloning tools were then used to create the two variations of Figure 13.7b shown in Figure 13.8. To produce (a), File/Clone was first invoked to create an exact copy, or clone, of the charcoal drawing. Select All/Backspace was then used to clear the copy from the clone and the Soft Cloner tool was

(a)

(b)

(c)

Figure 13.6 Painter's brush controls

selected from the Brushes palette; applying the tool to the area of the eyes and mouth caused them to appear within the image frame. The original, or source image, was then reselected and inverted, so that subsequent use of the Clone tool caused the inverted image to appear as shown in (a). Finally the peripheral area was given a texture, using a large, soft brush loaded with a texture from the Textures palette.

Variation (b), which was produced using a process similar to that for (a), shows how cloning can be used selectively to introduce only certain parts of

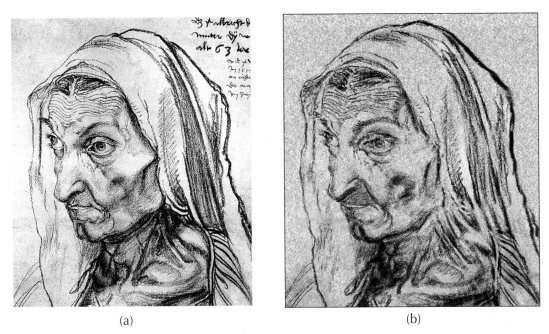

(a) (b)

Figure 13.7 Using the Scratchboard and Charcoal tools

(a) (b)

Figure 13.8 Painter special effects

an original source image into a new composition. Indeed, using this method, a new composite image can be created which draws elements from more than one clone source. To produce the composite shown in Figure 13.9, for example, a new document was created and the file containing the first face was opened. By selecting File/Clone Source, this image was specified as the clone source and a soft cloning brush was used to clone just the eyes into the blank new image. (After cloning, the cloned area can be selected, scaled, rotated and repositioned as required.) Next the image of the first face was closed, another file containing the second face was opened and now this second file was specified as the clone source. Switching to the new document, the soft cloning brush was again used to clone just the area of the source image which included the eyes. This process was repeated using, in turn, three more source images. Finally, a texture fill was applied to the whole of the new image, using Effects/Surface Control/Apply /Surface Texture, to integrate the five different elements of the composition.

In cloning the five elements of Figure 13.9, the same soft cloning brush was used in every case, however, this does not have to be the case; the style and parameters of the cloning brush can be altered from clone to clone. Figure 13.10 shows four examples of different cloning brushes used to clone the same area of a source image.

As well as cloning, Painter offers a unique feature called the Image Hose, which appears as a special brush within the Brush Library and as an option

Figure 13.9 Composite cloning

in the Brush Controls dialog—Figure 13.11a. The Image Hose uses Nozzles—sets of images which can be sprayed in sequence, randomly, in a grid, or in response to pressure, image size or colour. The Image Hose brush variants (Figure 13.11b) are programmed to provide many variations in the way Nozzle elements flow from the brush. Nozzles can be prepared by grouping floating selections, or objects, in Painter and then saving the group in a Nozzle library in standard .Rif format. Figure 13.11c shows an example of a Nozzle prepared from an image consisting of a group of coins and Figure 13.12a shows the effect of applying the image hose to a canvas, using three different settings to control the spacing of the coins, namely Small, Medium and Large Random Linear. Nozzles can also be used to build up rectangular geometric patterns within all or part of an image. When applied randomly, the Nozzle at the top of Figure 13.12b produces the result shown immediately

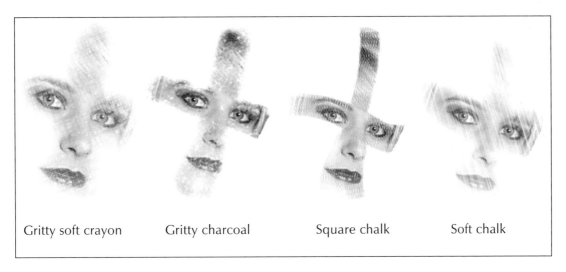

Gritty soft crayon Gritty charcoal Square chalk Soft chalk

Figure 13.10 Using different cloning brushes

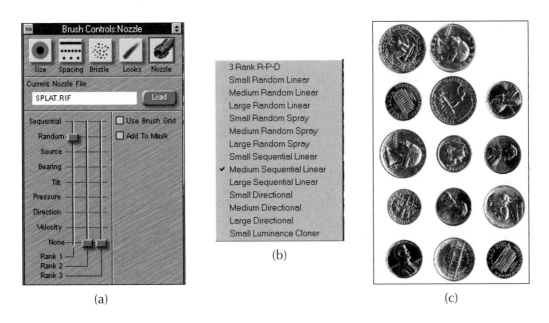

(a) (b) (c)

Figure 13.11 Painter's Image Hose dialog box (a), Variants menu (b) and a Nozzle example (c)

below it. If, however, Use Grid Box is first checked in the Nozzle dialog box (Figure 13.11a), then the application of the Nozzle is constrained within an XY grid pattern.

Virtually any vector drawing or bitmapped scan, photograph or painting can be used to construct a Nozzle. Figure 13.13 shows just three of a wide range of sample Nozzles provided with Painter. Multiple Nozzles can also be applied to the same composition to produce more complex effects; Figure 13.14a used four Nozzles, applied in the sequence (i) Cloud Nozzle, (ii) Large Shrub Nozzle, (iii) Pebbles Nozzle, (iv) Small Plant Nozzle. If required, Nozzle opacity can be adjusted down from the 100% default before application

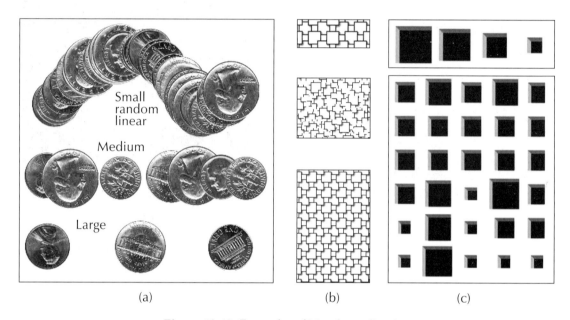

(a) (b) (c)

Figure 13.12 *Examples of Nozzle application*

Figure 13.13 *Range of nozzle types*

and, as mentioned earlier, using the settings in the Nozzles dialog box, and the variants of the Image Hose brush, a wide range of different effects can be achieved. Finally, Figure 13.14b shows the result of spraying a frame full of images using a Nozzle built from four distorted versions of an image seen earlier in the book.

(a) (b)

Figure 13.14 *Using multiple Nozzles (a) and applying an image-based Nozzle (b)*

Summary

Even in the months it has taken to compile this modest publication, the price/ performance ratio of desktop computer hardware has continued its headlong fall, with the market maintaining a healthy growth rate of 20% per annum plus. As the market grows, economies of scale drive down the prices of all essential PC commodities. In particular, hard disk and CD-ROM drive prices have plummeted, as has the cost per MHz of processor chips and the price of peripheral devices such as laser printers and scanners. Although less spectacular, prices of other system components like motherboards and graphic cards and peripherals like monitors have also continued to fall in real terms. Meanwhile, on the performance front, Power PC and Intel processors continue their ceaseless game of MHz leapfrog; EDO RAM and pipeline burst caching have significantly increased memory performance, disk drive access times have fallen, while data throughput has increased with help from new bus technologies like PCI; CD drives have accelerated from twin speed to quad speed to hex speed while scanner, laser printer and inkjet printer resolutions have jumped to new heights.

Taking advantage of the more powerful hardware engines, true multitasking operating systems have now established a firm foothold on the desktop, while modestly priced software application upgrades are also responding to the increasing power of the average desktop specification, to offer powerful and exciting new features which, until recently, could only be found on expensive high-end systems. Compatibility among applications has also improved, as more and more import/export filters are included with each upgrade, while a growing convergence between vector and bitmap applications—particularly those from the same vendor—allows the designer to produce hybrid compositions using the best features of both technologies.

As we saw in the first chapter, the choice and range of DIY raw material has increased with the advent of more affordable and more powerful scanners and digital cameras, while the quantity, if not always the quality, of clipart libraries and stock digital photo libraries has also mushroomed.

As well as offering a forum of growing value for the exchange of ideas and information between graphic designers around the globe, the Internet sub-

stantially increases the potential for collaborative projects and for electronic publishing, as tools like HTML become more sophisticated and widely accepted.

With no sign yet that the pace of innovation on the desktop is slackening and with a new computer literate generation now coming of age, the future for digital design and publishing is indeed bright. As Sir Herbert Read, the distinguished art historian once said,

> Art is ... pattern informed by sensibility.

So might we say, if Sir Henry will forgive us, that,

> The art of digital design is flair powered by technology!

Bibliography

Aldrich-Ruenzel, N. and Fennell, J. (eds). Designer's Guide to Typography, *Oxford: Phaidon,* **1991.**

Baird, R.N, Turnbull, A.T. and McDonald, D. The Graphics of Communication, *New York: Holt, Rinehart & Winston,* **1987.**

Blatner, D. and Roth, S. Real World Scanning and Halftones, *California: Peachpit Press,* **1993.**

Dean Lem Associated Inc. Graphics Master 4, 4th Edition, *Los Angeles:* **1988.**

Collier, D. Collier's Rules for Desktop Design and Typography, *Wokingham, England: Addison-Wesley,* **1991.**

Craig, J. Production for the Graphic Designer, *New York: Watson-Guptill,* **1976** *(revised edition* **1990***).*

Craig, J. and Barton, B. Thirty Centuries of Graphic Design, *New York: Watson-Guptill,* **1987.**

Craig, J. and Bevington, W. Working with Graphic Designers, *New York: Watson-Guptill,* **1989.**

Dalley, T. (ed). The Complete Guide to Illustration and Design, *London: Phaidon,* **1980.**

Gill, R.W. Basic Rendering, *London: Thames & Hudson,* **1991.**

Gosney, M. and Dayton, L. The Desktop Colour Book, *California: MIS Press,* **1995.**

Gosney, M., Dayton, L. and Chang, P.I. The Verbum Book of Scanned Imagery, *California: M&T Books,* **1991.**

Greiman, A. Hybrid Imagery, *London: ADT Press,* **1990.**

Heller, S. and Fink, A. Low Budget High-Quality Design, *New York: Watson-Guptill,* **1990.**

Hollis, R. Graphic Design — A Concise History, *London: Thames & Hudson,* **1994.**

Meggs, P.B. History of Graphic Design, *New York: Van Nostrand Reinhold,* **1983.**

Miles, J. Design for Desktop Publishing, *London: Gordon Fraser,* **1987.**

Olsen, G. Getting Started in Computer Graphics, *Ohio: North Light Books,* **1993.**

Parker, R.C. Looking Good in Print, *Chapel Hill, North Carolina: Ventana Press Inc,* **1988.**

Peacock, J. et al. The Print and Production Manual, *London: Blueprint, (5th edition)* **1990.**

Pender, K. Creative PC Graphics, *Wilmslow, Cheshire: Sigma Press,* **1996.**

Pipes, A. Production for Graphic Designers, *London: Laurence King Publishing,* **1992.**

Porter, T. and Goodman, S. Manual of Graphic Techniques 2, *London: Butterworth Architecture,* **1982.**

Porter, T. and Greenstreet, B. Manual of Graphic Techniques 1, *London: Butterworth Architecture,* **1980.**

Sanders, N. and Bevington, W. Graphic Designer's Production Handbook, *New York: Hastings House Publishers Inc,* **1981**

Tektronix Inc. Picture Perfect: Color Output in Computer Graphic, *Wilsonville, Oregon:* **1988.**

Turnbull, A.T. and Baird, R.N. The Graphics of Communication, *New York: Holt, Rinehart & Winston,* **1980.**

Glossary

24-BIT COLOUR A description of systems which allocate 24 bits of data to each pixel in an image. Usually, the bits are allocated as 8 bits each for the three additive primary colours (red, green and blue). That arrangement provides over 16.7 million colour possibilities.

ALPHA CHANNEL In applications like Photoshop, alpha channels are used to create and store masks. Alpha channels are additional to the three channels of an RGB image or the four channels of a CMYK image.

AMBIENT LIGHT Normal background light, for example, daylight, as opposed to artificial light cast by room lights or spotlights.

APPLICATION Computer software which carries out a particular task, such as desktop publishing.

AUTOTRACE A feature of some drawing programs which creates a set of vectors to represent apparent outlines of a bitmapped image. Used to create draw-style images for graphics programs starting from a paint-style image. Often the original is an image created by scanning a hand-drawn image.

BEZIER Using the Bezier tool, smooth curves can be created by placing and manipulating Bezier nodes and the handles which radiate from these nodes.

BIT The primary unit in computers—a binary digit (a 1 or a 0).

BITMAP A type of graphics format in which the image is made up of a large number of tiny dots (bits) arranged on a closely spaced grid.

BITS/PIXEL A description of the number of levels of information a system stores about each point in an image. For every extra bit, the number of available colours or shades of grey doubles. Also called pixel depth.

BLEND A feature on many digital painting programs that allows softening of the edges or mixing of colours where two objects or regions meet.

BUMPMAPPING In Photoshop, the Texture Channel in the Lighting Effects dialog box allows use of a greyscale texture to affect how the light bounces off the image. By creating unique textures, or by using general textures like those of paper or water, 'bumps' can be produced in the image which appear to bounce the light off a three-dimensional surface. Channels can be used to set the height of the bumps.

BYTE 8 binary bits of data grouped together to store a character, digit or other value. The term was popularised by IBM in connection with its 360 Series computers, and is now universally used in the industry. In most recent devices, each byte can be used to store one character of alphanumeric data, so the size of such items in memory can be interchangeably given in bytes or characters.

CAMERA READY COPY (CRC) or MECHANICAL A complete and finished layout of type and images ready to be photographed by a process camera or imaged directly to a printing plate.

CHANNELS *See* Alpha Channel

CLIPART Copyright-free illustrations, available as conventional artwork and in formats that which can be used directly in DTP-produced publications.

CLIPPING PATH Bezier paths drawn with the pen tool may be exported and saved in EPS format for use in an illustration or page-layout program. A clipping path makes everything except the selected area appear transparent when the image is printed or previewed in the drawing or DTP application. This allows use of part of an image in another document without obscuring the other document's background.

CLONE In a painting application, the cloning tool takes a sample of the original image, which can then be applied to, or painted over, another image. In a drawing application, subsequent changes applied to the original object (the master) are automatically applied to update the copy (the clone).

CMYK Cyan, magenta, yellow and key (black). This is the system used to describe and separate colours for printing. Other systems include RGB (red, green, blue) for transmitted colour, as on computer screens, and HLS (hue, luminance, saturation), a more theoretical description. The Pantone Matching System matches colours by mixing 11 basic colours.

COLOUR CORRECTION The process of changing the colour balance of an image to approach more closely the desired values. Images are colour-corrected to make up for the differences between the response of the film and ink and the human eye and to compensate for the effects of the printing process.

COLOUR DISPLAY SYSTEM The colour computer display screen itself, and the graphics card which drives it.

COLOUR SEPARATIONS A set of films for the cyan, magenta, yellow and black components of a full-colour image.

COMPOSITE IMAGE An image created from the blending of two or more other images, e.g. Photoshop's Mode options determine which pixels in a floating selection will replace the underlying pixels, based on a comparison of the pixels. Darken mode, for example, pastes only pixels that are darker than the pixels in the underlying image.

CONTINUOUS TONE Artwork or photography containing shades of grey.

CROPPING Removing unwanted portions of an image, e.g. to reduce the saved file size or prior to copying and pasting the cropped area into another composition.

CYAN Process blue—really more turquoise in colour.

DESKTOP SCANNER A device for converting line and halftone copy into a digital form readable by illustration or DTP programs.

DIGITISING RESOLUTION The fineness of detail that a scanner can distinguish. Unless otherwise stated, it is the spatial resolution, reported in dots per linear inch (or dots per mm in metric areas).

DIGITISING TABLET A device used for computer drawing and painting using a puck or stylus on a flat sensitised plate.

DINGBAT A symbol or ornament such as ✳ or ❑ which is treated as a character in a font.

DITHER PATTERN For a scanner, a pattern of dots used to simulate grey tones or intermediate colours. Also called screen pattern.

DITHERING A crude computer method of screening. Thermal wax and inkjet printers produce their colours by interspersing pixels of cyan, magenta, and yellow (and sometimes black) in regular patterns, grouped together in either 2 ∞ 2 or 4 ∞ 4 matrices.

DPI Dots per inch, a measure of the resolution or addressability of a raster device such as a laser printer.

DRAWING PROGRAM A computer program which stores images in terms of the lines and curves used to create them. *See also* Painting Program.

DROP CAP A large initial letter dropping into the lines below and signalling, for example, the beginning of a new chapter.

DROP SHADOW A copy of an object positioned below it and offset from the original to create the appearance of a shadow. In a drawing program, the tone of the shadow can be adjusted. In a painting program, the edges can be blurred for additional effect.

DTP Desktop publishing—electronic page make-up.

DYE-SUBLIMATION PRINTS Colour proofs produced by mixing vapourised dyes on the surface of the paper.

E-MAIL Correspondence, usually text only, created, transmitted and received electronically via a network.

EMBOSSING A finishing process producing an image in low relief.

ENVELOPING Constraining the boundaries of text or of a drawn or painted object to fit within a predefined shape.

EPS Encapsulated PostScript—a format for transferring drawings created in Illustrator and FreeHand, for example, into DTP programs.

EXTRUDING Applying a three-dimensional appearance to a selected object by adding surfaces to it. In a drawing program, the surfaces become new objects. Extruding an object creates an extrude group which includes the original object and the extruded surfaces.

FAMILY A set of fonts related to a basic roman typeface, which may include italic and bold plus a whole range of different 'weights'.

FEATHER To blend or smooth the edge of a region or shape into a background or other object, especially in a slightly irregular fashion to achieve a natural-looking effect.

FILM RECORDER Output device for making transparencies from an image created in the computer.

FLOPPY DISK Magnetic medium for storing and archiving digital information and for carrying computer documents around, from the studio to the service bureau, for example.

FOUR-COLOUR PROCESS Full-colour printing in which colours are approximated by various percentages of the process colours: cyan, magenta, yellow and black. A full-colour image is separated by filters into four different films—one for each of the four process colours—and four plates are used for the printing.

FRAME-GRABBER An input device that uses a television camera to capture a picture or three-dimensional object, or a video frame, converting it into digital form readable by a computer program.

GAMMA CURVE A graphical representation of an image, showing the distribution of pixels in the image with colour values ranging from dark to light.

GEL An image placed between a light source and a surface so that it casts a shadow on to the surface.

GUI (GRAPHICAL USER INTERFACE) The way in which an operating system (such as Microsoft Windows or Apple System 7) presents itself on the computer screen to the user, using devices like icons to simplify interaction.

HALFTONE A continuous-tone image converted to line by turning it into a pattern of dots, either electronically, by laser, or by photographing it through a screen.

HIGHLIGHT The lightest area on an image being photographed (and therefore the darkest area on the negative).

ICON A small picture on the computer screen representing an application, tool or document.

IMAGE COMPRESSION As applied to scanners and graphics computer systems, encoding the data describing an image in a more compact form to reduce storage requirements or transmission time.

IMAGESETTER A high-resolution output device, producing typesetting or whole pages on bromide paper or film.

INKJET PRINTER An output device that creates an image by spraying tiny drops of ink on to paper. *See also* Bubblejet Printer.

LANDSCAPE The orientation of a page when the width is greater than the height.

LASER PRINTER An output device in which black toner is attracted to an image on a drum that has been electrostatically charged by the action of a laser; the image is transferred to paper and fixed by heat.

LATHING A technique for creating a three-dimensional object with axial symmetry by first creating a two-dimensional outline and then rotating the outline around a specified axis.

LAYER Like the transparent acetates used to build up the layers of a traditional composition, the electronic layers of a drawing or painting program are used to keep elements of a composition separate from each other. The attributes of each layer, e.g. the layer's transparency, can be adjusted independently of the other layers.

LINE ART Illustrations containing only blacks and whites, with no intermediate tones (or similarly, a bitonal arrangement of some other colour). Line art can be reproduced without the screening or patterning step most printing processes need to produce a range of tones.

LINE SCREEN Measurement of a halftone screen, short for lines per inch or lpi; the higher the number of lines, the finer the screen.

LINOTYPE A typesetting machine for letterpress in which a whole line of type (line o' type), or slug, is cast in one operation.

LITHOGRAPHY A Planographic printing process in which greasy ink is transferred from the surface of a dampened plate or stone directly on to paper.

MAGENTA The process colour red; really more a purple colour.

MAKE-UP Assembly, scaling and positioning of the components of a composition on the final page.

MASKING Drawing a path around an area of a composition so that an effect can be applied just to that area, or conversely, applied only to the area outside the mask.

MIPS (MILLIONS OF INSTRUCTIONS PER SECOND) Measure of the processing speed of a computer.

MODEM A device which enables digital information to be sent down telephone lines; an abbreviation of modulator/demodulator.

MOIRE Unwanted 'basket-weave' effects caused by superimposed regular patterns, such as halftone dots. Screens must be set at angles that minimise moire.

MONTAGE 1. A composite image, especially one made up of elements that are distinct or would normally not be placed together. 2. A type of video sequence made up of many short images where the symbolic meaning of the images or their relations are the message, rather than any literal temporal or spatial sequence.

MORPHING A technique for transforming, or meta*morph*osing, one object through a series of steps into another object.

MOUSE In computing, a small pointing device used to control the movement of a cursor on the screen.

NETWORKING Linking computers together so that they can communicate with each other and share output devices such as laser printers.

OFFSET LITHOGRAPHY Usually abbreviated to offset litho, prints first on to a rubber or plastic blanket, and then on to the paper.

OPACITY The property of a layer defining the visibility of objects lying on a lower layer. The converse of transparency.

OPERATING SYSTEM Computer software which controls the internal workings of a computer.

OPTICAL CHARACTER RECOGNITION (OCR) The process of having a computer translate images of text into the corresponding computer codes.

PAINTING PROGRAM A computer program which stores the image on the screen as a bitmap. *See also* Drawing Program.

PALETTE The collection of colours or shades available to a graphics system or program. On many systems, the number of colours available for use at any time is limited to a selection from the overall system palette.

PANTONE MATCHING SYSTEM (PMS) A widely used proprietary system for specifying flat colour in percentages of 11 standard colours; coordinating papers and markers corresponding to Pantone colours can also be purchased.

PARALLEL INTERFACE A connection that sends the bits making up data across several lines at once. This type of connection is usually limited to short distances, but it is faster than the alternative serial interface.

PEN PLOTTER A point-to-point output device used mainly for engineering drawings; if equipped with a knife in place of the pen it can be used to cut stencils for screenprinting or vinyl letters for signs.

PHOTOCD A product launched by the Eastman Kodak Company in 1992 which converts 35 mm film negative or slide into digital format by a high resolution scanning process and stores the images on CD. Images are stored at multiple levels of resolution, allowing users to select an version with a quality and file size appropriate to their application.

PHOTOREALISTIC Description of images that look like they could have been produced by a photographic process. For a computer image, this usually means one with good spatial resolution and sufficient colour depth (number of colours).

PHOTOTYPESETTING OR PHOTOSETTING A process in which type is set on to bromide paper or film by exposure of light through a matrix containing tiny negatives of the letters, or directly by the action of a laser beam.

PIXEL Short for picture element and refers to the dot on a computer display. The resolution (sharpness) of a raster display is measured by the number of pixels horizontally by the number of scan lines vertically, e.g. 1280 x 1024.

PLATE A metal or plastic sheet with a photosensitive face on to which an image is chemically etched, either changing the characteristics of the surface as in lithography, or cutting below the surface as in relief or Intaglio printing.

POINT A unit for measuring type equal to approximately 1/72 inch (exactly 1/72 inch in DTP).

PORTRAIT The orientation of a page when the height is greater than the width.

POSTERISE To transform an image to a more stark form by rounding tonal or colour values to a small number of possible values.

POSTSCRIPT 1. A trademark of Adobe Systems Inc. for the firm's page description language used to describe images and type in a machine-independent form. 2. Loosely used to refer to the interpreter program that translates PostScript language files to the actual sequences of machine operations needed to produce an output image.

POSTSCRIPT LEVEL 2 An updated version of the PostScript language that adds support for colour, forms handling, data compression and many other features.

PROCESS CAMERA A camera designed to enlarge or reduce artwork and mechanicals and to produce film positives and negatives.

PROCESS COLOURS The four colours—cyan (process blue), magenta (process red), yellow and key (black)—used to approximate full-colour artwork.

PROOF Hardcopy that allows a check of the accuracy of setting, the position of design elements on a page or the fidelity of colour after separation.

RAM (RANDOM ACCESS MEMORY) Quick access temporary memory in a computer containing the job in hand, in the form of chips.

RAY TRACING A process for rendering a scene. The ray tracer sends hypothetical rays of light from the sources in the scene and calculates the visual effect for each pixel in the rendering, as rays encounter and reflect from the various objects making up the scene.

REGISTER 1. The alignment of the printed image with its intended position on the page. 2. The alignment of parts of an image with other parts, especially with parts that are printed separately, as in colour separation.

RELIEF PRINTING A printing process, such as Letterpress and Flexography, in which ink lies on the raised surface of the plate but not in the grooves and is transferred to the paper by pressure.

RENDER To produce an image from a model or description. Usually, this means filling in a graphic object or image with colour and brightness (or just shading for monochrome systems). Realistic rendering takes a lot of computing power and advanced techniques.

RESOLUTION A measure of the fineness and quality of an output device, usually measured in dots per inch (dpi)—the number of dots that can be placed end to end in a line that is an inch long.

RGB (RED, GREEN, BLUE) A system for specifying colour on a computer screen. *See also* CMYK.

RIP RASTER IMAGE PROCESSOR A device that converts a PostScript file into a bitmap.

ROM (READ ONLY MEMORY) Permanent unalterable computer memory in the form of chips.

ROMAN Normal type, as opposed to italic or bold, abbreviated rom; also a kind of type with serifs, such as Times New Roman.

SCALING Enlarging or reducing—usually applied to an image—and calculating the percentage of enlargement or reduction so as to anticipate the space it will occupy on a layout.

SCAN 1. To convert an image from visible form to an electronic description. Most available systems turn the image into a corresponding series of dots but do not actually recognise shapes. However, some attempt to group the dots into their corresponding characters (Optical Character Recognition) or corresponding objects. 2. Particularly, to use a scanner (an input device containing a camera or photosensitive element) to produce an electronic image of an object or of the contents of a sheet of paper. 3. A scanned image.

SCANNED IMAGE An image in bitmap form produced by a scanner. Many layout programs can scale or crop scanned images before placing them into a page.

SCANNER 1. An input device which converts a drawing or illustration into a corresponding electronic bitmap image. In the graphic arts industry, sometimes called an illustration scanner. 2. An input device which converts a page or section of text into the corresponding characters in memory or a computer file. Also called an OCR (optical character recognition) scanner.

SCREEN PRINTING A printing process using a stencil supported on a mesh or screen; ink is forced through the open mesh but is prevented from reaching the non-image areas of the paper by the stencil.

SEPARATION Film in register relating to one of the four process colours; also artwork or film in register relating to flat colour.

SHADOW 1. The darkest area of an image that is being photographed, and therefore the lightest area on the negative. 2. As a graphics tool, one that inserts a partial copy or dark outline behind a selected object, producing the appearance of a shadow.

SHARPEN An image enhancement that increases the apparent sharpness of an image by increasing the contrast of edges. Actually, the effect further distorts an image and its repetitive use on the same signal will create a less realistic image.

SHEAR In painting and drawing programs, to slant an object along a specified axis (much the way a type of simple italic might be made by slanting a normal upright roman character).

SKINNING A three-dimensional modelling technique which simulates the stretching of a flexible skin over a series of cross-sectional shapes or formers.

SMUDGE A feature on some graphics programs that blends colours or softens edges that are already in place in an image. The effect is supposed to resemble what would happen if the image was made of wet paint and you ran a finger over the area.

SOLARISE To change the intensity levels in an image in a way that particularly brightens or transforms the middle levels.

SPHERISE To modify an image so that it appears to be projected on to the surface of a sphere.

SPOT COLOUR Colour that is applied only as individually specified areas of a single ink colour; compare process colour, whereby colours may be mixed and each dot of painted colour must be determined by a more complex overall colour-separation process.

THERMAL-TRANSFER PRINTER An output device that prints by 'ironing' coloured wax on to paper by the action of heat

TILE 1. To fill an area with small, regular shapes, creating an effect that looks like a wall surfaced with individual tiles. 2. The individual shape that is repeated to fill an area. 3. A single sheet or portion that will be combined with others to assemble an oversize page. 4. A method of showing multiple windows on a display screen that puts images side-by-side instead of overlapping the windows like a stack of paper (called overlapped windows).

TRANSPARENCY A colour slide, usually either 35 mm, 5 in by 4 in, or 10 in by 8 in.

TRUETYPE An outline description format from Apple and Microsoft which rivals PostScript.

VIGNETTE A halftone that fades to nothing around the edges.

Index